THE PHOTOGRAPHER'S GUIDE TO
FILTERS

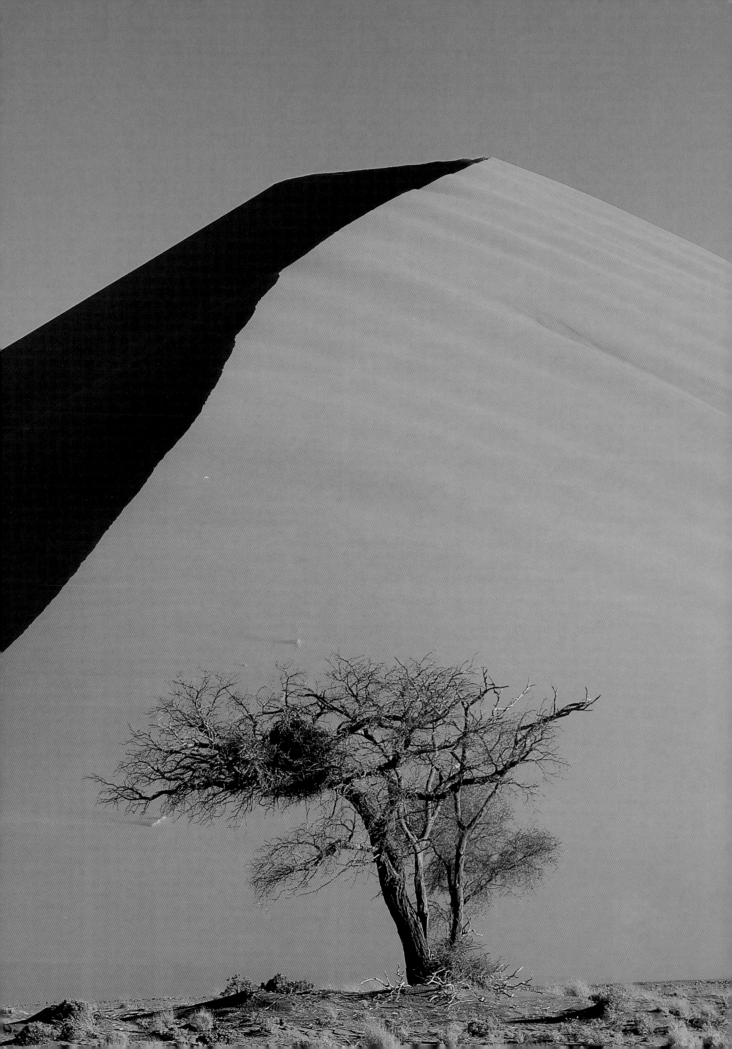

THE PHOTOGRAPHER'S GUIDE TO
FILTERS

Lee Frost

David & Charles

DEDICATION
For my children, Noah and Kitty,
and my wife, Julie.

A DAVID & CHARLES BOOK

First published in the UK in 2002
First UK paperback edition 2004
Reprinted 2004, 2005, 2006

Distributed in North America
by F&W Publications, Inc.
4700 East Galbraith Road
Cincinnati, OH 45236
1-800-289-0963

A catalogue record for this book is available from the
British Library.

ISBN 0 7153 1233 2 hardback
ISBN 0 7153 1400 9 paperback

Printed in Singapore by KHL Printing Co Pte Ltd
for David & Charles
Brunel House Newton Abbot Devon

Commissioning Editor Sarah Hoggett
Art Editor Diana Dummett
Senior Desk Editor Freya Dangerfield
Production Roger Lane

Visit our website at www.davidandcharles.co.uk

David & Charles books are available from all good bookshops;
alternatively you can contact our Orderline on (0)1626 334555
or write to us at FREEPOST EX2 110, David & Charles Direct,
Newton Abbot, TQ12 4ZZ (no stamp required UK mainland).

ACKNOWLEDGMENTS
All photographs by the author except for the following:
Simon Stafford, page 29 (left, both), page 30 (top left, both),
page 38, page 66 (top); Joe Cornish, page 44 (all); Chris Rout,
page 93 (all); Sandy Furniss, page 96; Tom Mackie, page 106;
Roger Howard, page 107 (both), pages 109, 111, 112, 113
(top), page 115 (main); Billy Stock, page 116 (all), pages 117,
138 (bottom), page 139

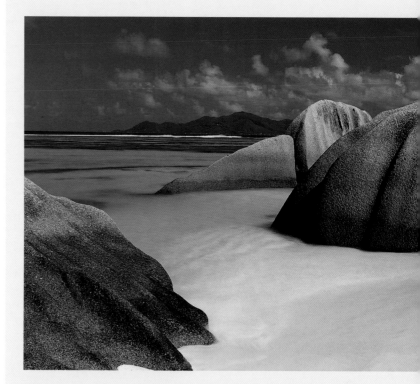

▲ ANSE SOURCE D'ARGENT, LA DIGUE, SEYCHELLES
This stunning tropical beach scene was photographed in the Seychelles, using a
polarizing filter to enhance the sea and deepen the blue sky. This filter alone can
completely transform an image when used correctly (see pp. 23–38).

PENTAX 67, 45MM LENS, TRIPOD, POLARIZING FILTER; FUJICHROME VELVIA; ¼ SEC. AT F/22

(PAGE 2) DUNE 45, NAMIBIA
The graphic simplicity of this shapely sand dune and the tree at its base was enhanced
using a polarizing filter to deepen the blue sky and increase colour saturation.

NIKON F90X, 80–200MM ZOOM, POLARIZING FILTER; FUJICHROME VELVIA; ¹⁄₁₅ SEC. AT F/8

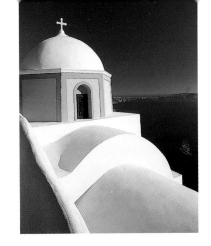

CONTENTS

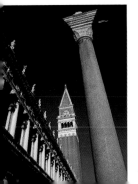

INTRODUCTION

Using filters has been an important aspect of my work ever since I first became interested in photography during my mid-teens. It was around that time – the early eighties – that Cokin filters were launched, and immediately I was hooked by the multitude of amazing effects they could help me create.

Needless to say I was soon the proud owner of a Cokin filter holder, adaptor rings for all my lenses, and a growing collection of filters that could do all sorts of weird and wonderful things. Early investments included a polarizer, warm-ups and grey graduates, as my main interest was, and always has been, landscape photography. I was entranced by the way a polarizer could deepen blue sky and make colours look stronger – I'd never seen anything like it. And by the way that cloudy skies no longer needed to be washed out and boring because I could darken them down with a graduated filter (even if they also came out a little on the pink side as well).

But it wasn't long before my hunger for filters took a more extreme turn and I added more – soft-focus, tobacco, pink and blue graduates, sepia, starburst, diffractors, multiple-image and coloured filters for black and white photography. It seemed amazing that you could place a simple filter on your lens and transform an image – just like that. What I had failed to realize at the time was that, while filters are capable of great effects, if the main elements aren't there in the first place – good light, sound composition, an interesting subject – those effects can never replace them. Long term, however, it was a useful learning curve. I took some awful pictures, but I learned a lot in doing so and it stood me in good stead for the future.

Today I still use filters. In fact, it's rare that I take a picture without a filter on my lens. More often than not, they are chosen for technical reasons – to control contrast, boost colours and allow me to make the most of the scene and light composed in my camera's viewfinder. But I'm not averse to using

▶ **VENICE**
Architecture, landscapes, abstracts, close-ups – a polarizing filter is invaluable for all kinds of photographic subjects and it should be the first item on your shopping list.

PENTAX 67, 105MM LENS, TRIPOD, POLARIZING FILTER; FUJICHROME VELVIA; ⅛ SEC. AT F/16

▼ **BAMBURGH CASTLE, NORTHUMBERLAND, ENGLAND**
Don't feel that you have to use filters on every picture you take. Sometimes the light is so stunning that it needs no improvement.

PENTAX 67, 55MM LENS, TRIPOD; FUJICHROME VELVIA; 1 SEC. AT F/16

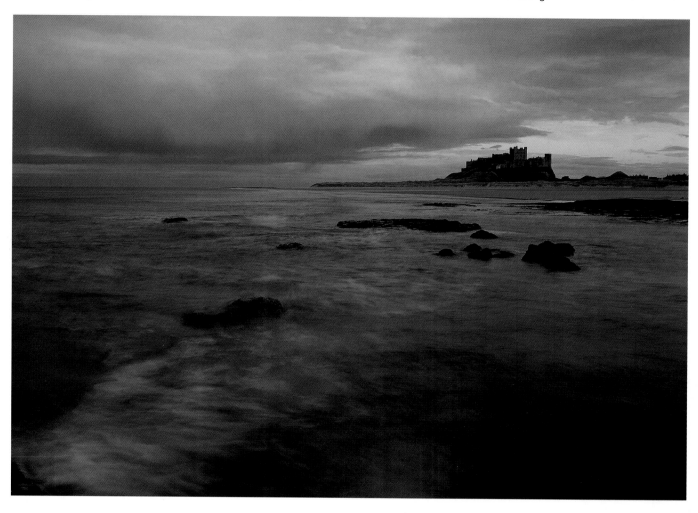

one every now and then purely for effect and often I'm surprised by how good that effect can be.

My main reason for writing this book is to pass on all the knowledge I have amassed over the years about filters – which ones you need, what they will do, why and when you would choose to use them. Chapter by chapter we will look at polarizers, graduated filters, colour-balancing filters, neutral-density filters, filters for black and white photography, soft-focus filters, colour filters, special-effects filters, filters for close-up photography and infrared and, finally, using filters together. All chapters include comparison pictures so that you can see exactly what effect specific filters have. There are also many inspirational images that show how filters can improve a picture when used carefully.

But before all that, a much more important factor has to be addressed – choosing a filter system. This is a subject often overlooked, but I have encountered numerous photographers who have carelessly invested large amounts of money in expensive filter systems, only to find that they are incompatible with certain lenses or camera formats, or that they have no idea how to use them. Filter manufacturers and photographic retailers are often to blame for this, being more interested in making a sale than offering sound advice to their customers. But, as that customer, you need to take charge and ask your own questions.

After reading this book, I hope that you will know what those questions are and avoid making expensive mistakes. I also hope that it will inspire you to explore the fascinating world of filters and use them to take better pictures – which, ultimately, is all they are designed to do.

▲ **VENETIAN MASKS**
Effects filters must be used with care, but on the right subject they can work well. Here I used a soft-focus filter to enhance this simple shot of two masks hanging outside a shop window in Venice.

PENTAX 67, 300MM LENS, TRIPOD, COKIN DIFFUSER 1; FUJICHROME PROVIA 400; 1/125 SEC. AT F/11

CHOOSING
A FILTER
SYSTEM

1

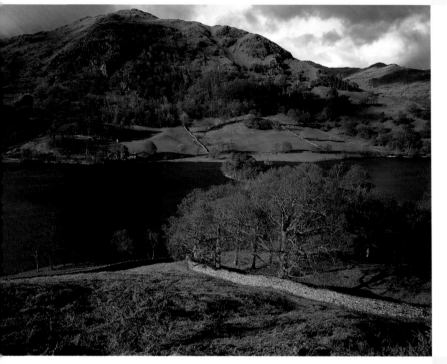

RYDAL WATER, LAKE DISTRICT, ENGLAND
Think long and hard before making a decision about
which filter system to invest in, otherwise you could make
an expensive mistake. I have been using the same filter
system for almost a decade now, and despite changing
camera systems and working with different film formats
along the way it has never let me down. Here I used
two slot-in filters in the holder to control contrast and
enhance the light.

HORSEMAN WOODMAN 54, 90MM LENS, 81B AND 0.6 ND
GRADUATE FILTERS, TRIPOD; FUJICHROME VELVIA; ½ SEC. AT F/22

With the promise of great results, it's tempting to rush out and spend
a small fortune on a collection of filters without really thinking about
what you are doing. However, with so many different filter systems to
choose from, all offering their own relative pros and cons, you need to
consider a number of factors before taking the plunge if you are to
avoid making a very expensive mistake.

The aim of this chapter is to work though all the factors you need to
consider, and look at the benefits and drawbacks of the best-known
filter systems, so you can invest in a filter system that will be compatible
with all your cameras and lenses – not only today, but in the future as
well. Initially, the outlay for achieving this may seem high, but long term
it will make your life much easier – as well as saving you money.

9

SLOT-IN OR SCREW-IN?

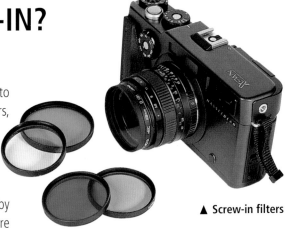

Slot-in or screw-in?

The first decision you need to make is whether to invest in a set of traditional round screw-in filters, or a modular slot-in system. The screw-in filters screw directly to the front of your lens, while the slot-in ones are slotted into a filter holder, which is attached to the front of your lens.

To be honest, the decision is made for you by the nature of each system. Screw-in filters are handy for certain types of filter that you use regularly (see p. 20), or filters to protect your lens's front element (see p. 82), but for general use a square, slot-in system is far more versatile.

The immediate benefit of a slot-in system is that you can use the same filters and holder on all your lenses (if you buy the right system) simply by investing in a set of adaptor rings to fit different thread sizes. Two or more filters can also be used together without risk of vignetting (see above), so you can combine different technical and creative filters to achieve different effects (see p. 136–41).

▲ **Screw-in filters**

Slot-in filters ▶

◀ Although screw-in filters have been around for longer, they cannot match slot-in systems in terms of versatility. If you intend using two or more filters together on a regular basis, the latter type will be far more convenient and also more cost-effective.

◀ **FISHGUARD BAY, PEMBROKESHIRE, ENGLAND**
Telephoto lenses are far less prone to vignetting due to their limited field-of-view. If you are using screw-in filters this means you can combine two or more without problems, while the smaller slot-in systems will be suitable – assuming you can buy adaptor rings that are big enough for the lens's filter thread. For scenes like this, keep your filters clean to avoid flare.

PENTAX 67, 300MM LENS, 81C WARM-UP FILTER, TRIPOD; FUJICHROME VELVIA; 1/30 SEC. AT F/11

CHECKING FOR VIGNETTING

Serious cases of vignetting (darkening of the image corners) are usually obvious when you peer through the camera's viewfinder, but some viewfinders show more of the image area than others, so don't assume that if you can't see it, it doesn't exist.

To check for this problem, set your lens to f/16 or f/22, point it at an area of plain sky or a white wall, then activate the depth-of-field preview. If you look carefully through the viewfinder you should be able to detect any signs of darkening towards the corners of the viewfinder. It's also a good idea to rotate the filter holder while looking through the camera's viewfinder, to see if vignetting is caused when the filter slots on either side of the holder are at an angle. This is a common problem with ultra wide-angle lenses, but can often be avoided by keeping the filter slots square.

Here's a final tip to avoid vignetting. If you use a rectangular film – any format other than 6 x 6cm, in other words – you will reduce the risk of vignetting by rotating the filter holder so the filter slot rails run horizontally top and bottom, rather than their usual position of side to side. This can't be done if you're using graduated filters and taking pictures with the camera in landscape format, as the holder slots must be either side of the lens. For other types of filter, however, it's something worth bearing in mind with wide-angle lenses.

▼ **RIVER BRATHAY, LAKE DISTRICT, ENGLAND**
This is what vignetting looks like. Sometimes you can see it through the viewfinder, but as most cameras only show 80–90 per cent of the total image area it can quite easily go undetected.

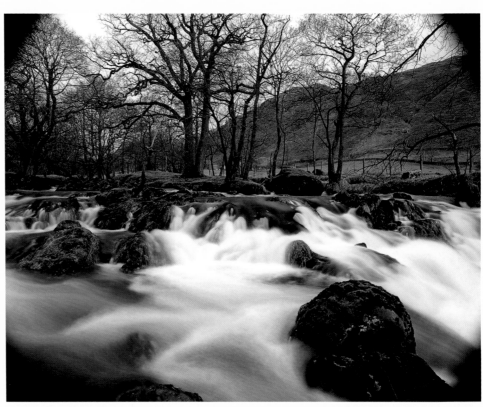

Screw-in filters, on the other hand, are made in a specific thread size – 49mm, 52mm, 77mm, and so on. If all your lenses have the same thread size, which is highly unlikely, this isn't a difficulty. It is more likely, however, that you will have three or four different thread sizes in your lens collection – more if you use medium-format as well as 35mm equipment – so there will be a compatibility problem.

One way around this is to buy the filters to fit the thread size of your largest lens – 77mm or 82mm, say – then a set of stepping-down rings that will adapt the filters to fit lenses with a smaller thread size. These rings are easily available and inexpensive. They also come in a wide range of sizes. But – there's always a but – if you take this option, the initial outlay will be huge if you need a set of 77mm or 82mm filters. You also have to remember that, even with large-diameter filters, there's a limit – usually two, rarely more than three – that you can use together before vignetting becomes a problem due to the combined depths of the filter mounts encroaching on the lens's field of view.

All things considered, then, a slot-in system is going to serve your needs much better long term. All you need to decide is which one...

SIZE MATTERS

Despite the fact that a few slot-in filter systems are getting close to satisfying all the requirements of the most demanding user, even the best have annoying flaws – especially if you work with more than one film format, or have a penchant for wide-angle lenses and zooms.

The biggest problem, as always with filters, is vignetting, or cut-off, because the filter holder is too small. Vignetting is mainly a risk with wide-angle lenses since they have a broad field of view. Given the huge rise in the availability and popularity of ultra wide-angle zooms in the 17–35mm, 18–35mm and 20–35mm ranges, the problem has become much more common.

The second factor is making sure there are adaptor rings in the range that are big enough to fit your biggest lens. Ultra wide zooms and fast telephotos tend to have a filter thread of 77mm or 82mm, as do many medium-format lenses, so if you invest in a system that covers only filter threads up to 62mm, say, then you are going to have problems.

67mm systems

The smallest slot-in systems – of which Cokin A is by far the most common – are based on filters with a width of 67mm. These systems can be used on 35mm format lenses as wide as 28mm without causing vignetting, while 62mm is the biggest filter thread they can accept. So, although the small filter size keeps the cost low, it clearly offers limited scope if you intend using lenses wider than 28mm.

84/85mm systems

The next step up is to 84/85mm systems, including Cokin P and Hitech 85.

The **Cokin P** system is possibly the most widely used filter system in the world as it offers a near-perfect compromise between cost, versatility and image quality. The increased size of both filter and holder means that vignetting isn't a problem on 35mm-format lenses as wide as 20mm, or on 50mm or 55mm lenses on medium-format cameras, while the maximum adaptor ring size of 82mm is more than adequate to cope with today's ultra wide-angle zooms and bigger medium-format optics.

◄ The Cokin A and equivalent systems are fine if you're on a budget, but watch for vignetting on wide-angle lenses.

If you want to use an 85mm filter holder on wider lenses – 17mm or 18mm – cut off the front slot with a hacksaw to reduce the depth of the side rails. This may sound drastic, but the side rails are made from plastic, so they're easy to adapt, and the maximum number of slots you should ever need is three, whereas the Cokin holder has four in total. Even better, why not buy two or three holders – they're very inexpensive – so you can have three-slot and two-slot versions? The alternative is to modify the filter holder in some way so that it will fit directly over the front of the lens's barrel, rather than attaching to the very end of the lens via a threaded adaptor ring. There are numerous ways of doing this, involving elastic bands or bits of bent wire, so experiment and see what you can come up with.

A great benefit of the Cokin P system is that the polarizing filter (see pp. 23–38) rotates in its own narrow slot at the rear of the holder. This means you can use other filters, such as neutral-density graduates (see pp. 40–52), at the same time, and control the position of both

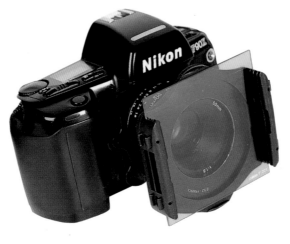

◄ The Cokin P system is incredibly popular, and is a good choice if you want a versatile filter system that isn't going to cost a fortune.

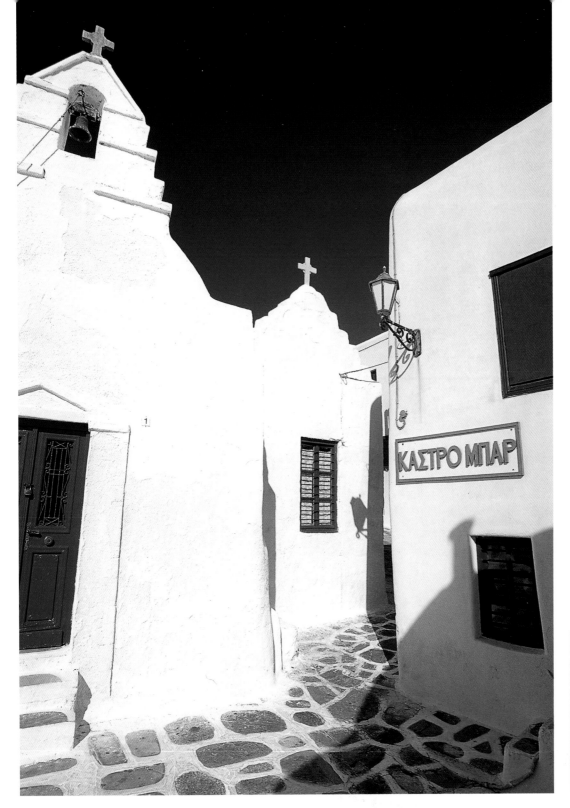

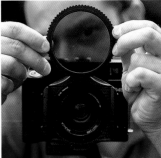

Wide-angle lenses cause the biggest headaches when you come to use filters, because their wide field-of-view increases the risk of vignetting. Avoid this by investing in at least an 84/85mm filter system. If you can afford it, a 100mm system will be even better. For this shot I attached a 105mm screw-on polarizer to the lens via an 82–105mm stepping ring.

NIKON F90X, 18–35MM ZOOM AT 20MM, POLARIZER; FUJICHROME VELVIA; ⅟₃₀ SEC. AT F/11

▲ You can see here how a Cokin P system polarizing filter can be aligned by eye, then slotted into its holder on the front of the lens – this factor makes it ideal for use with rangefinder cameras.

independently – aligning the graduate first, for example, then rotating the polarizer until the desired effect has been obtained.

This system is also ideal for use with rangefinder cameras where you don't have through-the-lens (TTL) viewing, because you can hold the polarizer just above the lens, rotate it in front of your eyes, then slot it back into the holder in the correct position.

Because this size of filter is so popular, other manufacturers, such as Jessops and SRB Filters in the UK, and Singh-Ray and Tiffen in the US, also produce filters to fit it. You can therefore pick and choose from a vast range of filters, choosing budget options if money is short, more expensive filters when it isn't, and also taking advantage of specialist filters that aren't available in the Cokin range.

With the **Hitech 85** system you can choose from a range of filter holders depending on your

needs, although they cost around eight times more than the Cokin P system holder, so you need to bear this in mind.

The standard holder has three filter slots plus a circular threaded ring attached to the front with a 95mm diameter. This ring allows you to attach a 95mm polarizing filter to the front so you can control its effect while using other filters in the main holder. There are two-slot and one-slot versions of the holder available with a 95mm front ring, but vignetting is a real risk on lenses wider than 24mm, even with the one-slot version, due to the combined depth of the filter holder and the polarizer. Having to buy a 95mm polarizer to use on the holder will also push up the price of the system considerably.

100mm systems and larger

Beyond 85mm filters you enter the world of expensive 100mm professional systems. The choice in this category is the greatest of all, and adaptor rings usually go up to 105mm so the filters can be used on the biggest lenses.

Lee Filters is one of the best-known manufacturers, and the first choice of many top professional landscape and travel photographers.

AVOIDING FILTER-RELATED PROBLEMS

Vignetting and various other filter problems can be overcome by using the low-tack gum normally used to attach artwork to walls. This material is easily available from office supply stores and it's invaluable for attaching filters direct to the front of a lens so you don't need to use a filter holder. By doing this you can use 85mm filters, such as Cokin P and Hitech 85, on a 17mm lens without vignetting.

Another application is to avoid the problem of using polarizing filters and graduated filters together and not being able to control the effect of both independently. All you need to do is rotate the polarizer until the desired effect has been achieved (see p. 24) then, using small blobs of low-tack gum placed on the rim of the polarizer, align your graduated filter and press it into place so the gum holds it firm. More filters can then be attached in the same way so you could combine a polarizer, graduate and warm-up, for example, without the need for a filter holder.

Attaching the filter direct to a lens can be fiddly because you'll need to stick balls of low-tack gum on the outside of the barrel, and they have a tendency to fall off – especially in cold weather. An alternative is to screw a filter holder adaptor ring to the lens first, place four small balls of low-tack gum – no bigger than 5mm diameter – onto the rear face of the filter, then press it onto the flat surface of the adaptor ring. Using small balls of low-tack gum means there will be a gap between each filter to avoid Newton's rings.

This may seem like a desperate measure to take when you have spent a small fortune on filters. However, your ultimate goal should be to use those filters on all your lenses without any risk of vignetting, and if this means using something as simple as a pack of low-tack stationery gum, so be it.

◄ These pictures show how low-tack gum can be used to secure filters to a lens.

Use the adapter ring from a filter-holder to provide a flat face, as here

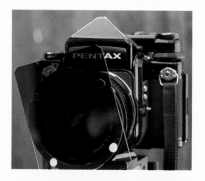

Two or more filters can be used together, fixed with small pieces of low-tack gum

Alternatively, place the gum either side of the lens barrel to attach filters

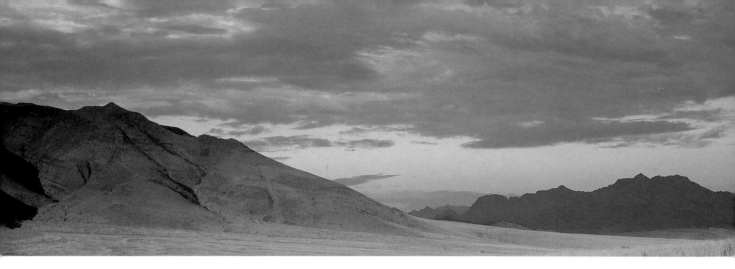

However, it's not without flaws, so consider whether it's the best system for you.

The standard holder comes as a kit so you can customize it to suit your needs, fitting slots for both 2mm- and 4mm-thick filters, and varying the number of slots to a maximum of four. At maximum capacity it can be used with 35mm-format lenses as wide as 21mm, and with medium-format cameras with 50/55mm lenses, without causing vignetting. This wide-angle capability is achieved by using wide-angle adaptor rings, which are recessed so the holder sits back on the lens a few millimetres, rather than attaching flat to the front.

Alternatively, Lee has recently introduced a push-on wide-angle holder with two slots that fits over the lens barrel and is held in place by a locking screw, rather than fitting via an adaptor ring. This allows it to be used on lenses that are as wide as 17mm without vignetting.

To overcome the problem of using a polarizer with standard slot-in filters, Lee has followed Hitech's idea and now offers an optional 105mm threaded ring that attaches to the front of the holder. If you use this ring on the push-on wide-angle holder it will be safe from vignetting down to focal lengths of 18–19mm, although to achieve that you need to purchase the polarizer from Lee Filters, as it has a shallower mount than most 105mm polarizers.

Hitech 100 is another highly capable system, but still has its annoying quirks that take a while to fathom. The main drawback here is the same as for Hitech 85 and Lee – namely, if you want to use a polarizer with other filters, you will need a holder with a threaded ring on the front, and a screw-on polarizer – 105mm in this case.

Using the standard three-slot holder, 28mm is the widest you can go without vignetting with a

▲ **NAMIBIA**
Once you get into larger film formats – especially rollfilm panoramics – the professional filter systems are invaluable, so it is wise to plan ahead when you invest in a filter system and try to predict what type of equipment you may need to use it on in the future. Here I used a Hitech 100 filter holder with two slots, placing a filter in each.

FUJI GX617, 180MM LENS, 81C AND 0.6 ND GRADUATE FILTERS, TRIPOD; FUJICHROME VELVIA; ½ SEC. AT F/22

▲ As well as their standard holder, Hitech and Lee Filters also manufacture wide-angle holders with fewer slots, so you can use them on wider lenses without vignetting. This is the Hitech two-slot holder with no front ring. A one-slot version is also available.

▲ The Hitech 100 system is highly versatile, but its one weakness is that a polarizing filter has to be mounted on the front of the holder, and this causes vignetting on all but moderate wide-angle lenses. One solution can be found on page 21.

polarizer attached, and a 50/55mm lens on a medium-format camera vignettes badly, even if you use a wide-angle adaptor ring. Using a two-slot or one-slot holder instead will allow the use of wider lenses – down to 20mm with the one-slot holder.

Where you need to use other filters without a polarizer, the Hitech 100 two-slot wide-angle holder without the 105mm front ring will manage lenses down to 17/18mm in 35mm format, and 40/45mm in rollfilm format, without vignetting, as long as it is used in conjunction with a wide-angle adaptor ring.

Cromatek 100 is a less popular system, but still well worth considering. This versatile system is based around a compact and inexpensive filter holder, which has two standard slots for normal filters and an inner slot at the back of the holder for the Cromatek polarizing filter.

Providing you keep the holder square so that the side rails are perfectly upright, it will work with 35mm format lenses down to 18mm, and medium-format lenses down to 45mm on 6 x 7cm or 40mm on 6 x 6cm without vignetting.

To maximize the system's wide-angle capability, the polarizer needs to be rotated before your eye then popped into the holder, which in turn is clipped onto the adaptor ring already screwed to your lens. By working in this way you can keep the side rails of the holder upright to minimize the risk of vignetting. The same technique will also allow you to use this system with rangefinder cameras that don't have TTL viewing.

Where vignetting isn't a risk, you can clip the holder onto your lens with the polarizer in place and then rotate the holder in order to obtain the required degree of polarization – the polarizer will move with the holder.

The biggest filter system available is the recently launched **Cokin X-Pro** range, which is based around 130mm-wide filters and will provide vignetting-free pictures on lenses as wide as 17mm. The biggest adaptor ring is also an astonishing 112mm, although very few lenses have a thread size so big, and 82mm is the limit for most lens systems.

The sheer size of the holder is a great bonus for ultra wide-angle lens users, but it also makes carrying the system a chore – graduated filters are

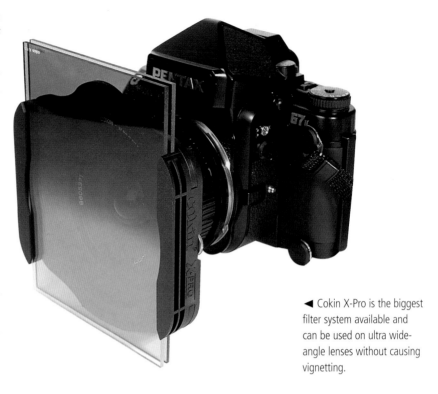

◄ Cokin X-Pro is the biggest filter system available and can be used on ultra wide-angle lenses without causing vignetting.

170mm deep, so you are going to lose a lot of storage space in your gadget bag or backpack to the holder and filters alone.

As the polarizer slots into the holder, you also need to rotate the holder to obtain polarization. This is fine in normal use, but means that if you want to use a graduated filter as well as a polarizer, which is common in landscape photography, you can't control the effect of both independently as you can with some of the other systems outlined in this section – specifically Lee, Hitech 100 and Cromatek 100.

Singh-Ray and **Tiffen** are two other brands worth considering. Available in the US, they are primarily made in Cokin P size (84mm), but bigger sizes are available on request. So, if you invest in a Lee, Hitech or Cromatek system, but would like to take advantage of specialist filters in the Singh-Ray range or Tiffen ranges, you should contact them for prices (see p. 142).

Whichever system you decide to invest in, think to the future as well as the present. Your widest lens at the moment may only be a 28mm, so you could get away with using one of the smaller systems. But in months or years ahead you may add something much wider to your lens collection, such as a 17–35mm zoom, or start shooting medium- or large-format, in which case your small filter system will be useless, and you will have to start all over again.

OTHER CONSIDERATIONS

Apart from size, you also need to consider whether the filter system you have chosen is compatible with other systems, and with the different ranges of filters that are available from the various manufacturers.

Cross-compatibility

Choosing a system that is compatible with other systems isn't essential, but it will broaden your options. For example, Cokin P and Hitech 85 systems are compatible, so you can use standard filters (not polarizers) from one system in the holder of the other. Since the Cokin P system holder costs far less than Hitech's, and also has adaptor rings up to 82mm, while Hitech 85 is limited to a maximum size of 77mm, you could therefore buy a Cokin holder and use Hitech 85 filters in it. This makes sense because the range of Hitech technical filters, such as neutral-density graduates and colour-balancing filters, is much more comprehensive than Cokin's, while Cokin has a better range of effects filters.

As already mentioned, the Cokin P system is also more versatile if you want to use a polarizer with other filters on wide-angle lenses, and the Cokin polarizer itself is more favourably priced than any 95mm screw-on polarizer that you would need for the Hitech 85 system.

In the bigger 100mm systems, the Lee filter holder will accept any 100mm-wide filters in its 2mm slots. Adaptors are also available so you can fit 85mm filters (Cokin P and Hitech) in the holder, although vignetting is a real risk if you do this with wide-angle lenses because the mask used for the smaller filters may get in the way.

Similarly, Hitech filters can be used in a Cromatek holder (and vice-versa). This is worth remembering as the Cromatek 100 holder is more versatile on wide-angle lenses and when using a polarizer with other filters, while the Hitech 100 filter range is much more extensive than Cromatek's.

Filter ranges

Finding a filter system that's going to be compatible with all your lenses and across different film formats is important, but don't lose sight of the actual filters available from each manufacturer.

The 'enthusiast' systems from Cokin are great all-rounders, but tend to be lacking in technical filters, such as colour-balancing and neutral-density graduates, offering just a small selection of the most popular filters rather than a full range.

Hitech 85 is better in this respect, with

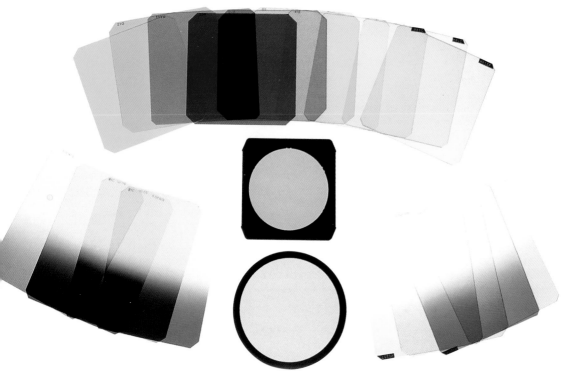

◄ Check out the technical filters available in a specific system before deciding if it's the one for you. Professional systems are better in this respect because they are aimed at photographers who need precise control and high quality.

In this picture a wide range of filters are shown, from polarizers and graduates to colour correction and contrast-controlling filters for black-and-white photography.

STORING AND CARING FOR YOUR FILTERS

Filters are optical accessories, just like lenses. If either is scratched or dirty then it's going to degrade the quality of your photographs and increase the risk of flare. To avoid this, treat your filters with reverence and care so they give optimum performance and last for years.

Storage

Individual filters come in boxes or wallets that provide adequate protection but can be fiddly to store and carry if you have a lot. A better solution is to buy some kind of filter storage case with individual pockets, so you can keep your filters together in one neat bundle for easy access.

The wallets manufactured for Compact Discs (CDs) are ideal for slot-in filters and they tend to cost less than purpose-made filter wallets. Write on the front of each pocket which filter is inside so you can keep your collection organized. If you have a large filter collection you could buy a wallet for technical filters and another for creative filters – most CD wallets have either 12 or 24 pockets.

Cleaning

Careful storage and handling of your filters should reduce the risk of damage, but regular use inevitably means they will become dirty or smudged with greasy fingermarks. To remove dust and dirt use a blast of canned air or a blower brush. For fingermarks and salty sea spray, breathe on the filter then wipe the surface carefully with a micro-fibre lens cloth.

Repeated cleaning will inevitably put fine scratches on the surface of the filter. Evidence of this may be that flare is hard to avoid in bright sunlight, or points of light look like stars when you peer through the filter. When that happens it's time to replace the filter, but if you're careful you shouldn't need to do that for years.

▲ The boxes and wallets filters come in when you buy them offer adequate protection, but can be awkward to access and take up a lot of bag space.

▲ One storage solution with slot-in filters is to place them in individual 5 x 4in polyester film sleeves, then store the filters in a padded wallet. I use a Lee Filters' case for this, although it was intended to carry only one filter.

▲ A great way to store slot-in filters is in a CD case. They're available on any high street, and cost far less than purpose-made filter cases.

▲ **Sossusvlei, Namibia**
Look after your filters and they will look after you. I am obsessive about keeping my filters clean at all times, so I check them before each use, and give them a good clean each evening if necessary. In a location like this filters become dirty very quickly and should be checked before each picture.

Pentax 67, 105mm lens, polarizer and 81C filters, tripod; Fujichrome Velvia; ¼ sec. at f/22

a full range of neutral-density graduates, colour-correction, colour-conversion and colour compensation (CC) filters, plus the usual coloured graduates, soft-focus, and a range of combination neutral-density graduate filters that combines neutral-density graduates in various densities with any 81-series warm-up filter. The thinking behind this is that neutral-density graduates and warm-up filters are often used together, so combining the two reduces the number of filters you need to use and minimizes loss of image quality.

One option, therefore, is to take advantage of Cokin's inexpensive P system holder and adaptor rings, but to pair it with Hitech's wider choice of technical filters so you benefit on both counts.

Singh-Ray's slot-in filter range is relatively small, but worth considering for certain special filters. The neutral-density graduates are of a very high quality, and there are various colour intensifiers available (see pp. 36–9), as well as polarizers and specialized polarizers, all made to fit a Cokin P system holder. In fact, Singh-Ray is the only manufacturer to produce polarizing filters that will fit in the narrow slot of a Cokin filter holder so, if you're unhappy with the basic Cokin polarizer but like everything else about the system, you could invest in a Singh-Ray polarizer instead.

The bigger 100mm systems are much more extensive, usually boasting hundreds of filters, including every technical filter available and the option to have filters made to your own specification. So, whether you choose Lee, Hitech or Cromatek, it's unlikely you will be left wanting. As these systems offer a fair degree of cross-compatibility you can also pick and choose (Lee's standard 4mm-thick filters won't fit the other holders, though). There's also the option of having filters made to size by other manufacturers – Singh-Ray and Tiffen offer this option. Lee Filters will also dip filters to your specification and make them in different sizes to fit other holders – you could have a set made to fit a Cokin P-System holder, for example.

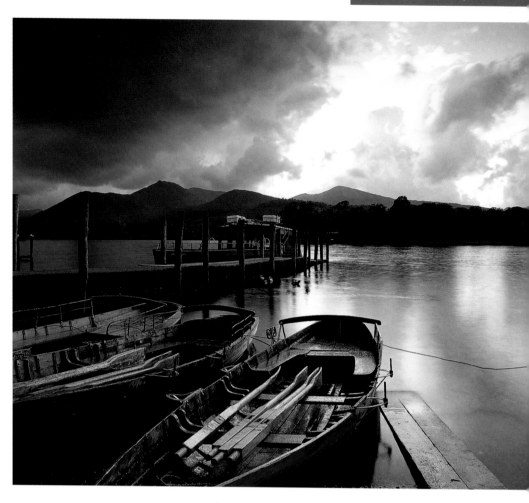

Materials used to make filters

Polarizers and many screw-in filters are usually fashioned from glass, while general slot-in filters are manufactured from optical resin known as CR39.

Glass offers better optical quality, is more resistant to scratching and is less likely to be damaged by repeated cleaning. It's more expensive, however, and fragile – drop a glass filter on a hard surface and that's likely to be the last time you ever use it.

Optical resin needs to be handled more carefully as it will scuff and scratch. But it's much tougher – almost unbreakable – and optical quality is high if you look after your filters.

Some manufacturers, such as Kodak (Wratten), Lee Filters and Hitech, also produce filters made from polyester gel – usually referred to as 'gels'. These are much thinner, flexible filters that are mounted in a plastic frame so they can be used in a holder alongside resin filters. Optical quality is high as the material is so thin. Gels are very delicate and can be easily damaged, so they're not really practical for regular use.

▲ **DERWENTWATER, LAKE DISTRICT, ENGLAND**
Some filter manufacturers can make filters to order, or they may include some less common examples in their range. Hitech, for example, manufacture combination ND graduate and warm-up filters so that you get two effects for the price of one. There is also less reduction in image quality if you use one filter instead of two. I used such a filter here.

PENTAX 67, 45MM LENS, COMBINATION 0.6 ND AND 81B WARM-UP FILTER, TRIPOD; FUJICHROME VELVIA; 2 SEC. AT F/16

THE CASE FOR SCREW-IN FILTERS

The advice so far has been firmly in favour of slot-in filter systems, simply because they are so versatile if you use a range of different lenses or work with more than one film format. That said, don't dismiss screw-in filters altogether as they have benefits, too.

Firstly, if you tend to use certain filters on a regular basis, then there's absolutely no reason why you couldn't use screw-in types. For example, a red filter is the most popular choice for black and white infrared photography (see p. 125), so you may choose to buy a screw-on red filter instead of a slot-in type. The same applies with other contrast-controlling filters for black and white (see p. 83), or any colour-balancing filters (see p. 53).

The best polarizing filters are generally screw-in models and, depending upon which filter system you opt for, you may have no choice but to use a screw-in polarizer.

Hoya is the most popular brand, with a wide choice of general-use filters and some 'special editions', including super-slim polarizers that are designed for use with ultra wide-angle lenses and zooms down to 17mm. Most filters are available in thread sizes of 39–82mm, with some smaller and bigger sizes available, too. Sigma, best known for its lenses, also manufactures slim polarizers for the same reason.

Where you are unwilling to compromise quality, brands such as Heliopan and B+W should be considered. They are more expensive than the likes of Hoya, but with most filters in both ranges (amounting to literally hundreds of different filters) made from Schott glass, image quality is second to none, and they are a good choice if you want the very best. Sizes from 39–95mm are available, although not all filters in each range come in the smaller or larger fits.

If you invest in a slot-in filter system that uses

◀ Don't dismiss screw-in filters altogether – they do have their uses and can form an important part of any creative filter system.

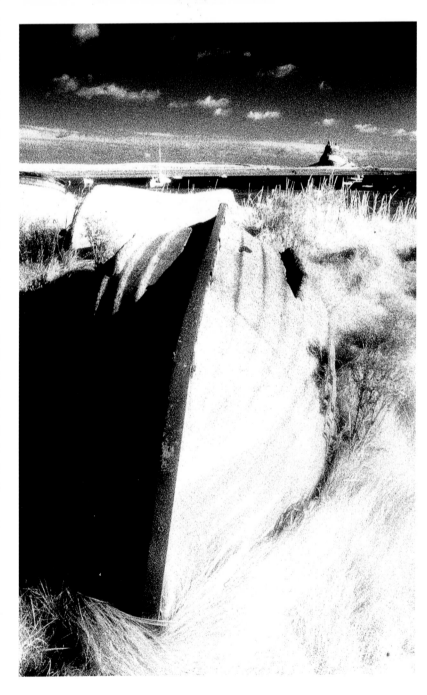

▶ **LINDISFARNE, NORTHUMBERLAND, ENGLAND**
I shoot a lot of infrared film, using a deep red filter to achieve the desired effect (see pp. 125–134). As I mainly use the same lens for infrared photography, I have a screw-in red filter specifically for it.

NIKON F90x, 18–35MM ZOOM AT 20MM, HOYA DEEP RED FILTER; KODAK HIGH SPEED MONO INFRARED; ¹⁄₆₀ SEC. AT F/16

◄ **WICKEN FEN, CAMBRIDGESHIRE, ENGLAND**
Screw-on polarizers are popular, especially for use on ultra wide-angle lenses and zooms. For this landscape shot I used a Kasemann 105mm screw-on polarizer.

PENTAX 67, 45MM LENS, POLARIZER, TRIPOD; FUJICHROME VELVIA; ¼ SEC. AT F/22

a screw-in polarizer (Hitech 85 and 100 and Lee), you can also fit that over-sized polarizer direct to your lenses via a stepping-down ring. This makes it possible to avoid vignetting even with ultra wide-angle lenses – a 105mm polarizer will be fine on lenses down to 17mm.

Clearly, by doing this you are limiting the number of filters that can be used together. But all need not be lost. It's common to use polarizer and warm-up filters together, for example. If you step

◄ One benefit of using an oversized polarizer with a stepping ring is that you can sandwich a warm-up filter between them, as shown here.

▲ I usually attach my 105mm screw-in polarizer direct to the lens using stepping-down rings. A 77–105mm ring is left on all the time, then I have a 67–77mm and a 77–82mm to adapt this set-up for other lenses. This picture shows the polarizer, along with 77–105mm and 77–82mm rings that are already screwed together.

down an oversized polarizer to fit a smaller lens, you can cut a warm-up filter gel down to size and fit it inside the stepping ring so when you attach the polarizer you have the two filters combined, with a small space between them to avoid Newton's rings (the pressure patterns often caused when two filters are placed together so they're touching).

Just one final point: if you fit a filter holder to the front of a screw-in filter already attached to your lens, remember that the holder will project a few millimetres further out than normal, so the risk of vignetting will increase with wide-angle lenses and zooms.

FILTERS AND EXPOSURE

Many filters reduce the amount of light entering your lens, so you may need to compensate for this in the exposure when using them to prevent your pictures coming out too dark. Each filter is given a 'filter factor' that indicates by how many times the initial exposure needs to be multiplied to make up for this loss. A factor of x2 indicates an exposure increase of 1 stop, x4 2 stops, x8 3 stops, and so on. The filter factor is usually printed on the filter mount or box.

If your camera has TTL metering, and you meter with the filter in place, any light loss will be taken into account automatically, so you needn't worry about it. However, if you meter without the filter in place, or use a handheld meter, you must increase the exposure accordingly based on the filter factor. The table below shows the filter factors for some common filters.

Filter	Filter Factor	Exposure increase
Polarizer	x4	2 stops
81A warm-up	x1.3	⅓ stop
81B warm-up	x1.3	⅓ stop
81C warm-up	x1.3	⅓ stop
81D warm-up	x1.6	⅔ stop
81EF warm-up	x1.6	⅔ stop
Blue 80A	x4	2 stops
Blue 80B	x3.6	1⅔ stops
Blue 80C	x2	1 stop
Orange 85	x1.6	⅔ stop
Orange 85B	x1.6	⅔ stop
Orange 85C	x1.3	⅓ stop
Yellow	x2	1 stop
Orange	x4	2 stops
Red	x8	3 stops
Green	x6	2½ stops
Yellow/green	x4	2 stops
ND 0.1	x1.3	⅓ stop
ND 0.2	x1.6	⅔ stop
ND 0.3	x2	1 stop
ND 0.6	x 4	2 stops
ND 0.9	x 8	3 stops
ND 1.2	x16	4 stops
Skylight	x1	None
Soft-focus	x1	None
ND graduates	x1	None

◄ NAMIB DESERT
A polarizing filter loses around 2 stops of light. You need to be aware of this, as slower shutter speeds increase the risk of camera shake, while wider apertures reduce depth of field.

NIKON F90x, 18–35MM ZOOM AT 18MM, POLARIZER, TRIPOD; FUJICHROME VELVIA; ⅛ SEC. AT F/22

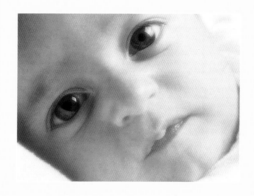

◄ BABY PORTRAIT
Soft-focus and other clear filters, including starburst, diffraction, close-up lenses and skylight or UV, require no exposure increase as they do not cause a light loss.

NIKON F90x, 105MM MACRO LENS, SOFT-FOCUS FILTER, TRIPOD; FUJICHROME SENSIA II 100; ¹⁄₁₂₅ SEC. AT F/16

◄ NORTHUMBERLAND
Graduated filters reduce the light passing through only in the graduated area, and as this is the effect you want – to reduce the brightness levels between the sky and the landscape – you do not adjust the exposure when using one.

PENTAX 67, 55MM LENS, 0.6 ND GRADUATE FILTER, TRIPOD; FUJICHROME VELVIA; 1 SEC. AT F/16

POLARIZING
FILTERS

2

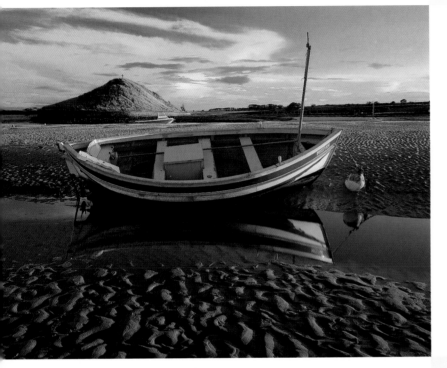

ALNMOUTH, NORTHUMBERLAND, ENGLAND
A polarizer is at its most effective early or late in the day
when the sun is low in the sky. For this evening shot it not only
enhanced the sky, but increased colour saturation and made
the hill in the distance more prominent.

WALKER TITAN 5x4IN, 90MM LENS, POLARIZER, 81B WARM-UP;
FUJICHROME VELVIA; 2 SEC. AT F/32

The first filter that most photographers purchase is a polarizer, and for
good reason – it's the most versatile filter you will ever need for any
type of scenic photography. Whether you are shooting landscapes,
architecture, gardens, woodland, waterfalls or, in some cases, close-
ups, it can make a significant difference to the impact and quality of
your photographs, deepening the colour of blue skies, making colours
appear more deeply saturated, and reducing or eliminating glare and
reflections, especially in bright, sunny weather. No filter collection
would be complete without at least one polarizing filter. Throughout
this chapter you will discover why, as well as learning when to use
a polarizer and how to get the best results from it. Although they
are not polarizers, red enhancing filters work in a similar way, helping
you to boost certain colours in a scene for maximum visual effect; they
are also covered in this chapter.

HOW POLARIZERS WORK

Wavelengths of light travel in all directions – up and down, from side to side, and at all other possible angles. When that light strikes a surface, some of the wavelengths are reflected and some are absorbed. The wavelengths that are absorbed define the colour of the surface they strike.

For example, a red car is red because the paintwork that gives it that colour absorbs all wavelengths of light apart from the red ones, which are reflected. It is the same with foliage – it appears green in spring and summer because it absorbs all wavelengths of light apart from those in the green part of the visible spectrum, which it reflects. Some of the wavelengths that are reflected from a surface become polarized, meaning that they travel only in one direction. It's these wavelengths that cause glare and reflections and make the colour of the surface appear less intense.

A polarizing filter blocks out that polarized light. To do this, the filter uses a special foil sandwiched between two sheets of glass. The front part of the polarizer can be rotated so that the orientation of the foil is changed. By doing this you can vary the amount of polarized light that is blocked out by the filter, and control the level of polarization achieved.

The best way to explain this is by using a simple analogy, as follows. Imagine two children are holding a length of rope and shaking it so the rope moves in a series of waves in one direction. Let's say they are doing this up and down. The movement of the rope mimics the way polarized light waves travel. If you then passed one end of the rope through a vertical gap in a fence and asked the children to continue shaking the rope up and down, the waves created by the rope would continue as before. If

you turned the fence on its side, however, so the gap between the railings was horizontal instead of vertical, the movement of the rope would be blocked by the railings that are now above and below it.

A polarizing filter does exactly the same thing. You have no idea in which direction the

◄ Polarizing filters come in all sizes and designs to screw directly to your lens or slot into a filter holder. The polarizers shown here are (left to right) Kasemann, Hoya, Cokin P system and Cromatek. In appearance they're not unlike neutral-density filters (see pp. 77–8).

◄ **GREEK CHURCH**
In bright, sunny weather, a polarizing filter will be an almost permanent fixture on your lens as it can be so effective in helping you make the most of a scene – like this colourful church on the Greek island of Spetse.

OLYMPUS OM4-Ti, 21MM LENS, POLARIZER; FUJICHROME RFP50; 1/30 SEC. AT F/8

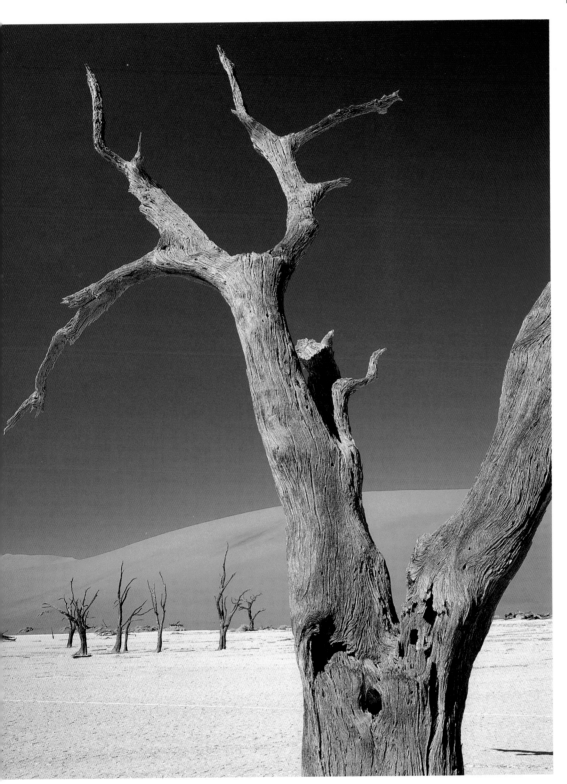

◀ **DEAD VLEI, NAMIBIA**
Use it correctly, in the right conditions, and a polarizing filter can make a significant difference to the colour saturation, clarity and overall impact of a photograph. Here I used a polarizer primarily to deepen the blue sky, although doing so made the skeletal tree stand out more boldly due to its lighter tone, as well as emphasizing the orange of the distance sand dunes.

PENTAX 67, 45MM LENS, POLARIZING FILTER, TRIPOD; FUJICHROME VELVIA; ⅛ SEC, AT F/16

wavelengths of polarized light are travelling, but by rotating a polarizer you can eventually find a point at which most or all of that light is blocked out by the polarizing foil in the filter.

The best way to determine this position is by fitting the polarizer to your lens, then carefully rotating the front of it while looking through your camera's viewfinder. As the polarizing foil is rotated, you will see the intensity of colours increase then decrease, reflections come and go, and blue sky go darker then lighter again. The point at which you stop rotating is when you feel the effect seen through the camera is at its strongest.

If you use an autofocus SLR and the front of the lens rotates during focusing, the effect of a polarizing filter will change. To prevent this happening, focus the lens first, then rotate the polarizer. If you need to adjust focus once the polarizer has been aligned, you may have to adjust its angle of rotation again before taking any pictures.

METERING AND EXPOSURE

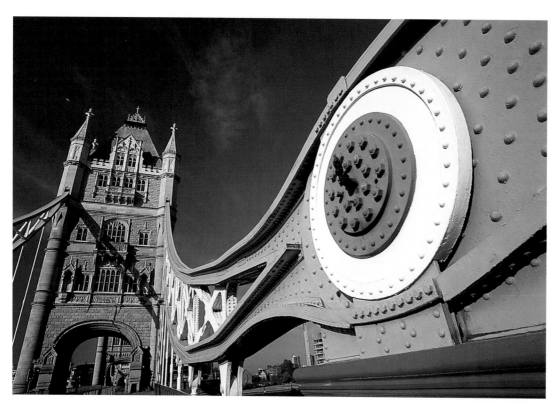

◄ **TOWER BRIDGE**
If you buy the right kind of polarizer for your camera, getting the exposure spot on should pose no problems. Most photographers today use autofocus SLRs, which require a circular polarizer to avoid exposure error. For this shot of Tower Bridge in London I used a Cokin P system circular polarizer, metering through it with my camera set to aperture-priority exposure mode.

NIKON F5, 18–35MM ZOOM AT 18MM, POLARIZER, TRIPOD; FUJICHROME VELVIA; ⅛ SEC. AT F/16

A polarizer has a filter factor of x4. This means that it reduces the light passing through it by 2 stops. If you take meter readings with a polarizer already in place, your camera's TTL metering system will compensate for this light loss automatically so you don't have to change anything. If you meter without a polarizer in place, or you use a handheld meter, the exposure reading obtained must be increased by 2 stops. So, if your handheld meter says the correct exposure is ⅟₃₀ sec. at f/16, with a polarizer in use you must increase the exposure to ⅛ sec. at f/16, or ⅟₃₀ sec. at f/8, or ⅟₁₅ sec. at f/11, all of which represent a 2-stop increase by adjusting the shutter speed, lens aperture or a combination of both.

The main thing to remember is that by losing 2 stops of light there's a greater risk of camera shake if you don't mount your camera on a tripod. ISO50 film effectively becomes ISO12, for example, when a polarizer is used, and even on a bright, sunny day exposures are going to be around ⅟₁₅ sec. at f/11 or ⅛ sec. at f/16.

Circular or linear?

You must also buy the right type of polarizer if exposure error is to be avoided when metering through it. There are two types to choose from – linear and circular. The basic rule is this: if you own an autofocus SLR or a camera with spot metering or a semi-silvered mirror you need to use a circular polarizer. For all other camera types a linear polarizer will be fine.

If you're unsure which type you need, take your camera along to a photo dealer, fit a polarizer on one of your lenses, point it towards something that's evenly lit, like a matt white wall, and rotate the filter. If the exposure doesn't change as you rotate the filter, use a linear polarizer. If it does change, use a circular polarizer.

If you use a linear polarizer on the wrong type of camera, and meter through it, exposure error may result. This is because AF SLRs and other camera types polarize some of the light inside the camera, but if it has already been polarized by the filter a false meter reading is given. Circular polarizers avoid this by using a ¼-wave retardation plate in their construction, which causes the light waves passing through to rotate so they appear unpolarized to the camera's metering system.

If you already have a linear polarizer and need to use it on a camera requiring a circular polarizer, take a meter reading without the polarizer in place, then increase the exposure by 2 stops.

WHEN TO USE A POLARIZER

Once you realize its benefits you will find that a polarizer spends more time on your lens than any other filter – with the possible exception of a skylight or UV filter used to protect the lens's front element (see p. 82).

Deepening blue skies

When photographing a scene that includes blue sky you will achieve the strongest effect from using a polarizing filter if you keep the sun at a right angle to the camera – to your left or right, in other words. This is because the sky contains most polarized light in the areas that are at 90 degrees to the sun. The sky will also deepen more during the morning and afternoon when the sun is lower in the sky, while the effect is less noticeable during the middle hours of the day.

If you are using a wide-angle lens or zoom – with a focal length of 28mm or wider – you need to take care. Polarization is uneven across the sky, so at certain shooting angles in relation to the sun you may find that the sky darkens more on one side (because that part contains more polarized wavelengths) than the other. This effect can look rather odd, and becomes more noticeable with wider lenses simply because they allow you to capture a much broader area of sky – with lenses wider than 20mm you may find that uneven polarization is impossible to avoid. If changing your shooting angle isn't an option, the only solution is to use a neutral-density graduate filter and position it at an angle so that it tones down the lighter corner of the picture and reduces the effect of uneven polarization (see pp. 46–8).

Many photographers think that deepening blue sky is the main benefit of using a polarizer. However, by making the sky a darker tone, you get other benefits, too. For a start, white clouds stand out boldly against the deep blue background, and on bright, sunny days this effect can look stunning. Other things captured against the sky will also stand out far more dramatically if you use a polarizer – trees, birds, aeroplanes and buildings. This is not only because the darker sky makes lighter colours more prominent, but also because a polarizer cuts through haze, so clarity is improved and even small features in the distance suddenly seem more clearly defined.

At the same time, don't be tempted to use a polarizer every time there's a blue sky, because sometimes its effect can look over the top. At high altitude in mountainous areas, for example, the blue of the sky is already so deep that using a polarizer can make it go almost black – which is clearly unnatural. But you needn't go to the Himalayas to see this. On a perfect, sunny day pretty much anywhere you can get the same effect as long as you include the area of sky where there's the most polarized light – especially when using Fujichrome Velvia colour slide film, which has very saturated colour rendering to begin with.

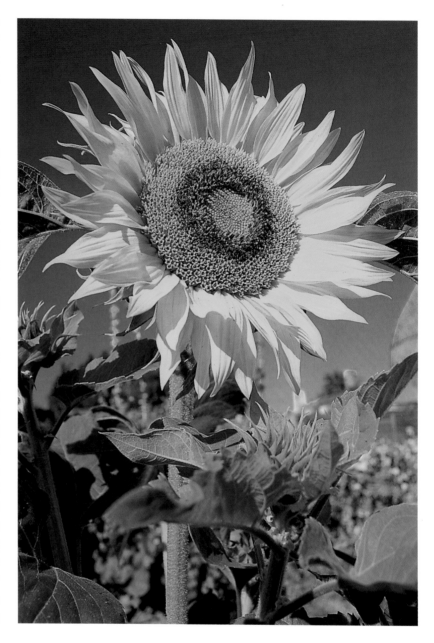

▲ SUNFLOWER
I photographed this sunflower in my garden from a low angle, so it was juxtaposed against the blue sky. The striking contrast between blue and yellow always produces strong images, and here I made the most of it by using a polarizing filter to deepen the blue sky and remove glare from the flower.

NIKON F90X, 28MM LENS, POLARIZING FILTER; FUJICHROME VELVIA; 1/15 SEC. AT F/11

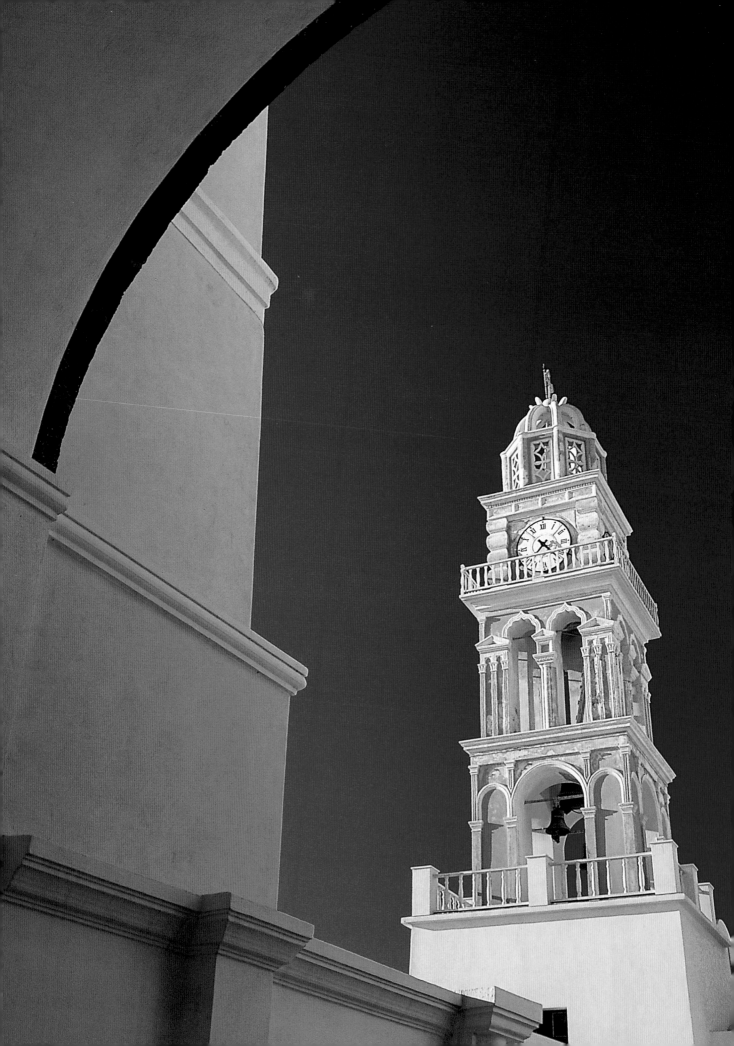

Reducing glare and reflections

As well as deepening blue sky, a polarizer also eliminates glare on non-metallic surfaces. Glare is created by polarized light. Visually, it often appears as a reflective 'sheen', especially on foliage and painted surfaces when viewed in bright sunlight, and it significantly reduces colour saturation.

By carefully rotating a polarizer while peering through your camera's viewfinder, you can align the foil so that it blocks out the polarized light that causes the glare. The difference this makes

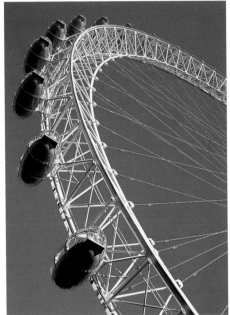

No filter

With polarizing filter

No filter

With polarizing filter

▲ **SUMMER LANDSCAPE**
The rich colours in a landscape scene are often masked by glare, caused by polarized light reflecting off the foliage. Used carefully, however, a polarizing filter will take care of this, blocking out the polarized light so colour saturation is increased.

◄ **SANTORINI**
A polarizing filter can have an amazing effect on blue sky, deepening its colour and cutting through haze so that lighter colours stand out boldly. This picture was taken during early morning, when the sun was relatively low in the sky and the polarizer was able to have its most potent effect.

NIKON F90X, 18–35MM ZOOM, POLARIZING FILTER; FUJICHROME VELVIA; ⅛ SEC. AT F/16

can be enormous. Colours that seem flat and washed out to the naked eye suddenly seem vibrant and crisp. Combine this with the effects a polarizer has on blue sky and you will be amazed by the impact your pictures have – there really is no comparison between a polarized and non-polarized photograph.

Reflections can also be reduced or eliminated in glass and water. This property is of less use on a day-to-day basis, but in some situations it will prove invaluable. If you are photographing a building or car, for example, you can use a polarizer to remove reflections from the glass windows. Similarly, if you include water in a landscape picture – perhaps using a river or a stream as foreground interest – a polarizer will eliminate surface reflections so that you can see into it.

This effect also works well on seascapes. The photographs you see in travel brochures advertising holidays to tropical locations such as

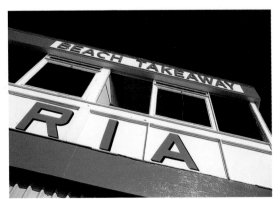

▲ **LONDON EYE**
This pair of pictures shows what a difference a polarizing filter can make to blue sky. Both were taken within seconds of each other and, although the unfiltered shot is acceptable, the impact of the filtered version is much greater.

◄ **BEACH TAKEAWAY**
Don't feel that you have to use a polarizing filter when including blue sky in a picture. Sometimes its effect is just too great and blue sky goes almost black which to most people appears unnatural.

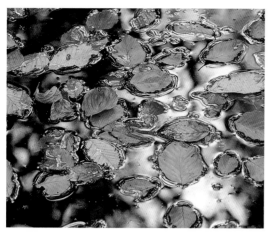

No filter

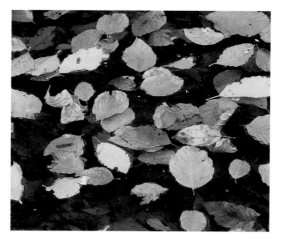

With polarizing filter

◄ **AUTUMN LEAVES**
A polarizer's ability to eliminate reflections and glare is illustrated brilliantly by this pair of pictures, showing autumn leaves in a woodland puddle. The reflections of the sky in the unfiltered shot create annoying highlights, but a polarizing filter soon took care of them, producing a totally different picture.

the Maldives or Sri Lanka are always shot with a polarizer to make the sea look crystal clear – and the sky a deep, rich blue.

To eliminate reflections, the angle between the reflective surface and the lens axis needs to be around 30 degrees. Sometimes you will achieve this, or get close to it, in the way you naturally

position the camera to take a photograph, but often you will need to adjust the camera position to get a better effect.

The question you need to ask yourself is, what is more important – getting rid of the reflections completely but then perhaps compromising the composition of the picture, or putting composition

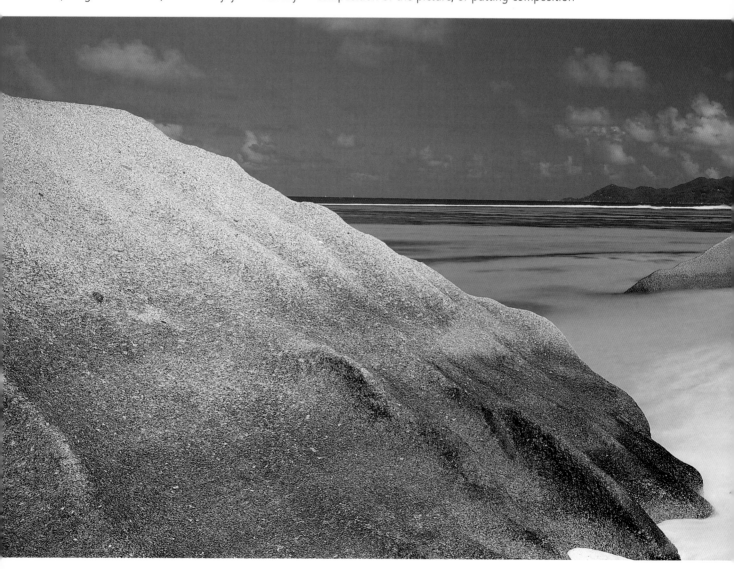

first and hoping that the reflections will disappear – or at least be made less obvious.

Sometimes, of course, you will want to include reflections as an integral part of the composition, so you need to take care when using a polarizer in these situations because it can have a negative effect. Buildings reflecting in a canal or a landscape scene reflecting in a mirror-calm lake can look stunning, but if you then use a polarizer to deepen the blue sky or increase colour saturation, you may find that the reflection is spoiled. If this happens you again need to question your priorities – richer colours and a deeper sky but poor reflections, or vivid reflections and weaker colours and sky. If you're lucky you won't have to compromise at all – the angle between the reflection and the lens axis may be such that the reflection is hardly affected. And in some situations, a polarizer will remove the sheen from the surface of water so the reflections are enhanced.

The great thing about a polarizer is that you can see exactly what effect it's having simply by looking through your camera's viewfinder, so if you don't like what you see, you don't have to use it, or can change it.

Other situations

As already discussed, polarizers give their best performance in bright, sunny weather, when the combined effects of deepening blue sky, cutting through haze, increasing colour saturation and reducing reflections can produce staggering results. Early morning and late afternoon are also the prime times of day, although a polarizer will be effective at any time; and when haze is a problem – as is often the case around the middle of the day in summer – it can improve clarity no end. That said, you needn't limit the use of a polarizer to sunny weather because it can be effective at other times, too.

▼ SEYCHELLES
Scenes like this, captured at Anse Source d'Argent on La Digue, cry out for a polarizing filter. Its effect on the sea was particularly strong, removing reflections so the beautiful aquamarine colour stood out – as well as deepening the blue sky and emphasizing the white clouds.

FUJI GX617 PANORAMIC CAMERA WITH 90MM LENS, POLARIZING FILTER, TRIPOD; FUJICHROME VELVIA; ½ SEC. AT F/22

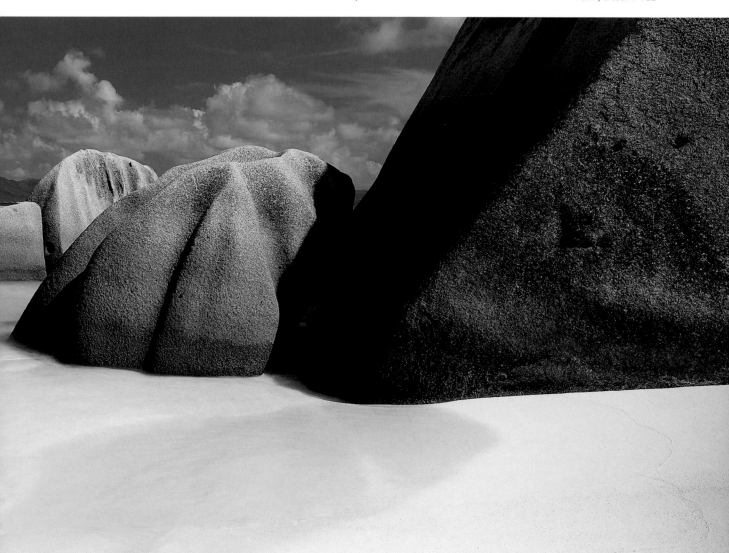

In dull, overcast conditions, for example, there tends to be a lot of glare around. A polarizer will cut through this like a knife, dramatically increasing colour saturation and producing much crisper images. Try it on autumnal woodland scenes and you will be amazed. Glare on damp foliage masks the true depth of colour, but when this is removed by a polarizing filter the difference is enormous and your pictures will be infinitely better for it. A polarizer will also remove reflections in any weather conditions or at any time of day. I have used one before when taking pictures of buildings at dusk, in order to get rid of reflections in windows.

You can also use a polarizer as a neutral-density filter (see pp. 77–9). It reduces the light passing through by around 2 stops, the same as a 0.6 ND filter would do, so you can use it to force an exposure increase when photographing rivers and waterfalls, for example, or if you are using fast film in bright sunlight.

◀ OIL SEED RAPE
The lush green of spring foliage and the vibrant yellow of the oil-seed rape flowers in this scene have been improved significantly by using a polarizing filter.

OLYMPUS OM2N, 21MM LENS, POLARIZER, TRIPOD; FUJICHROME RFP50; ⅟₁₅ SEC. AT F/11

HOW TO CROSS-POLARIZE

A creative technique you can try with polarizing filters is known as cross-polarization. This involves placing one polarizer over a light source, and a second one on your camera lens. If you then place a transparent plastic object between the two filters, such as items from a geometry set, a piece of stretched polythene or a clear plastic filter box, any stress marks in it appear as brightly coloured patterns. It sounds odd, but close-ups of these objects can create striking abstract images.

To have a go yourself you need two polarizing filters. If you have two normal polarizers, you can place one on the camera lens then one on the lens of a slide projector, and use the projector as a light source. However, a much better method is to buy a sheet of polarizer gel as your second polarizer – available from many high-street photo dealers. You can then lay this gel on a lightbox and place the plastic objects on top of it so the foil acts as a background.

All you have to do then is rotate the polarizer on your lens until the colourful patterns appear – by rotating you get an effect like a kaleidoscope, where the colours constantly change. When using a polarizer gel, any areas of it that are visible in the shot come out black, so the colours in the plastic stand out boldly.

To meter, simply set your camera to aperture priority exposure mode, set the aperture to f/8 or f/11, then let your camera determine the correct shutter speed. You would also be advised to bracket exposures 1 stop over and 1 stop under the metered exposure with the camera's exposure compensation facility, to ensure that one frame is perfect.

◀ CROSS POLARIZATION
This is the type of effect you can achieve by using two polarizers to reveal the stress patterns in plastic.

Combining with a warm-up filter

Polarizers are pale grey in appearance, like neutral-density filters, and are supposed to be completely neutral in terms of colour rendering. However, not all brands are. Some of the less expensive polarizers tend to be a little on the cool side, so you may find that your pictures come out with a slight blue colour cast, especially when shooting in bright, sunny weather. If this proves to be the case, use an 81A or 81B warm-up filter to balance the coolness so colours look natural.

Many photographers use a warm-up filter with their polarizer all the time. This approach is fine if you are shooting landscapes, or working in naturally warm light with other subjects such as buildings. But don't overdo it, as the warm-up filter may add an unattractive yellow cast to white clouds or other light tones, such as whitewashed buildings. Because the polarizing filter deepens blue sky and makes lighter tones stand out more prominently, you will see this yellowing effect even more than if a polarizer wasn't used.

Some manufacturers even produce warm-tone polarizers, so you don't need to use a separate warm-up filter. They usually have the equivalent of an 81A filter built in, so they are safe to use all the time without risk of unwanted colour casts. It's only when you use warm-up filters of 81B or stronger that care must be taken.

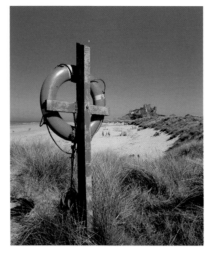 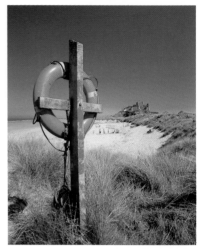

No filter **With polarizing and 81B warm-up filters**

▲ **BAMBURGH CASTLE, NORTHUMBERLAND, ENGLAND**
The light around midday can be a little on the blue side, and a polarizing filter will tend to emphasize this. By using a weak warm-up filter in conjunction with a polarizer you can balance the coolness and produce more attractive colours.

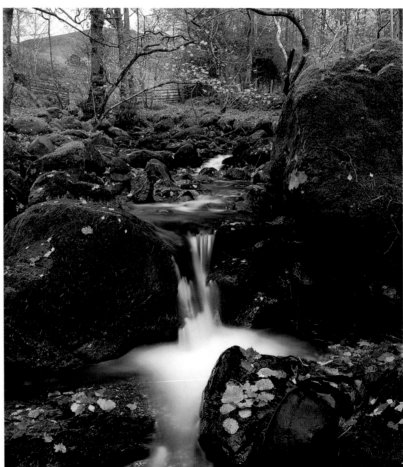

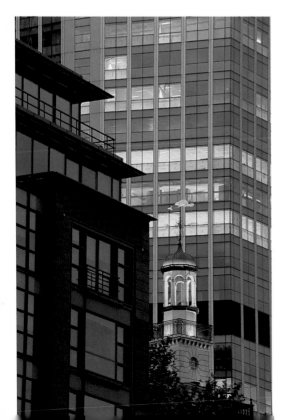

◀ **CITY OF LONDON**
A polarizing filter was used to help reduce the reflections in the windows of the office buildings, and make the white church tower between them stand out more.

NIKON F90X, 80–200MM ZOOM AT 200MM, TRIPOD, POLARIZER; FUJICHROME VELVIA; 8 SEC. AT F/11

▲ **BORROWDALE, LAKE DISTRICT, ENGLAND**
Here, use of a polarizer has cut through glare on the damp foliage and mossy rocks to produce richer colours, and its 2-stop light loss forced an exposure increase to emphasize the blur of the moving water.

PENTAX 67, 55MM LENS, POLARIZER AND 81B WARM-UP FILTERS, TRIPOD; FUJICHROME VELVIA; 2 SEC. AT F/16

POLARIZERS FOR NON-SLR CAMERAS AND WIDE-ANGLE LENSES

Using a polarizing filter with a non-SLR camera, such as a panoramic model or a rangefinder, is actually trickier because you can't gauge its the effect it is having by looking through the camera's viewfinder.

The way you solve this problem will depend upon the filter system you use. Systems that use a slot-in polarizer, such as Cokin, are easy to work with – all you need to do is hold the polarizer just above the front of the lens, rotate it while looking through the filter itself then, when the desired position has been achieved, lower the filter and slot in into the holder, taking care not to change its position (see p. 13).

Another option you have is to rotate the filter as described above, then lower it in front of the lens and secure it with blobs of low-tack gum pressed onto the outer edges of the lens barrel or on to an adaptor ring for one of the 100mm filter systems – Cromatek rings are ideal for this (see p. 14).

Polarizers for ultra wide-angle lenses

If you own an ultra wide-angle lens or, more commonly, an ultra-wide zoom such as an 18–35mm or a 17–35mm, you may find it impossible to use a polarizer from your usual filter system without vignetting at the wider end of the focal length range.

Fortunately, some manufacturers have overcome this by designing ultra-slim screw-on polarizers specifically for wide lenses and zooms. Hoya and Sigma are the two main players in this respect, producing polarizers with a mount just 5mm deep so they will work at focal lengths as wide as 17mm. This slimness is usually achieved by removing the front thread, which you would normally use to attach other filters (if you did attach another filter to the front of the polarizer you would get vignetting with wide lenses, so a thread is unnecessary anyway).

If you do need to attach other filters, such as a neutral-density graduate or a warm-up, to a slimline polarizer, do so using slot-in filters that are held in place by small balls of low-tack gum.

MAKE YOUR OWN ULTRA-WIDE POLARIZER

If you have an ultra wide-angle zoom or prime lens with an 82mm filter thread, you can concoct your own vignetting-free polarizer using a Cokin P system circular polarizer and a P system 82mm adaptor ring. This will cost a fraction of the price of a special ultra wide-angle screw-on polarizer but works just as well:

1 Place the 82mm Cokin P system adaptor ring on a flat surface, such as a kitchen worktop, and drop the polarizer into it (the Cokin P system polarizer is ideal as it sits neatly inside the adaptor ring and has notches around the edge that help you secure it). Only the 82mmadaptor ring is suitable because it has a groove machined around the outer rim. Rings with a smaller diameter have a flat surface, so they won't work.

2 Make three or four clips from bent wire – paper clips are ideal – so the bend sits in the groove around the outer edge of the adaptor ring, as shown, while the free ends pass between the notches around the edge of the Cokin polarizing filter and sit 5–10mm apart on the top surface of the filter rim.

3 Hold the filter and ring together using tape or low-tack gum.

4 Mix a small quantity of quick-setting glue that has a thick consistency and place blobs on the free ends of each clip to stick them to the filter rim. Leave overnight for the glue to set. The end result should be a polarizing filter that rotates freely in its own adaptor ring, held in place by the clips. Additional slot-in filters can then be attached to the front using low-tack gum, and you should get vignetting-free results down to at least 20mm – wider with some lenses.

ADAPTING A SCREW-IN POLARIZER

If you use a screw-in polarizer you need to put reference marks on the rim of the filter so you can align it correctly. Here's one way of doing so:

1 Etch a single mark on the rear section of the filter mount, then screw the filter onto your lens and count the number of full turns you need to make before the filter tightens.

2 Repeat this several times until you know roughly where the reference point on the rear of the filter needs to be in relation to the circumference of the lens's front element so that when it is fully screwed on, that reference point will be at the top of the lens.

3 Now unscrew the polarizer, and, with the rear reference point at the top, mark a series of numbers or lines around the rotating front section of the polarizer at 5mm intervals.

4 Holding the polarizer with the rear reference point at the top, rotate it in front of your eye to achieve the desired level of polarization. Then check to see the number or line you have marked on the front section of the filter that lies opposite the reference mark on the rear section.

5 Screw the polarizer onto your lens as described in step 2, above, so that when it is fully screwed on, the rear reference point is at the top.

6 Now rotate the front section of the polarizer, if necessary, to ensure that the number or mark established by following step 4, above, is opposite the reference point on the rear section of the filter.

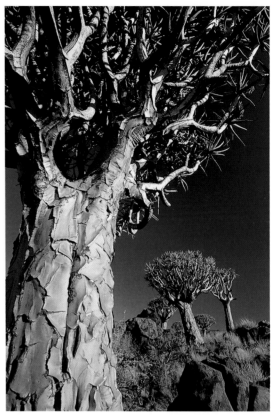

▲ **QUIVER TREES**
This shot of Quiver trees in Namibia was taken using an 18–35mm zoom lens at 18mm with the DIY Cokin P system polarizing filter. As you can see, there are no signs of vignetting on the photograph.

◄ This close-up of a Kasemann screw-in polarizer shows a series of numbers marked on the rotating front ring. In conjunction with a reference point marked on the stepping ring that connects the filter to a lens, I am able to rotate the polarizer before my eye to get the effect required, then make sure the polarizer is still aligned once attached to the lens of my non-TTL panoramic camera.

▼ **SANTORINI**
Using a polarizing filter with a rangefinder camera can be tricky as you are unable to gauge the effect of the filter by looking through the camera's viewfinder. However, with practice you can overcome this problem to produce perfect results.

FUJI GX617 PANORAMIC CAMERA WITH 90MM LENS, POLARIZER ATTACHED WITH LOW-TACK GUM, TRIPOD; FUJICHROME VELVIA; ¼ SEC. AT F/16

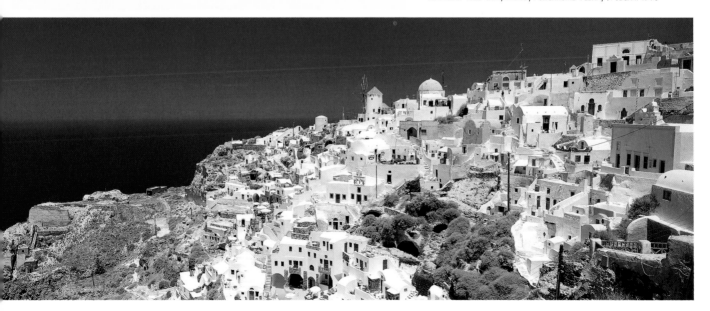

RED ENHANCING FILTERS

Red is the most powerful colour of all, and will dominate a scene even if it occupies only a small part of a picture, because our eye is naturally drawn towards it.

Unfortunately, warm colours often don't look as vibrant in a photograph as they do to the naked eye. One solution to this problem is to use a polarizing filter so glare is reduced or eliminated and colour saturation is increased. Another option is to use a red enhancing filter.

Enhancing filters are more popular in the USA than elsewhere, but they are growing in popularity in the UK and Europe as more photographers discover the benefits they offer. Most well-known filter manufacturers, such as Cokin, now include an enhancer in their range.

◀ **SAHARA DESERT**
I used a Lee enhancing filter for this shot of the Erg Chebbi dunes in the Sahara Desert of southern Morocco. Its effect was to warm up the orange dunes, as well as enriching the clear blue sky. A polarizer was also used.

NIKON F90X, 17–35MM ZOOM, ENHANCING AND POLARIZING FILTERS; FUJICHROME VELVIA; ½ SEC. AT F/16.5

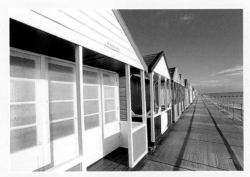

No filter

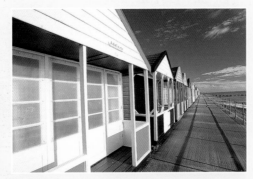

Enhancer

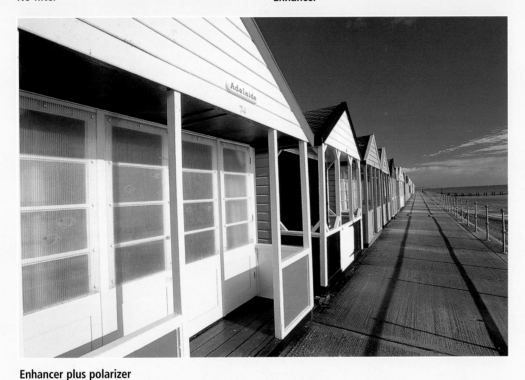

Enhancer plus polarizer

◄ **BEACH HUTS**
This set of pictures shows the effect an enhancing filter can have. The first shot was taken with no filters, and the second with a Lee Filters glass enhancement filter. Notice how the orange paintwork on the nearest beachhut is much more intense, while the concrete walkway is warmer in colour, the sky is a richer blue, and white clouds have picked up a slight magenta cast. The final shot was taken using the same enhancer in conjunction with a polarizer, to produce even richer colours.

NIKON F90X, 17–35MM ZOOM AT 17MM, LEE FILTERS ENHANCEMENT FILTER, POLARIZER, TRIPOD; FUJICHROME VELVIA; ⅛ SEC. AT F/11 (FINAL SHOT)

Seeing red

Enhancing filters work by deepening colours at the warmer end of the visible spectrum, especially reds. This is achieved using didymium glass in the construction, which contains two rare elements – praseodymium and neodymium. These elements selectively absorb and transmit various wavelengths of light and, in doing so, enhance certain colours.

Reds show the strongest effect. If the reds in a scene are already very intense you may not see a great difference, but where enhancers do work is on scenes containing weaker reds and warmer hues. Other colours can be enhanced, too. Orange goes deeper with a slight shift towards red, while yellows appear more golden.

This effect works particularly well on autumnal woodland scenes that contain lots of oranges, reds

and yellows – especially if the richness of colour in the foliage is beginning to fade or you are shooting in dull weather when colours are naturally more subdued. Sunrise and sunset shots can also be enhanced – pale shades of red, orange and yellow in the sky will look much stronger on the final pictures if you use a red enhancer. As warm colours tend to have positive connotations, these effects almost always produce better results.

The effect of an enhancing filter can be gauged by viewing the scene through the filter, like you would with a polarizer. The only difference is that some brands of film give a better effect than others, so what you see when you look through the filter may not necessarily appear quite the same on the final picture.

Something else to bear in mind is the effect

enhancing filters have on other colours, particularly at the cooler end of the spectrum. Enhancing filters have a magenta colouring, so any light or neutral shades, such as white clouds, will pick up this colour and the end result may not be particularly attractive. Lighter, pastel shades of any colour show the effect more than deeper colours.

Greens tend to come out looking weaker, which is not surprising since they're opposite red on the colour wheel. So, if the scene that you are photographing contains a lot of green foliage, the effect of an enhancer may be counterproductive. Some enhancing filters record greens better than others, so try different makes before choosing one. Blues, purples and violets don't suffer too badly as the magenta colour of the enhancer tends to be lost. Pale blue sky may look a little odd, but deep blue sky will come out a little deeper, while purples and violets shift more towards red.

Whites are the trickiest as they almost always take on a colour cast. In bright sunlight the effect won't be too noticeable on bright highlights, or small areas of white such as snow on distant mountains. White clouds do take on a magenta cast, however, as do the lighter tones in moving water that you have blurred with a long exposure. If in doubt, take pictures of the scene with and without an enhancer in place, so you can choose the shot that works best.

In combination

Enhancers can be combined with other filters, particularly polarizers, but you need to consider the additional light loss. A polarizer loses 2 stops, and a red enhancer a further 1–1⅔ stops, depending on the brand. This would reduce the effective speed of ISO50 film to just ISO3–ISO6, making longer exposures necessary and a tripod essential.

When using an enhancer with neutral-density graduated filters, the colour cast created by the enhancer can produce attractive results, especially when shooting at dawn or dusk when the sky is naturally warm, or in stormy weather – the addition of a little magenta to a dark sky is unlikely to look odd. That said, if your ND graduated filter isn't truly neutral, the overall colour shift in the sky may be too much and produce unnatural results.

◄ WOODLAND SCENE
Red enhancing filters are effective on autumnal scenes like this, where deciduous leaves have a high red content in their colouring.

NIKON F5, 80–200MM LENS, TRIPOD AND RED ENHANCING FILTER; FUJICHROME VELVIA; ⅛ SEC. AT F/8

GRADUATED
FILTERS

MERRIVALE, DARTMOOR, ENGLAND
A photograph like this just couldn't be taken without
the use of a neutral-density graduated filter. Meter
readings from the sky and the granite outcrops in the
foreground established that there was a 3-stop difference
in brightness between the two. Had I shot without a
graduated filter, the sky would have been over-exposed
by that amount, losing all traces of colour and detail in
the process. This was avoided by using a 0.9 ND grad
to reduce the brightness of the sky by 3 stops.

HORSEMAN WOODMAN 5 x 4IN CAMERA, 90MM LENS, HITECH 0.9
ND GRADUATE AND 81B WARM-UP FILTERS, TRIPOD; FUJICHROME
VELVIA; 2 SEC. AT F/22

When taking scenic pictures, the sky is often brighter than the ground,
so you meter to expose the ground correctly, the sky is over-exposed,
while if you correctly expose the sky, the ground is under-exposed.

With black-and-white photography this problem is easily overcome
in the darkroom – you meter for the ground then, while making a
print from the negative, the washed-out sky can be 'burned in' by
giving it extra exposure under the enlarger. However, colour slide film
doesn't give you the option to manipulate an image after it has been
exposed, so any localized exposure control must be implemented at
the moment you take the photograph.

This is where graduated filters come in. They allow you to darken
the sky so it requires the same amount of exposure as the ground,
recording a balanced image in a single exposure.

NEUTRAL-DENSITY GRADUATES

Neutral-density graduates (ND grads) are designed to darken the sky without changing its natural colour. Neutral density is effectively measured darkness, and neutral-density filters reduce all the colours in the spectrum by an equal amount so the effect produced is completely natural. The filters themselves are dipped or dyed to give them a grey colouring. Conventional ND filters (see p. 77) are coated across their entire area, whereas ND grads are half clear and half coated, with a transition zone across the centre where the two areas merge together.

Some of the less expensive filter systems aimed at the enthusiast market include ND grad filters that aren't completely neutral, so when you use them in certain situations it's not uncommon for the area affected by the graduated part of the filter to take on a colour cast.

The ND grads in professional filter systems are made to a much higher standard, and are carefully checked to ensure they give even light absorption across the visible spectrum. This is best achieved by hand-dipping the filters individually and building up the colours slowly.

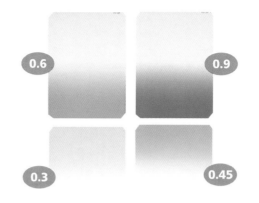

Professional ND grads also come in different densities, so you can darken the sky by a controlled amount. A logarithmic scale is used, with the most common filters being 0.3, 0.6 and 0.9 densities, which reduce the light by 1, 2 and 3 stops respectively. Some systems also include 0.45 and 0.75 ND grads, which reduce the light by 1½ and 2½ stops respectively.

On a day-to-day basis you will probably find 0.6 and 0.9 densities the most useful. A 0.3 density is so weak that it wouldn't give much of an effect on

◄ Neutral-density graduate filters come in different densities so you can reduce brightness levels in the sky, or other parts of the scene, by a measured amount. The four filters here have densities of 0.3, 0.45, 0.6 and 0.9, which reduce brightness by 1, 1½, 2 and 3 stops respectively.

▼ BRENTOR, DEVON, ENGLAND
Grads with a hard transition zone give a more defined effect than softer ones, so where you have a clear horizon and bright sky they are more suitable. Here a 0.6 density hard grad was used to tone down the sky when the sun rose over the distant hills.

PENTAX 67, 45MM LENS, 0.6 ND GRAD (HITECH), TRIPOD; FUJICHROME VELVIA; ½ SEC. AT F/16

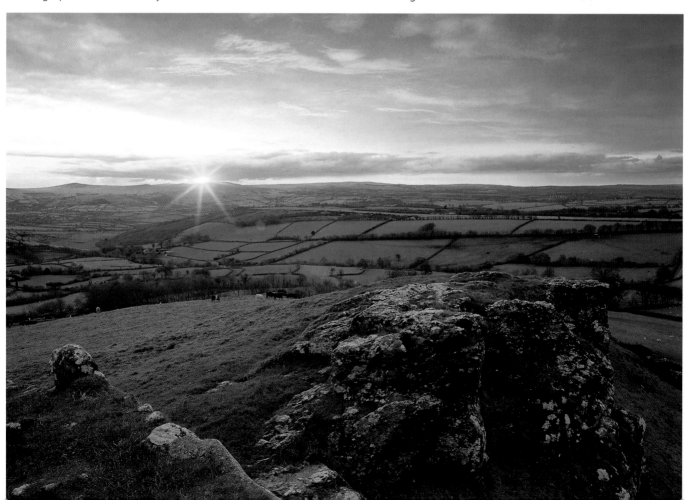

its own, although it's worth adding one to your collection so that you can use it in combination with one of the others – a technique we will discuss later. If you want total control it's worth investing in all five of the densities mentioned above.

Soft or hard grads?

Another important factor to consider when choosing ND grads is whether to buy 'soft' grads or 'hard' grads. These terms are used in reference

No filter

▲▼ ALDEBURGH, SUFFOLK, ENGLAND
When choosing ND graduate filters, be aware that not all brands are completely neutral. Less expensive brands may add a colour cast, as you can see from this pair of pictures.

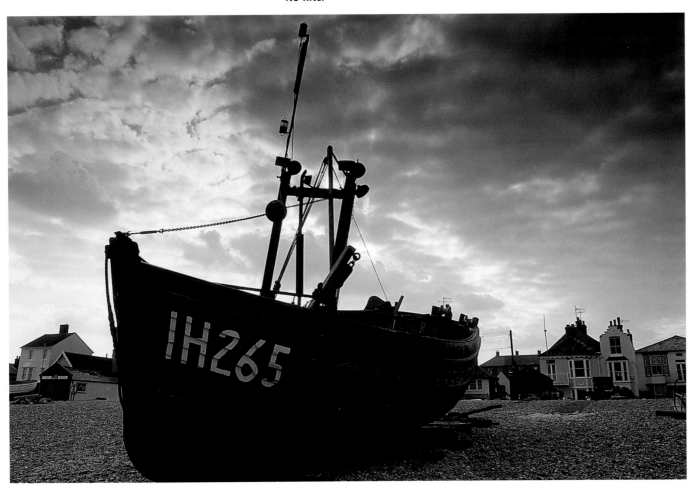

With cheap ND grad filter

SLOT-IN OR SCREW-IN?

The most versatile graduated filters are those made to slot into a system holder, as you can align the filter with a high degree of accuracy so it affects only the areas you want it to. Screw-in graduated filters are less useful because the graduated area usually covers half of the filter surface and their position on the lens is fixed. So, if you compose a scene where the sky occupies the top third of the image area, for example, the graduated part of the filter will also darken part of the ground and give an unnatural effect. The only way to avoid this is by always composing your photographs so the sky and ground each occupy half of the image area, but in most situations this is impractical, and should generally be avoided if you want to produce interesting compositions.

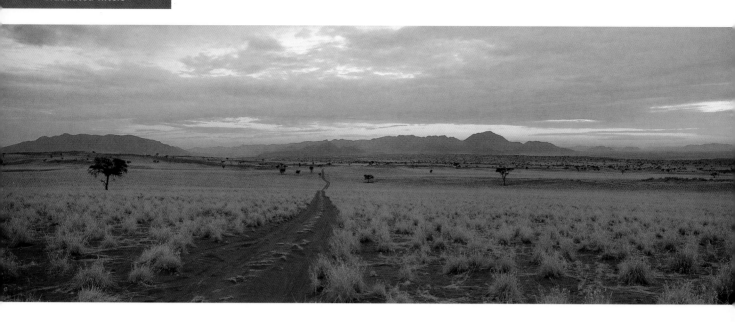

to the transition zone. With soft grads the transition from graduated to clear is very gentle, while with hard grads it's more sudden.

Soft grads are easier to use if you're a beginner since they give greater room for error. If you push the filter too far down into the holder so that part of the neutral-density area overlaps onto the ground, it's unlikely that you will see this on the final photograph, whereas hard grads are less forgiving, and incorrect alignment shows up more clearly.

The down side of soft grads is that the density of the graduated part of the filter – 0.6 or 0.9, for example – covers perhaps only the top third of the total filter area before fading slowly to nothing. In reality, however, the sky tends to be at its brightest just above the horizon, where a soft grad has little or no effect, and then darkens with height, so unless you align a soft grad lower than you would theoretically need to, it won't give the desired effect, and you could end up with an unnaturally bright band of sky immediately above the horizon.

Hard grads overcome this by giving their specified density across more of the neutral-density area, so you can reduce the brightness of the sky with more accuracy, without having to cover part of the landscape with the filter's transition zone.

Accurate alignment

When it comes to aligning a graduated filter accurately there are two techniques you can use. Ideally, both require you to mount your camera on a tripod, so its position is fixed, and to compose the photograph. Using grads when shooting

handheld is tricky because slight changes of camera position will alter the alignment of the grad in relation to the sky and ground.

If your camera has a depth-of-field preview (stop-down preview) facility, as many SLR cameras do, one option is to activate the preview with the lens set to its minimum (smallest) aperture. Doing this darkens the viewfinder and, if you then carefully push the grad down into its holder while looking through the viewfinder, you will be able to see the effect it is having on the sky. Once positioned, recheck after a few seconds without using the depth-of-field preview and, if you have positioned it correctly, the effect of the filter shouldn't be detectable.

The same technique can also be used with large-format cameras, but instead of using a depth-of-field preview you simply set the aperture to its smallest f/stop – or almost the smallest – then align the filter while you are still under the dark cloth and viewing the image on the ground glass screen.

With rangefinder cameras that don't offer through-the-lens (TTL) viewing, graduated filters must be aligned by sight. All you do is compose the shot, then approximate how much of the image area is occupied by sky – the top quarter, top half, and so on. Looking head-on at the front of the lens with the filter holder attached, you then need to visualize the rectangular (or square) picture format within the circle of the holder and align the grad so that it covers what you think is the correct area. This is a little hit and miss, but with practice you should be able to get it right every time.

▲ **AFRICAN SUNRISE**
Aligning ND grads when using a non-TTL viewing camera may seem tricky at first, but getting perfect results is actually very easy. For this shot taken in Namibia I composed the scene, then aligned the grad filter on the lens by eye so it covered the top half of the front element.

FUJI GX617 PANORAMIC CAMERA, 180MM LENS, 0.6 ND GRAD, TRIPOD; FUJI VELVIA; 2 SEC. AT F/22

DECIDING ON DENSITY

Choosing the correct density of ND grad can be a little confusing to begin with, though with experience you will be able to determine this fairly accurately simply by looking at the sky and comparing its brightness to that of the ground.

More often than not a 0.6 density grad will provide the best compromise, giving a 2-stop light reduction in the sky, while a 0.9 density grad becomes more useful when the sky is brighter than average. A common example of this is if you are shooting into the light at dawn or dusk when the landscape is lit mainly by sky light from overhead, so it's much darker than the brighter area of sky you are including in your picture.

For a more accurate assessment of the brightness difference between sky and ground you need a spotmeter – either a handheld spotmeter, or the spotmetering facility that a growing number of SLR cameras have.

First you need to determine the correct exposure for the ground – this is the exposure you will be using for the final shot. If it is comprised mainly of mid-tones, then all you need to do is take a meter reading from a mid-tone in the scene. If there are no obvious mid-tones, take a reading from the brightest area, then the darkest, and find the average of the two. For example, if the brightest reading is 1/60 sec. at f/16 and the darkest is ¼ sec. at f/16, the average of the two is ⅟₁₅ sec. at f/16.

Next, do the same for the sky. If there are areas of cloud that you feel equate to a mid-tone (think of a mid-grey colour when making your visual assessment), then take a reading from one of those areas. Alternatively, meter from the brightest and darkest areas and find the average of the two, as already explained above.

To determine the density of grad filter you need, all you do is find the difference between the readings (or average readings) for the sky and the ground. For example, let's say the correct exposure for the ground is ⅟₁₅ sec. at f/16, as above, and the correct exposure for the sky is ⅟₆₀ sec. at f/16. The difference in brightness is 2 stops, so you would need to use a 0.6 density ND grad. If the sky exposure were ⅟₁₂₅ sec. at f/16, the difference would be 3 stops, making it necessary to use a 0.9 density ND grad.

Where the difference between the two readings doesn't equate to full stops, select the nearest lighter ND grad rather than the nearest darker

▼ **MALHAM COVE, NORTH YORKSHIRE, ENGLAND**
Although ND graduate filters are primarily intended to balance the sky and landscape, you can also use them to make the sky come out even darker than it was in reality. Here the sunlit foreground was brighter than the sky, so a graduate filter wasn't necessary. However, I decided to use one anyway, to darken the sky even more and emphasize the stormy weather conditions.

PENTAX 67, 55MM LENS, 0.6 ND GRAD; FUJICHROME VELVIA; ⅟₆₀ SEC. AT F/8

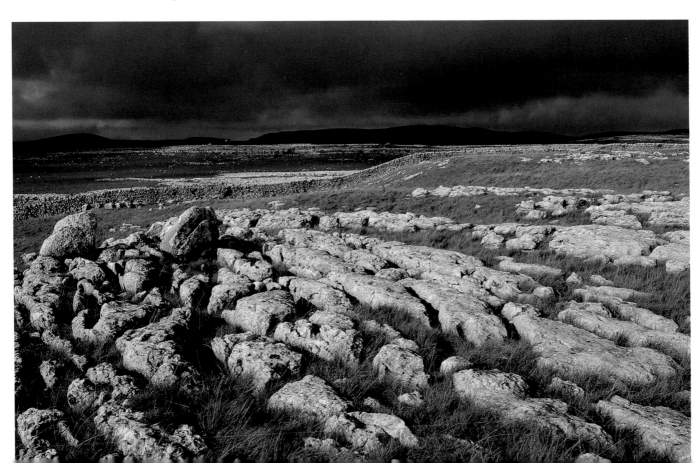

grad, as a photograph tends to look more natural if the sky is a little lighter than the ground. For example, if, on comparing your exposure readings for sky and ground, you find that the sky is 2½ stops brighter, a 0.6 density grad would be the better choice, rather than a 0.9.

There are exceptions to this rule, of course. When shooting in stormy weather the ground may be sunlit against a dark sky, in which case you may want to make the sky even darker to emphasize the dramatic lighting. Your choice of ND grad will also be determined to a certain extent by the effect you wish to record, so don't feel you must do what is technically correct.

Exposure control

If you don't have a spotmeter, a more rough-and-ready way of assessing the brightness difference between sky and ground would be to take a general meter reading with your camera from both areas. Tilt the camera down to meter from the ground, then up to meter from the sky, making sure the other area is excluded from the viewfinder. Switching to a longer

COMBINATION ND GRADS

Working on the basis that the more filters you use together, the greater the loss of image quality will be, some manufacturers produce filters that combine an ND graduate with an 81-series warm-up (see p. 60). A full range of both is usually available, so you could have any density of ND grad – 0.3, 0.6, 0.9 – with an 81A, B, C, D or EF filter built in. If you find that you often use a warm-up filter and an ND grad together, as many landscape photographers do, combination ND grads are well worth considering.

lens or adjusting the focal length of your zoom lens may be necessary when you do this, especially if you are taking the final picture with a wide-angle lens. Having determined the strength of graduated filter you need, and aligned it in its holder, all that remains is to take the final picture.

If you have used a handheld meter to determine the correct exposure for the ground, you will usually set this on your camera in manual exposure mode. The same can also be done if you take meter readings to assess brightness difference using your

No filter

0.3 ND grad

0.6 ND grad

0.9 ND grad

▲ **Yorkshire coast**
This set of photographs by Joe Cornish illustrates the importance of choosing the correct density of ND grad if you want to make the most of a scene. With no filter in place the sky has washed out and shows little colour or detail. As the density of ND grad is increased, however, so the sky becomes darker. Joe

used hard grads, placing the transition zone over the horizon and, although a 0.6 density grad produces an acceptable result, it's the final image in the sequence, taken with a 0.9 ND grad, that records the sky as it appeared to the naked eye.

camera's TTL metering – before fitting the grad, take a final meter reading from the foreground and set it in manual exposure mode so that the exposure doesn't change when you recompose the shot or fit the ND grad on the lens.

A quicker technique with TTL-metering cameras is to compose the final shot, position the ND grad, having already determined which density you require, then meter normally with the grad in place. Traditionally, this was advised against because the metering systems in SLRs tended to be rather basic, and there was a risk of exposure error if you metered with the filter in place because the darker graduated part would fool the camera's metering system. Modern metering systems, however, are far more sophisticated, taking brightness readings from various points across the frame to determine correct exposure. If you meter with the ND grad in place, therefore, those brightness readings will be the same because it has already reduced the brightness of the sky, so you should get accurately exposed results.

Broken horizons

ND grad filters are designed to be used on scenes where you have an even horizon over which the transition zone of the filter can be placed. In reality, however, that isn't always the case, and it's not uncommon to have trees, buildings, hills or other features breaking the horizon line and intruding into the sky. In these situations the effect of the filter is going to be more obvious because anything breaking the horizon line will be darkened by the grad, while areas of the same feature below the horizon will be left unchanged.

One way around this is to use a soft grad with a more gentle transition zone so the effect isn't so obvious. If you have only hard grads, choose a weaker density. Doing so means the sky won't be darkened by the amount you would normally require, but neither will the features against it.

Alternatively, you can go ahead as normal and accept that any features above the horizon will be darkened. If those features are distant, the effect won't be too bad, whereas if they are in the foreground it will be obvious. On assessing the final images you can decide if the darkening looks unnatural, or if you can live with it.

If in doubt, use the grad you would normally choose to give sufficient light reduction in the sky, then take other shots with weaker grads and choose the image that gives the best compromise.

▲ **ALNMOUTH, NORTHUMBERLAND, ENGLAND**
Broken horizons can present problems when using ND grads as it is inevitable that anything breaking into the sky will be darkened. Fortunately, in this case there were only a couple of slender sail masts to worry about, and the effect the grad had on them doesn't look at all odd.

PENTAX 67, 45MM LENS, 0.9 AND 0.3 ND GRADS TOGETHER, TRIPOD; FUJICHROME VELVIA; 1 SEC. AT F/22

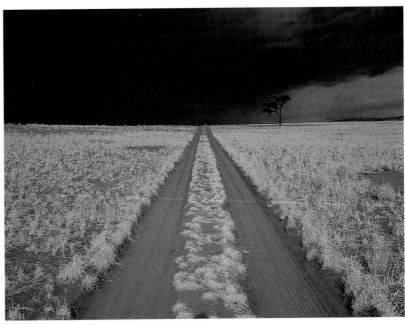

▲ **NAMIB RAND**
I wanted to capture a real thundery feel when I photographed this African landscape, with the dark sky drawing attention to the light-coloured grass in the foreground. The single tree on the horizon was also darkened by the ND grad, but it's still light enough to be clear against the sky and adds a certain poignancy, being alone in such a stormy landscape. Moments later the heavens opened!

PENTAX 67, 105MM LENS, 0.6 ND GRAD, TRIPOD; FUJICHROME VELVIA; 1/15 SEC. AT F/16

UNUSUAL APPLICATIONS

Of course, you don't have to limit the use of ND grads to straightforward darkening of the sky in the upper part of the frame. If the sky is much brighter on one side of the frame than the other, you could use an angled ND grad to reduce the brightness of that area. Similarly, if you are photographing a scene that's brightly lit on one side but in shade on the other – such as a street scene – an ND grad can be aligned with the transition line running vertically through the scene, or diagonally across it, to match the division between light and shade in the scene itself (see p. 48). With the graduated part of the filter over the sunlit area, you can then expose for the shadows, knowing that the sunlit area will also come out correctly exposed because its brightness has been reduced by the ND grad.

Another practical use for ND grads is when photographing a scene with its reflection in calm water filling the foreground. The reflection will always require more exposure than the scene itself, so if you meter for the scene above water, the reflection of it will come out darker.

For a more balanced image, an ND grad can be positioned over the scene – not only sky, but landscape as well – with the transition zone meeting the fake horizon created by wherever the body of water in the foreground meets the landscape. By taking a meter reading from the scene without the filter in place, then increasing the exposure by an amount equal to the density of the filter used – 1 stop for 0.3, 2 stops for 0.6 – you will bring the brightness of the reflection in line with that of the scene being reflected once the filter is in place.

ND grads can also be used to reduce the brightness in different parts of a scene. If, for

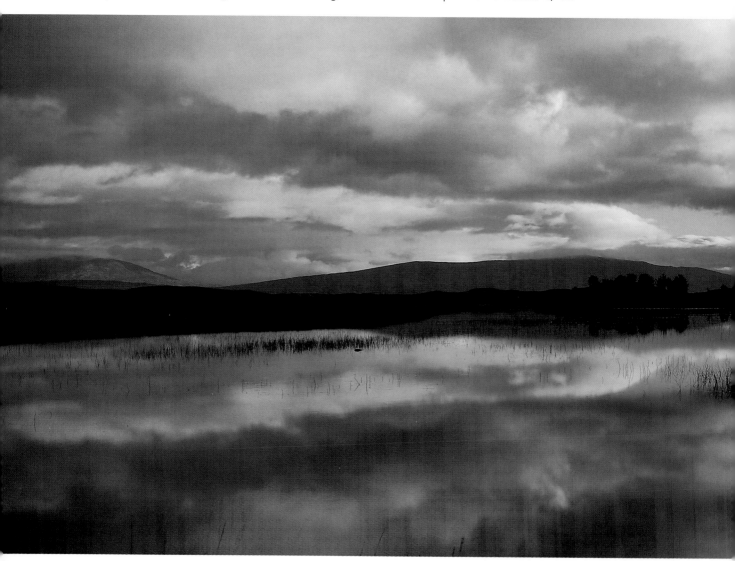

example, there's a bright area in the foreground that's going to dominate the image, you could invert and angle an ND grad to cover it, so that it becomes darker and less obtrusive.

Using ND grads together

Your use of ND graduates needn't be limited to just one, either. In some situations you may need to combine densities to achieve the required level of light reduction in the sky – especially when shooting into the light. By combining 0.9 and 0.3 ND grads, for example, you would get a 4-stop light reduction (1.2 density).

More useful is the fact that two ND grads can be used together with their transition zones staggered, so they affect different parts of the scene in different ways. For example, imagine you are photographing a scene where the sun is partly obscured by cloud so it is illuminating the middle distance, but the foreground isn't directly lit by the sun. This effectively means you have three bands of varying brightness to contend with – the brightest area being the sky, then the sunlit middle distance, and finally the darker foreground.

By taking spot readings from the foreground and sunlit middle distance you could determine the difference in brightness between the two, and which ND grad was required to tone down the sunlit area. Let's assume the difference was 2 stops, requiring a 0.6 ND grad. By taking meter

▼ Loch Ba, Rannoch Moor, Scotland

Here's a classic situation where an ND grad filter will help you to produce a more balanced image. To the naked eye the reflection of the sky in this Scottish loch looked no darker than the sky itself, but it was, and the difference would have shown very clearly on film. To prevent that happening, I used a 0.45 ND grad to darken the sky by 1½ stops, and increased the exposure for the scene by that amount to lighten the reflection. In retrospect, a 0.6 ND grad would probably have been better because the sky and reflection still aren't perfectly balanced.

Fuji GX617 panoramic camera, 90mm lens, centre-spot ND filter and 0.45 ND grad, tripod; Fujichrome Velvia; 1 sec. at f/22

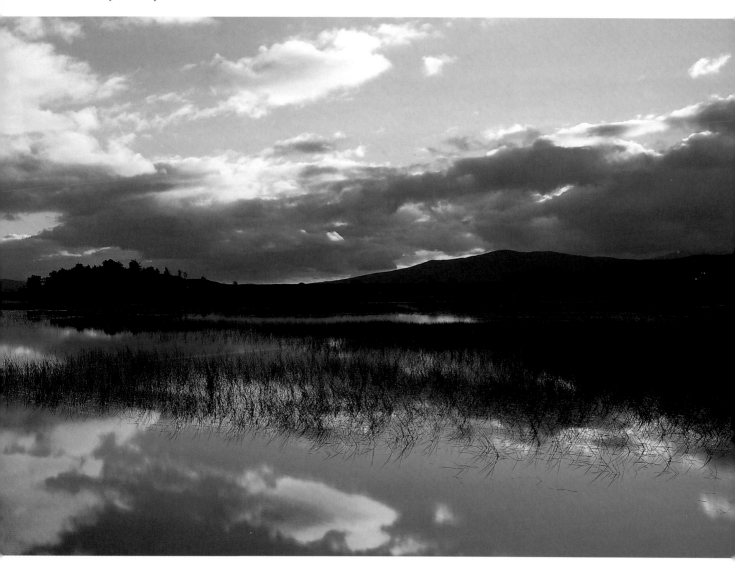

readings from the sky you could then determine the difference in brightness between the sky and the foreground, as you would normally do. Let's say it's 3 stops, requiring a 0.9 ND grad.

If you use just a single 0.6 ND grad and align it so the transition zone falls just below the sunlit area, you will get the desired effect in that area, but the sky will still be a stop too bright because it requires a 0.9 ND grad. The solution? To combine the 0.6 grad with a 0.3 grad, and align it so its transition zone meets the horizon. By doing so you will correctly expose three different areas of

brightness in a single frame and, if the grads are aligned correctly, no one looking at the final photograph would have a clue.

These unusual applications are less common, and more tricky to visualize when you first start using ND grads, but once you understand completely how they work, and are able to assess the brightness levels in a scene so you can visualize what the final image will look like both with and without an ND grad, you will realize just how versatile they are – and wonder how you ever managed without them.

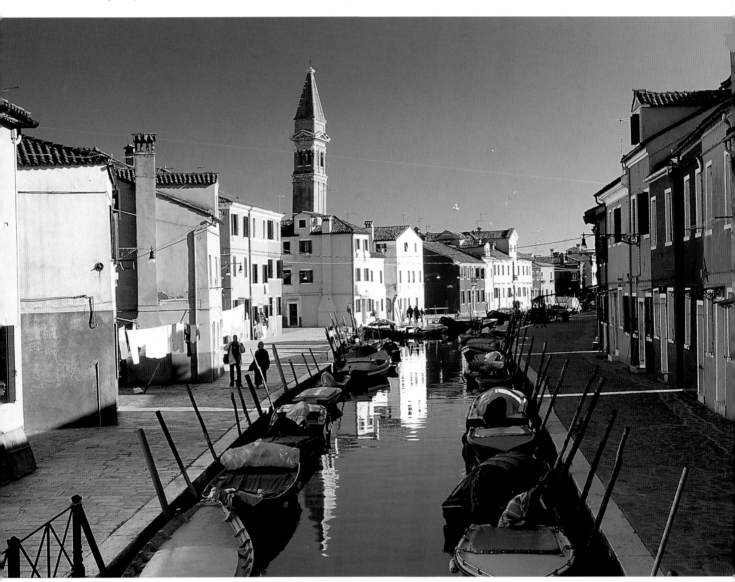

▲ BURANO, VENICE

This scene presented a less common problem, but one that an ND grad filter could solve. The area to the right of the canal was in shade, while the area to the left was in full sun. Exposing for the sunlit areas would have made the shadows too dark, while exposing for the shadows would have over-exposed the brighter areas. To overcome this an ND grad was positioned so the transition line ran diagonally from the

bottom left corner of the scene to top right, with the graduated zone covering the sunlit area. I was then able to increase the exposure by 2 stops, lightening the shady areas without over-exposing the sunlit part of the scene.

NIKON F90X, 50MM LENS, POLARIZING AND 0.6 ND GRAD FILTERS, TRIPOD; FUJICHROME VELVIA; ¼ SEC. AT F/16

COLOURED GRADUATES

Coloured grad filters are designed more for effect than to tone down bright sky, although obviously they do cause a light reduction in the sky as well as adding their colour to it. Many different colours are available, from blue, tobacco, pink and green, to mauve, coral, yellow, orange and red. There are also various two-colour grads available, and professional manufacturers usually offer them in different densities.

How you view coloured grads will depend upon your general attitude towards filters. If you're a purist, the chances are you wouldn't let anything but ND grads near your lenses, whereas if you are game for anything, you will accept their coloured cousins with open arms and relish the effects they can produce.

Personally, I take them with a pinch of salt. Some of the colours are simply ridiculous and you are unlikely to find a situation where they could do anything but ruin a potentially successful

▼ ▶ La Digue, Seychelles

This set of pictures shows how you can transform the mood of a photograph using coloured grad filters. All the images were captured within minutes of each other, just after the sun had set.

Pentax 67II, 45mm lens, tripod; Fujichrome Velvia; various speeds from 1–6 sec. at f/11

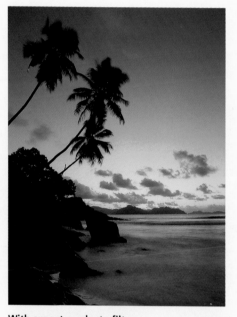

With sunset graduate filter

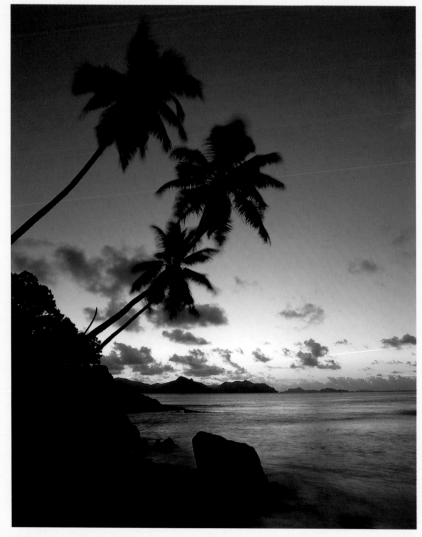

With mauve graduate filter

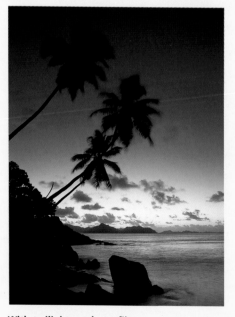

With twilight graduate filter

photograph, whereas others can be highly effective when used with care on the right type of subject or scene. I feel no shame in admitting that I'm the proud owner of numerous coloured grads – even if they don't see the light of day very often. I also know of several professional landscape and travel photographers who have the odd one or two tucked away, even if they wouldn't like to admit it.

Coloured grads for dawn and dusk

The most useful coloured graduate filters are those with colours that do exist naturally, if only because the effect they give isn't going to look ridiculous. One of the best is the sunset grad, which bends the rules of graduated filters a little in that it has a warm colouring across the whole filter, with the top half being noticeably darker, instead of being half-coloured and half-clear – rather like a more extreme combination ND grad.

As the name implies, sunset grads are designed to help you enhance pictures taken at sunset (and sunrise of course) by boosting the warmth of the colours in a scene. You should need to do this only when those colours are very subdued, such as in dull or misty weather. It's also worth remembering

that the colour temperature of the light (see p. 54) is very low at sunrise or sunset, so your pictures will come out warmer than you expected anyway, and the addition of a sunset grad may produce an effect that's plainly unnatural.

Where these filters do come in useful is for enhancing pictures taken in dull or flat light – landscapes shot on fast, grainy film through a sunset grad and soft-focus filter can look truly magical. Scenes that contain warm colours – such as deciduous woodland in autumn, or desert sand dunes – can also benefit from the extra warmth a sunset grad will introduce.

Most filter manufacturers include a sunset grad in their range, though subtlety is the key – a moderate version will be far more useful than a deep orange grad that makes everything look vividly lurid. Other graduates with a warm colouring can also be used to enhance pictures taken at dawn or dusk. Coral, amber, pale pink, pale orange, apricot, autumn, straw – different manufacturers use different names, but they're all designed to do pretty much the same job.

The key is to match the filter with the natural colours in the sky – there's little point choosing a pink graduate when the sky is predominantly orange, for example, because the end result will be neither one thing nor the other. If the colours in the sky are naturally quite strong, coloured grads should be avoided altogether in favour of an ND grad, otherwise the effect will look over the top.

If you are using coloured grads at dawn or dusk, keep the composition simple. Coloured skies make good backdrops to silhouettes or trees or buildings, but if you have an empty foreground that's more muted in its colouring, the sky will look even more unnatural.

▲ Coloured grad filters come in all manner of colours, as you can see from this selection. The majority have a single colour, but various dual-colour versions are also now available from some manufacturers.

TWO FOR ONE

A technique worth trying with coloured grads is to use one colour on the sky, then another grad with a different colour, inverted, on the foreground. This may sound ridiculous, but the effect can work well. An inverted blue grad can be used to enhance banks of bluebells, for example, which tend to come out purple on colour film. Similarly, when photographing a field of mellow corn you could use a blue filter on the sky, then an inverted coral, amber or pale yellow filter to colour the crops in the foreground. The same combination of filters could be used to photograph sand dunes, monuments, a bank of reeds or any other subject that's naturally warm in colour. It's obvious when you do this that filters have been used, but the effect can look striking if you do it on the right subject.

Coloured grads for daytime shooting

Even greater care should be taken when using coloured grads for normal daytime shooting. A blue grad can effectively enhance a sky washed out by haze or blanket grey cloud. Or try a pale pink or coral filter if you're shooting early or late in the day when the light is naturally warm. But if you reach for colours such as tobacco, sepia or green, it's always going to be obvious in your pictures that a filter has been used. There's nothing wrong with that, but the majority of photographers who use coloured grads abuse them, thinking that the addition of a tobacco sky is going to make a boring picture more interesting. It won't. You will still end up with a boring picture – the only difference is that it will have a more colourful sky!

The main thing to be aware of is that if you use coloured grads in dull or hazy weather the sky is going to stand out because everything beneath it will be rather muted. So try to include something bold and colourful in the foreground to act as a foil to the colourful sky – a red sports car filling the foreground with a blue grad on the sky would create an eye-catching effect, whereas a blue-gradded sky with an empty foreground wouldn't.

Using and abusing

The technical side of using coloured graduates isn't quite as involved as with ND grads because the colouring effect they have will usually be more important to you than reducing the brightness of the sky by a precise amount. Most coloured grads don't come in a range of different densities, anyway – there may just be a light or dark version. So, there's really no need to assess brightness levels, and if you're using a modern SLR camera you can position the grad, then meter through the lens as you would normally. Alternatively, take a meter reading for the foreground, set it on your camera in manual mode, then fit the filter.

▼ Sunset filters come in different densities. Shown here are the Cokin Sunset 2 and Cromatek Moderate Sunset. I favour the latter as its effect isn't so intense.

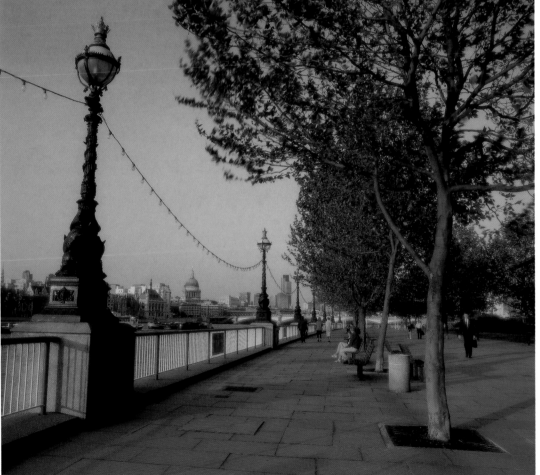

◄ **THAMES EMBANKMENT**
Sunset filters can produce attractive results when used with care and on the right type of scene. This photograph of the Thames Embankment in London was taken during early evening when the light was naturally warm, and although the filter has increased that warmth to a level you would never normally see, it doesn't look too unnatural.

PENTAX 67, 55MM LENS, COKIN SUNSET 1 AND DIFFUSER 1 FILTERS, TRIPOD; FUJICHROME VELVIA; 1/30 SEC. AT F/11

With sunset graduate filter

Where you do need to take care is when aligning coloured grads. ND grads – especially those with a soft transition zone – are reasonably forgiving if you position them too low or too high in the holder, but coloured grads aren't. If you place one too low you will get colour bleeding beneath the horizon into the landscape, which will look very odd indeed, while placing one too high will result in a band of sky just above the horizon that has no colour at all – an effect that looks equally odd.

All things considered, neutral density graduates are far more versatile than coloured grads, so make sure you invest in a set first and learn how to use them properly. If, on achieving that goal, coloured grads appeal to you, then by all means add a few to your filter collection. But choose them carefully, stick with natural colours, and use them only when the effect they give really can enhance the picture you're about to take. If it can't, or you have any doubts, leave them out.

No filter

◄▲ **Budle Bay, Northumberland, England**
This pair of pictures shows the difference a sunset grad filter can make to a scene. The increase in warmth is significant, and when a sunrise or sunset is naturally subdued, such a filter can undoubtedly give it a helping hand.

Pentax 67, 55mm lens, Cokin Sunset 1 filter, tripod; Fujichrome Velvia; 2 sec. at f/16

COLOUR-
BALANCING
FILTERS

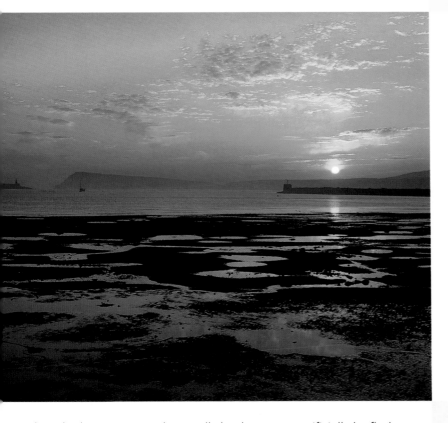

FISHGUARD BAY, PEMBROKESHIRE, WALES
The colour temperature of light changes constantly
throughout the day, and this factor can have a profound
effect on the pictures you take. At sunrise, as here, the
colour temperature is very low because light at the blue
end of the spectrum is filtered out, leaving the warmer
wavelengths to perform their magic in this scene with
spectacular consequences.

PENTAX 67, 105MM LENS, NO FILTERS, TRIPOD; FUJICHROME VELVIA;
⅕ SEC. AT F/11

Light, whether it is created naturally by the sun or artificially by flash,
tungsten, fluorescent and other manmade sources, consists of
wavelengths of electromagnetic energy. Light in the visible spectrum is
made up of wavelengths that we can see. Outside this spectrum lies
invisible light – wavelengths that are undetectable to the human eye.
On the one side, at the cooler end of the electromagnetic spectrum,
can be found ultra-violet radiation, followed by x-rays, then gamma
rays and cosmic rays. At the other end, on the warmer side of the
electromagnetic spectrum, are infrared radiation, heat, radar waves
and radio waves.

 For general photography the only type of light we are interested in
is that found within the visible spectrum, commonly known as 'visible
light'. Infrared radiation is also harnessed for specialized infrared
photography (see pp. 125–34).

VISIBLE LIGHT

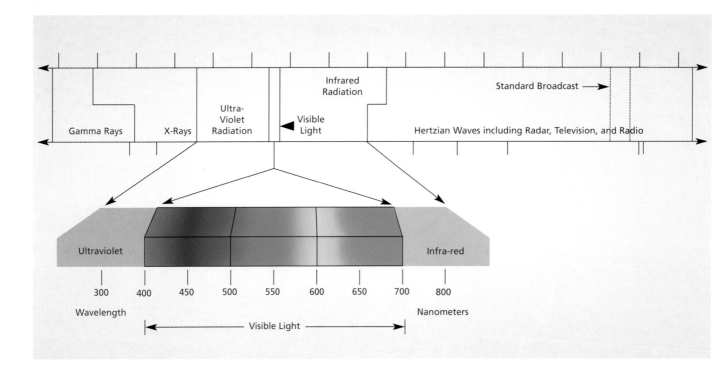

Visible light is made up of colour wavelengths going from warm to cold. The sequence of these wavelengths is most commonly seen in rainbows, which are created when the sun shines through falling rain and the raindrops then divide the light into its individual colour wavelengths – red, orange, yellow, green, blue, indigo and violet – seven in total.

When these colour wavelengths are present in equal quantities the result is white or neutral light. Often, however, there is an imbalance present, with some wavelengths being more evident than others, and this changes the 'colour' of the light.

Haze and atmospheric pollution scatter the light wavelengths, for example, and those at the cooler end tend to be absorbed so the light has a greater content of red and becomes warmer. Similarly, in dull weather or at high altitudes in mountainous regions, light at the red end of the spectrum is in lower quantities so the light appears bluer.

Our eyes are able to adapt to these changes very quickly using what's known as chromatic adaptation, so that even if the light has a high content of warm wavelengths or of cool wavelengths, everything still appears 'normal'. Unfortunately, photographic colour film can't adapt in this way. It's designed to record light

with an equal balance of wavelengths – white light, in other words – so once the imbalance of wavelengths exceeds certain limits, either towards the warmer end of the spectrum or the cooler end, it will record these variations and your pictures will take on noticeable colour casts.

Tungsten lighting is a good example: if you take pictures on normal colour film in tungsten light, those pictures will come out with a strong yellow/orange colour cast. At the time the pictures were taken you weren't aware of any colour casts because your eyes had adjusted to it, but as film can't adjust, it records light in a very literal way.

This is something we need to be very aware of at all times, partly because what the film in your camera records isn't always what the eye sees, but also because variations in the colour of light don't need to be that great before colour casts become apparent.

If you take pictures outdoors – in bright sunshine under a cloudless blue sky, for instance – there's a strong possibility that those pictures may exhibit a slight coolness, especially around midday. The same applies if you are under shade, where the light on your subject comes from the sky rather than the sun, or in dull weather, when cloud cover diffuses the sun and the sky behaves like one huge, diffuse light source.

▲ This illustration shows where visible light falls in the electromagnetic spectrum, and the individual colours from which it is created.

▶ **NAMIB DESERT**
During early morning and later afternoon the light has an attractive warmth that brings scenery to life. You use filters to enhance this effect, though often they aren't really necessary and pictures will come out warmer than you expected them to, because your eyes can adapt to changes in colour temperature but film cannot.

PENTAX 67, 55MM LENS, POLARIZER, TRIPOD; FUJICHROME VELVIA; ⅛ SEC. AT F/16

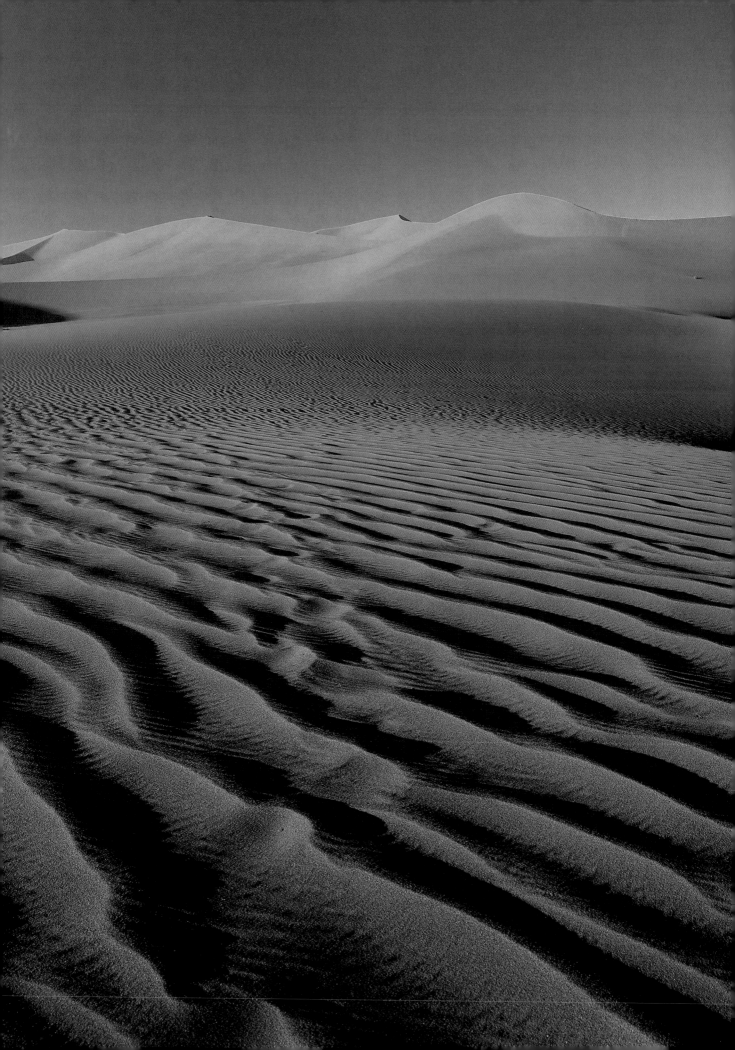

THE COLOUR TEMPERATURE OF LIGHT

Variations in the colour of light in the visible spectrum are referred to as a colour temperature, using a system known as the Kelvin scale (K), borrowed from thermodynamics. Temperature is used as a form of measurement simply because the way the colour of daylight changes is exactly the same as if you heat a substance. Heat an iron bar, for instance, and it will eventually glow red, then orange to yellow until it is white hot. Beyond that, the bar would melt, but if it didn't, and its temperature continued to rise, it would eventually appear blue. The cooler the light is, therefore, the higher its colour temperature, and the warmer it is the lower its colour temperature. Don't be confused into thinking colour temperature actually has anything to do with heat, though – it refers only to the actual colour of the light.

Average noon daylight

Normal photographic colour film – which we use to take just about all our pictures – is balanced to record colours naturally in light with a colour temperature around 5,500K. Such conditions are assumed to be found on an average sunny day around midday under blue sky containing a proportion of white clouds. Provided that the colour temperature of the light doesn't vary by a large degree – above 6,000K or below 5,000K – then it's unlikely you will notice any obvious colour casts on your pictures. Beyond those limits, however, colour casts will begin to appear, and you have to decide whether or not to use filters to combat them and produce photographs where the colours appear natural.

Where daylight is concerned, the colour temperature can be influenced by a number of factors. As already mentioned, 'bad' weather tends to produce cooler light, and therefore a blue colour cast, because cloud cover filters out wavelengths at the warmer end of the spectrum and scatters those at the cooler end, so they predominate in the

MIRED SHIFT

Another measurement used alongside colour temperature that can be useful is the mired scale (micro reciprocal degree). The mired scale is necessary because colour temperature is not proportional throughout the Kelvin scale, and the shift from one temperature to another is not the same at the warmer end of the scale as it is at the bluer end.

Every colour-balancing filter has a mired shift value, so by using the mired scale to measure the difference between what the colour temperature of the light is and what you want it to be, you can accurately select the filter required to give you that shift.

To do that you need to divide 1 million by the colour temperature of the light in Kelvin, and by the colour temperature you want, find the difference between the two totals, then select a filter with a mired shift value equal to that difference.

For example, if you are taking pictures under household tungsten bulbs, which have a colour temperature of 2,500K, the mired value is 1 million/2,500 = 400. The mired value of average noon daylight, for which normal colour film is designed to give natural results, is 1 million/5,500 = 182. The difference between the two is 182–400 = –218. You therefore need to use a filter, or a combination of filters, that will give to a mired shift of –218.

In practice you don't really need to apply the mired scale. Most filter manufacturers produce tables that show the actual colour temperature shift of each colour-balancing filter, so all you need to do is choose a filter that gives you the desired shift – or as close as possible. As you will tend to use the same filters regularly, you will also know exactly what their effect is and when to use them.

In the above example, you would need to use a filter (or filters) that gave a colour temperature shift of 3,000K, to 5,500K. Throughout this chapter, data tables show the colour temperature shift of each filter, rather than their mired shift.

light reflected from the sky. The same applies in the shade under clear blue sky, where the colour temperature of the light can be as high as 10,000K, or at high altitudes where there is a greater concentration of ultra-violet light and bluer wavelengths.

At the other extreme, the colour temperature of daylight is much warmer at sunrise and sunset, gradually increasing during the morning until it reaches the 'neutral' 5,500K, then decreasing through the afternoon as the sun drops in the sky. So, if you photograph a scene just after sunrise or just before sunset, it will record on film far warmer than you actually remembered it because the colour temperature of the light is very low – down to perhaps 2,000–2,500K. Those pictures will also appear far warmer than pictures of the same scene taken several hours later in the morning or earlier in the afternoon, when the sun is higher in the sky and the light is more neutral.

The time of day at which the daylight becomes neutral depends enormously on the time of year. In Western Europe and the Northern USA in summer the sun rises very early and sets late, so in sunny weather the colour temperature of the light may reach 5,500K as early as 6am and hover around that until 6pm. In spring and autumn the period is shorter – around 8am–4pm – while during winter the sun doesn't climb very high in the sky and the colour temperature of the light often never gets beyond 4,500K, so the light is always slightly warm, even at midday.

With artificial light sources the difference in colour temperature compared to 'average noon daylight' is generally huge. One notable exception is electronic flash, which is specifically made to have a colour temperature of 5,500K so it gives neutral results on daylight-balanced film. Tungsten, the most common form of artificial lighting, has a colour temperature around 3,000–3,400K, while the light from a fire is below 3,000K and that of a candle flame or oil lamp as low as 2,000K (see p. 58).

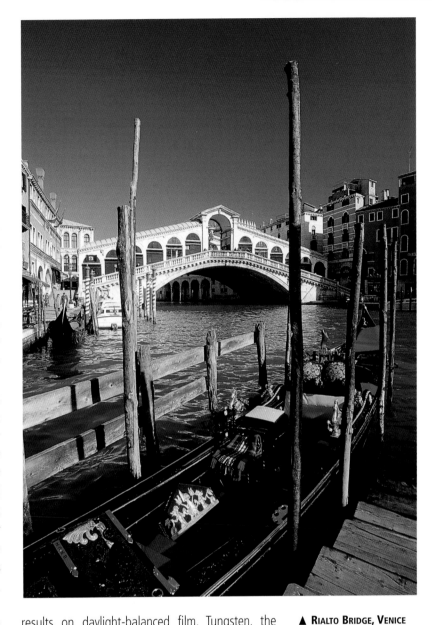

▲ **RIALTO BRIDGE, VENICE**
From mid-morning through to mid-afternoon, the colour temperature of the light is fairly neutral at around 5,500K, so colours appear natural, and no corrective filtration is required to balance colour casts when shooting on daylight-balanced film.

NIKON F90x, 18–35MM ZOOM AT 18MM; FUJICHROME VELVIA; 1/30 SEC. AT F/16

FILM CHOICE

An important factor to consider when dealing with colour casts, especially those created by artificial sources such as tungsten or fluorescent, is that colour negative film is more tolerant of colour temperature shifts than colour slide film. This is mainly because any dominant colour casts can be corrected at the printing stage, simply by adjusting the filtration, whereas there is no intermediate 'rescue' stage with colour slide film, so you need to get it right first time. The only other option with slide film is to scan the original into a computer, then use software such as Adobe Photoshop to adjust the colour balance and get rid of any casts. Tungsten-balanced film is also available to give natural results in a tungsten-lit environment (see p. 64).

COMPARING COLOUR TEMPERATURE

The colour temperature illustration shown here will help you to compare and understand the way colour temperature changes, and how film records it.

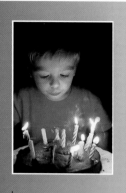

CANDLE FLAME
You can see from this unfiltered picture on daylight-balanced film how, in the absence of any other light source, the light from a candle flame appears to be bright orange due to its low colour temperature.
COLOUR TEMPERATURE: 1,800–2,000K

TORCH BULB
The warm glow on these old boots was created by taking the picture using nothing but a small pen torch as the main source of illumination. The light trails created by tracing the outline of the boots with the torch are also obviously warm.
COLOUR TEMPERATURE: 2,500K

DOMESTIC TUNGSTEN BULB (60–100 WATT)
Pictures taken under normal tungsten room lighting on daylight-balanced film don't exhibit a colour cast as warm as that from a candle flame or fire, but it is still very obvious. Whether you find it acceptable is a matter of personal preference.
COLOUR TEMPERATURE: 2,800K

SUNRISE/SUNSET
Natural daylight reaches its warmest (lowest colour temperature) at sunrise or sunset. This is caused by the shorter blue wavelengths being absorbed by the atmosphere and more of the warmer wavelengths passing through so they dominate and influence the colour of the light.
COLOUR TEMPERATURE: 3,000K

EARLY MORNING/LATE AFTERNOON
Once the sun has risen, or just before it sets, and the sun is higher in the sky, light doesn't have to travel so far through the atmosphere, so few of the blue wavelengths are absorbed. The light is still warm, however, so pictures taken at this time will appear warmer than you remembered them.
COLOUR TEMPERATURE: 3,500K

TUNGSTEN PHOTOFLOOD LIGHTS 3,400K

STUDIO QUARTZ BULBS 3,200–3,400K

2,000K 3,000K 4,000K 5,000K 5,500K 6,000K 7,000K 8,000K

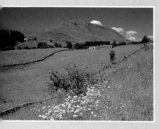

AVERAGE NOON DAYLIGHT
The light is neutral, with a colour temperature at, or close to, what normal colour film is designed to record as natural colours. You can see from this picture that there are no signs of a colour cast.
COLOUR TEMPERATURE: 5,500K

TRICKY LIGHTING

Vapour discharge lighting, which works by using electricity to vaporize a metal such as mercury or sodium, doesn't fall on the colour temperature scale, so it's more difficult to control. Fluorescent is by far the most common as it's now widely used as an alternative to tungsten for interior lighting. Fluorescent lamps are really mercury vapour lamps with a fluorescent coating on the inside of the tube, and they produce a greenish colour cast on daylight film. Correcting this cast fully can be hit and miss because the filtration required depends on the make of the tube (see p. 70).

Sodium vapour, typically used for things like street lighting or to floodlight buildings at night, creates a yellow cast on daylight film and is pretty much impossible to correct. Mercury vapour, used to light warehouses and for heavy industry such as petro-chemical plants, adds a blue-green cast, though again it's tricky to correct. These sources will be referred to in terms of suggested filtration on page 74.

▲ BATH ABBEY
Here's a good example of discharge lighting used to illuminate a building and street. Neither would be easy to balance with filters, but the strong colours actually add something to the final picture.

MAMIYA C220, 80MM LENS, TRIPOD;
FUJICHROME VELVIA; 25 SEC. AT F/11

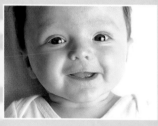

ELECTRONIC FLASH
While the colour temperature of daylight varies, that of electronic flash is fixed at 5,500K so you can use it indoors or out and produce pictures that are free of colour casts – provided that it is the predominant source of illumination, as in the case of studio photography.
COLOUR TEMPERATURE: 5,500K

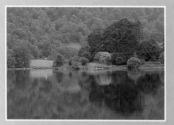

UNDER CLOUDY SKY
When this photograph was taken, on a dull day with blanket cloud cover, the scene appeared normal. However, because the colour temperature of the light had been increased by the cloud scattering the blue wavelengths, it has an obvious cool cast.
COLOUR TEMPERATURE: 7,000K

SHADE UNDER BLUE SKY
Daylight reaches its bluest under such conditions. Because most of the light present is reflected from the sky, which itself is deep blue and has a high colour temperature (10,000K or more), pictures take on a deep blue colour cast.
COLOUR TEMPERATURE: 7,500K

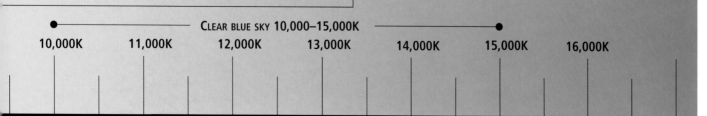

CLEAR BLUE SKY 10,000–15,000K

| 10,000K | 11,000K | 12,000K | 13,000K | 14,000K | 15,000K | 16,000K |

COLOUR-CORRECTION FILTERS

The two ranges of filters aimed at correcting colour imbalances have warming or cooling effects on the colour rendition.

Warm-up filters

Of all the colour-balancing filters available, the 81 series of amber-coloured warm-up filters are the most useful on a day-to-day basis. The range is as follows: 81, 81A, 81B, 81C, 81D and 81EF, with 81 being the weakest, and 81EF the strongest. In practice the 81 is so weak that the effect it gives is hardly noticeable, whereas the 81D and EF are much stronger and must be used with care.

Technically, warm-up filters are intended for correcting minor blue deficiencies in the light. When taking pictures in dull weather or in the shade, for example, the light tends to be slightly blue, so an 81B or 81C filter will balance that to give more natural colour rendition. Similarly, if you

are shooting in bright sunlight under blue sky at midday, there's a tendency for pictures to come out with a cool cast, and an 81B or 81C will again address that – especially if you are using a polarizing filter, which may add to the coolness.

Experience will tell you which warm-up to use, although in most situations, if you need one for corrective purposes, the mid-range 81B or 81C are

◀ You can see here how the colour of warm-up filters becomes stronger through the range from 81A to 81EF

▼ **VENICE**
For this shot, I used an 81D filter to enhance the warm glow of the dawn sky. The sun had just risen out of shot to the left and bathed the scene in a golden light. I could have photographed the scene with no filters at all, but I often warm up shots taken at dawn and dusk.

PENTAX 67, 165MM LENS, 81D WARM-UP FILTER, TRIPOD; FUJICHROME VELVIA; 1/30 SEC. AT F/22

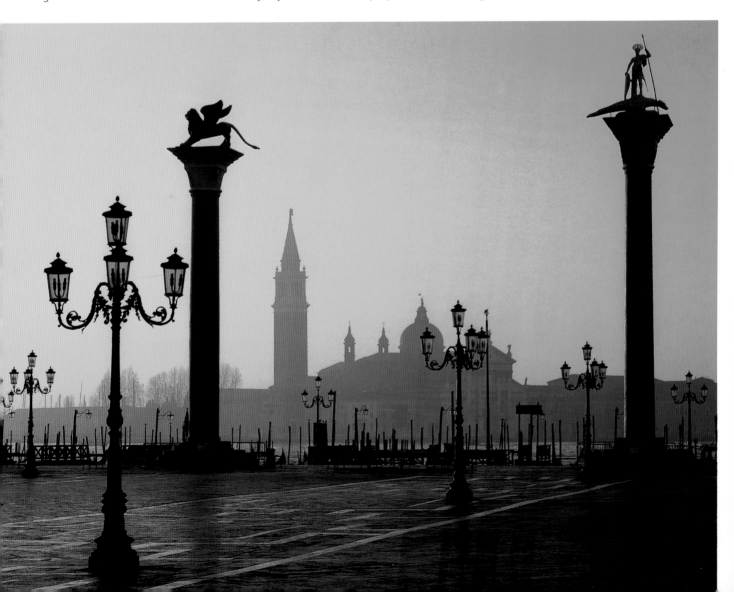

No filters

With 81A

With 81B

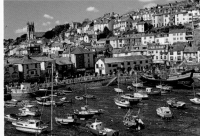

With 81C

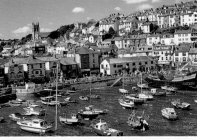

With 81D

With 81EF

▲ BRIXHAM, DEVON, ENGLAND

This set of pictures shows the effect warm-up filters have on a scene, with the overall balance of the image becoming warmer as the density of filter increases.

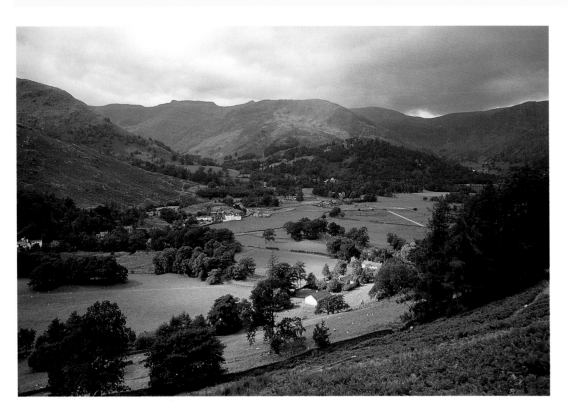

◀ LAKE DISTRICT, ENGLAND

In dull, cloudy weather an 81A or 81B warm-up filter will help to balance any ambient coolness in the light so as to produce more natural colours.

OLYMPUS OM1N, 50MM LENS; FUJICHROME RD100; 1/60 SEC. AT F/8

the safest bet. Any weaker than that and you probably won't see any difference, but any stronger and you may find that you over-correct and end up with an unnatural warm cast across the whole image, especially when shooting in dull weather. Indoors, the light from some portable flash guns or studio flash units can be a little cool, so an 81A or 81B filter will give neutral skin tones.

More commonly, warm-up filters are used for creative effect, to make the light seem warmer

COLOUR TEMPERATURE SHIFT AND FILTER FACTORS

The table below shows the shift in colour temperature that 81-series warm-up and 82-series cool filters give, and the amount of light loss they incur.

Filter	Colour temperature shift (K)*	Exposure increase
81	−100	+ 1/3 stop
81A	−200	+ 1/3 stop
81B	−300	+ 1/3 stop
81C	−400	+ 1/3 stop
81D	−500	+ 2/3 stop
81EF	−650	+ 2/3 stop
82	+100	+ 1/3 stop
82A	+200	+ 1/3 stop
82B	+300	+ 2/3 stop
82C	+400	+ 2/3 stop

* The + and − symbols are used to denote either an increase or a reduction in colour temperature respectively.

than it actually is. This is no bad thing, because warm light is almost always attractive, and during early morning or late afternoon an 81C or 81D will enhance the light and any warm colours in a scene such as old stonework bathed in sunlight, or autumnal woodland. The effect is obvious, but because the light was naturally warm anyway it doesn't look false.

For a really warm effect, use an 81EF or even combine an 81EF with a second, weaker warm-up. This can work well at sunrise or sunset, especially if the light itself isn't that warm due to the weather conditions at the time, or in misty weather. In combination with a colour slide film that has a warm bias anyway, such as Fujichrome Velvia or Kodak Elitechrome 100 Extra Colour, this can produce stunning results, while it will aid films that are less generous in their recording of warm tones, such as Kodachrome 64 and 200.

Finally, warm-up filters work well in conjunction with soft-focus filters to produce beautiful, dreamy photographs of landscapes, architecture and flowers, as well as portraits and nude studies.

Deciding which warm-up filter to use will come with experience and practice. If in doubt, go for

▼ **BURGHLEY PARK, LINCOLNSHIRE, ENGLAND**
Where the colours in a scene are naturally warm, you can afford to be more ambitious with your choice of warm-up filter. Here I used an 81EF in order to liven up the rich colours in this autumnal woodland scene.

NIKON F90x, 18–35MM ZOOM AT 20MM, 81EF AND COKIN DIFFUSER 1 FILTERS, TRIPOD; FUJICHROME VELVIA; 1/15 SEC. AT F/16

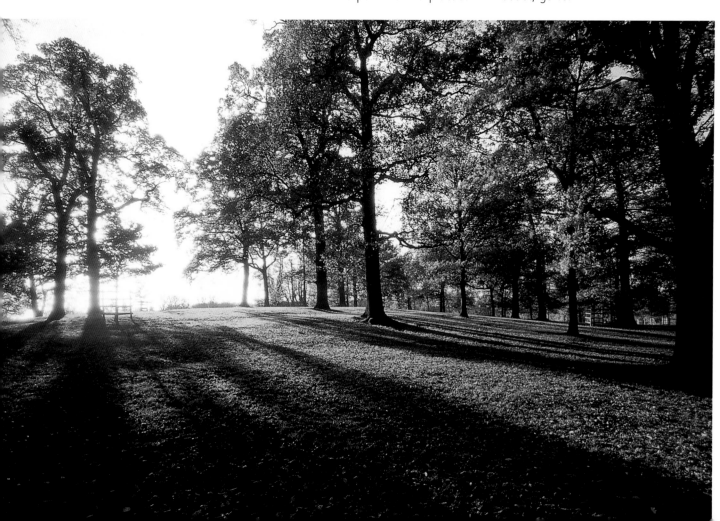

a moderate 81B or 81C. The biggest mistake photographers make is trying to warm up an image too much, which can be counterproductive. If you use an 81D or 81EF in sunny weather, for example, white clouds will take on an unnatural yellow cast, while blue sky tends to record as a muddy grey/blue tone – as if affected by atmospheric pollution or smog. Similarly, while warm skin looks healthy, if you overdo the use of warm-ups when shooting portraits, your subject will end up looking jaundiced!

Equip yourself with 81A, 81B and 81C initially, then use them either singly or in combination to achieve a full range of warming effects. An 81D and 81EF can be added later to complete your collection and give you further options.

Cool customers

The opposite to warm-ups is the 82 series of cool filters. They also come in various strengths – 82, 82A, 82B and 82C, with 82 being the weakest and 82C the strongest. They are designed to correct slight warm deficiencies in the light, so clearly they're not as useful as warm-ups on a day-to-day basis.

One use would be to reduce the warmth of skin tones on portraits taken outdoors in really warm sunlight, or to reduce the warmth of other subjects shot in warm light where you needed a more accurate colour balance – such as architecture. The cooling effect of, say, an 82C could also be used to reduce the warmth of tungsten or candlelight so it's still obviously warm but not over the top.

More commonly, however, cool filters are used to enhance the blue cast you would naturally get on photographs taken in misty or snowy conditions, moonlight, in pre-dawn light before sunrise and in bad weather.

◄▼ **VALLEY OF THE ROCKS, NORTH DEVON, ENGLAND**
The cool 82-series filters (left) are less useful for corrective purposes than the 81 series, but come in handy if you want to enhance a naturally cool scene to give it a cold, mysterious feel. Shown here are the 82, 82A, 82B and 82C.

NIKON F90X, 20MM LENS, 82C FILTER, TRIPOD; FUJICHROME VELVIA; ¼ SEC. AT F/8

COLOUR-CONVERSION FILTERS

The next step from colour-correction is colour-conversion filters. Again, there are two groups – blue 80 series and orange 85 series – and both are intended to correct bigger shifts in colour temperature to ensure you record colours as naturally as you can or would like.

The blue 80 series

This is the most useful for technical applications as it's mainly intended to correct tungsten lighting and other warm light sources for use with daylight-balanced film. There are four filters in the range, from 80A, the strongest, to 80D, which is the weakest.

Referring back to the colour temperature illustration on pages 58–9, you can see that domestic tungsten light bulbs have a colour temperature around 2,800K, so to correct them fully for daylight-balanced film, a filter, or filters, would be required to give a shift of +2,700K.

From the table on this page you can see that the strongest filter in the 80 series – the 80A – gives a shift of only +2,300K. This is usually enough, taking away much of the excess warmth from the tungsten light, but leaving enough to suggest a warm effect. If you wanted

to take out all traces of warmth, however, you would need to add a second blue filter that gave an additional shift in colour temperature of +400K, which is exactly what an 82C cool filter gives.

Where such a high level of correction is required, most photographers start out with tungsten-balanced colour slide film. This is then corrected to give natural results in light that has a colour temperature of 3,200K. In the

No filter

With blue 80A filter

◄▲ **READING GLASSES**
This pair of pictures shows how the warm colour cast of tungsten light can be corrected using a blue 80-series filter. The filtered image (left) still retains a little warmth as the filter didn't fully correct the light, but had I used a stronger filter in order to achieve that, the final image would have looked rather boring.

above example, there would still be a slight warm cast to the pictures, and for full correction you would need an additional shift from 3,200K down to 2,800K, which an 82C cool filter would again provide.

For more examples, see the panel on this page. The suggestions for filtration given in the panel, with or without tungsten-balanced film, are mainly intended for guide purposes. In some situations it would be necessary to filter out the warmth of tungsten lighting completely – when using tungsten photolamps or photofloods in a studio for portraiture or product photography, for example. But where tungsten lighting, or the light from candles, fires and oil lamps, is there as the available light, and contributes to the mood of the situation, you are advised to avoid filtering out the warmth completely as doing so will ruin the effect.

Creative coolness

Even if you're unlikely to need one to cool down warm light sources, it's well worth adding an 80A or 80B to your filter collection so you can use it to add a strong blue cast to the occasional photograph.

This effect works well in dull, misty or foggy weather, or when shooting in moonlight, as a blue cast will give your pictures a cold, sinister feel that can work brilliantly. Shooting into the sun to create striking silhouettes is another situation when a blue 80-series filter can be used to add a monochromatic blue tone that will simplify the image in your picture and heighten its graphic appeal.

COLOUR TEMPERATURE SHIFT AND FILTER FACTORS

The colour temperature shifts given by each filter in the blue 80-series range, along with light loss/exposure increase, is as follows:

Filter	Colour temperature shift (°K)	Exposure increase
80A	+2,300	+2 stops
80B	+2,100	+1⅔ stops
80C	+1,700	+1 stop
80D	+1,300	+⅔ stop

Orange appeal

In the same way that the blue 80 filters are like stronger versions of the 82 cool series, so the orange 85-series filters are basically like strong warm-ups, offering a much greater colour temperature shift. The only thing that's likely to confuse is the fact that the series is jumbled, with 85B the strongest, 85C the weakest, and 85 falling between the two. Don't even think about asking why!

An obvious use for these filters is to warm up excessively cool light. In the shade under blue sky, where the colour temperature may be 7,500K, for example, you would need a colour temperature shift of 2,000K to bring it back to the 'normal' 5,500K, and an orange 85 would do that. An 85C would balance light with a colour temperature of 7,200K, which is shade under a partly cloudy sky.

USING FILTERS WITH TUNGSTEN-BALANCED FILM

Here are some examples of how the blue 80 series, in combination with 82 cool filters and tungsten-balanced film, can be used to correct different types of warm lighting.

Light source	Colour temperature shift required (°K)	Filters alone	Filters with tungsten-balanced film (3,200K)
Candle flame	From 1,800 to 5,500	80A + 80D	80D
Tungsten bulbs	From 2,300 to 5,500	80A + 82C	82C
Tungsten photolamps	From 3,200 to 5,500	80A	None
Tungsten photofloods	From 3,400 to 5,500	80B	81A

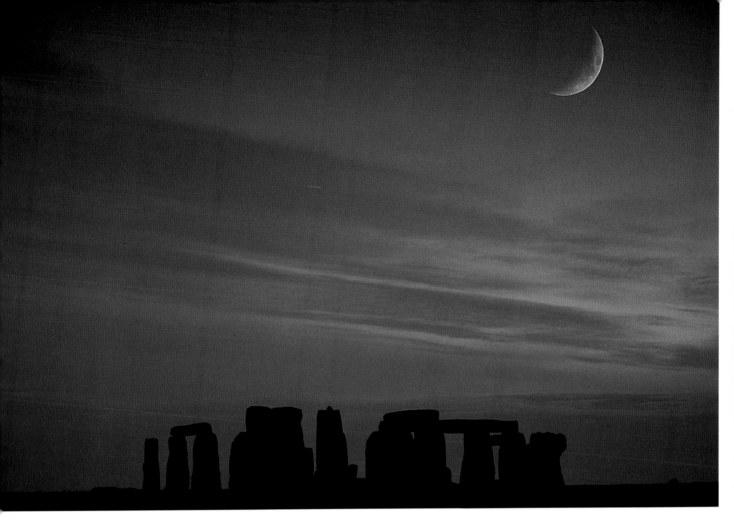

More critically, the orange 85 filter is designed to correct Type A tungsten-balanced film, which is intended for use in light with a 3,400K colour temperature, so you can use it in 5,500K daylight without a blue colour cast. Similarly, the orange 85B will correct Type B tungsten-balanced film, which is optimized for light with a colour temperature of 3,200K, for the same purpose. Not that you would need to or want to balance tungsten film for use in daylight – at least not very often.

Far more likely is that you would use an orange 85-series filter to warm a picture more than would be possible with a warm-up filter from the 81 series. This approach can pay dividends when photographing a sunrise or sunset that's rather muted – an 85, 85B or 85C will add an effective warm glow that looks completely natural. The same applies when shooting silhouettes against a sky at dawn or dusk, to add an overall warm colour cast to pictures taken in flat, dull weather, for pictures of sand dunes that are naturally warm anyway, or for backlit scenes, such as autumnal woodland, where you are exposing for the shadow areas to burn out the background and capture atmospheric, high-key images.

COLOUR TEMPERATURE SHIFT AND FILTER FACTORS

The colour temperature shifts for the orange 85 series are as follows:

Filter	Colour temperature shift (°K)	Exposure increase
85	−2,100	+⅔ stops
85B	−2,300	+⅔ stops
85C	−1,700	+⅓ stop

▲ **STONEHENGE**
Photographer Simon Stafford chose an 80 series here, not to balance a colour cast, but to add its own to this evocative dusk shot. The resulting coolness enhances the mystery of the famous stone circle far better than natural daylight could have.

NIKON F4, 35MM LENS, 80A FILTER, TRIPOD; KODACHROME 64; 4 SEC. AT F/8

◄ The 80-series colour conversion filters are much stronger than the 82 series shown on page 63. Of the set, the 80A is the most useful for dealing with domestic tungsten lighting.

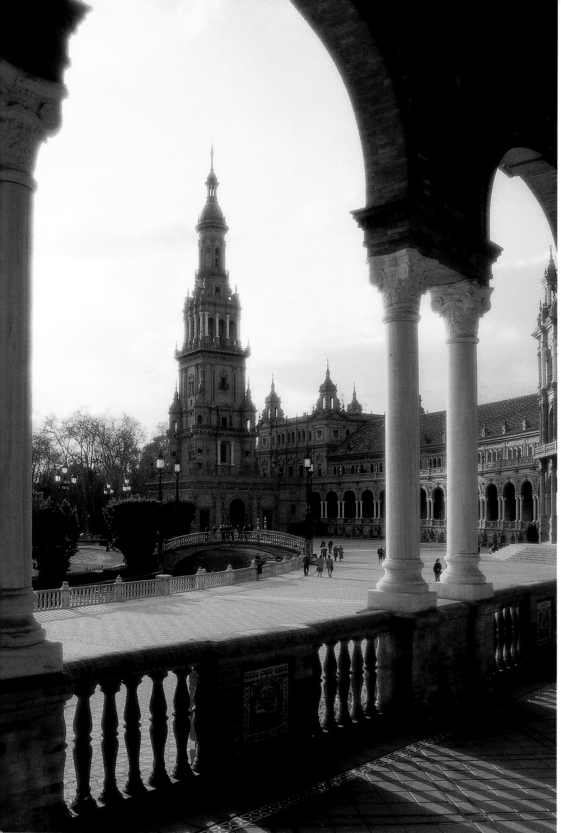

◄ **Plaza de España, Seville, Spain**
This photograph of the Plaza de España was taken on a bright but overcast day, so the natural colour balance of the scene was rather grey and dull. To change that, and produce a more evocative image, I used an orange 85 filter.

Olympus OM4-Ti, 28mm lens, orange 85 and Cokin diffuser 1 filters, tripod; Fujichrome Velvia, 1/30 sec. at f/16

Finally, try combining an orange 85-series filter with a soft-focus filter and fast, grainy film for dreamy, impressionistic effects. This can work beautifully on all manner of subjects, from portraits, still-lifes and nude studies to flowers, architecture and landscapes.

◄ Unless you want to expose tungsten-balanced film in daylight or correct seriously cool colour casts, the orange 85 filters are mainly used to warm up pictures.

COLOUR-COMPENSATING (CC) FILTERS

The main purpose of colour-compensating (CC) filters is to correct colour deficiencies in the light other than (or including) the red and blue casts caused by variations in the colour temperature of the light. The red and blue casts are generally balanced using colour-correction or colour-conversion filters.

These other colour casts – green, yellow, magenta, and so on – can result from a variety of causes, including artificial light sources, such as fluorescent or mercury vapour, light reflecting off coloured surfaces so it takes on a colour cast, and climatic variations in daylight. Extended exposures for night and low-light photographs result in reciprocity failure (see panel), which causes unusual colour casts with some films that you may or may not wish to correct.

Colour-compensating filters work by allowing you to block out one or more of the colours in the light that you don't want to record before it reaches the film. In order to do this accurately you need to be very specific in your choice of filter, so there are six colours of CC filter available – yellow, magenta, cyan, red, green and blue – and each colour comes in different densities. Kodak Wratten CC filters are perhaps the best known, but CC filters are also available from other manufacturers

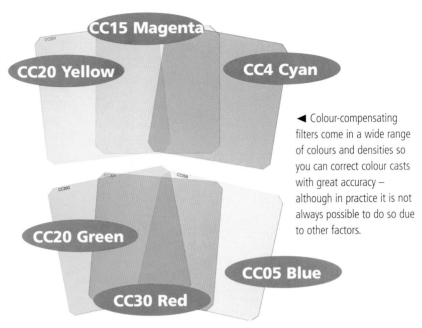

CC15 Magenta

CC20 Yellow

CC4 Cyan

CC20 Green

CC30 Red

CC05 Blue

◀ Colour-compensating filters come in a wide range of colours and densities so you can correct colour casts with great accuracy – although in practice it is not always possible to do so due to other factors.

of professional filter systems, either as flimsy polyester gels or more durable resin filters.

How they work

Each filter works by allowing its own colour to pass through while blocking out other colours according to the subtractive process.

Red, blue and green are known as the addititve primaries. A blue filter will allow blue to pass

◀ COMPUTER ROOM
Architectural photographers often use colour-compensating filters – especially when shooting interiors that are illuminated by artificial lighting. Usually a reading is taken with a colour temperature meter to determine what the colour imbalances in the light are, and which filters will cancel them out to produce natural-looking photographs. In this case, Tim Soar used a combination of filters.

SINAR 5 x 4IN LARGE-FORMAT CAMERA, 65MM LENS, CC15 MAGENTA, CC10 GREEN AND CC5 RED FILTERS, TRIPOD; FUJICHROME VELVIA; SEVERAL SEC. AT F/22

FLUORESCENT LIGHTING

If you take pictures in fluorescent lighting they will come out with a green colour cast on daylight film. This is because the lamps have a discontinuous spectrum, caused by the fluorescers in the tubes glowing at different wavelengths. To get rid of the green cast you have three options. The simplest is to buy a CC30 magenta gel, which will partly, but not totally, balance any type of fluorescent lighting to give a more natural result. Instead, you could buy a proprietary correction filter – an FL-D for use with daylight-balanced film, or an FL-B for use with tungsten-balanced film.

If you want to correct the cast fully you must find out which type of tube is in use, then choose the right filter/s. Some professional filter manufacturers produce a range of filters specifically for different types of fluorescent lamp, but an easier option is to use CC filters according to the data below.

No filter

With FL-D filter

◄ **STOCK EXCHANGE**
This pair of pictures shows the effect of using an FL-D filter to balance the green cast caused by fluorescent lighting.

Type of fluorescent lamp	Daylight-balanced film Filter/s	Tungsten-balanced film Filter/s
Daylight	40M+40Y (+1)	85B+40M+40Y (+1⅔)
White	20C+30M (+1)	60M+50Y (+1⅔)
Warm white	40C+40M (+1½)	50M+40Y (+1)
Warm white de luxe	60C+30M (+2)	10M+10Y (+⅔)
Cool white	30M (+⅔)	60R (+1⅓)
Cool white de luxe	20C+10M (+⅔)	20M+40Y (+⅔)

R = red; Y = yellow; M = magenta; B = blue
The figures in brackets represent the exposure increase in stops.

RECIPROCITY LAW FAILURE

◄► TRAFALGAR SQUARE
Reciprocity failure is common when photographing night scenes, and some photographers use a colour-compensating filter to counteract its effects. Fujichrome Velvia has a tendency to take on a greenish cast when subjected to long exposures, for example, so for Derek Croucher's shot (right) he used a CC15 magenta gel to balance the green. It has also added a warm, pinky cast to the building, which itself is most attractive.

LINHOF TECHNIKARDAN WITH 6 X 9CM ROLLFILM BACK AND 90MM LENS, TRIPOD; FUJICHROME VELVIA; 30 SEC. AT F/16

If you expose film for more than one second, the reciprocal relationship between aperture and shutter speed that ensures that sufficient light reaches the film to give the correct exposure breaks down. The main outcome of this is that the film becomes less sensitive to light, so you may need to increase the exposure over and above what your lightmeter says is correct to avoid under-exposure.

The precise amount of exposure increase required varies from film to film, although film manufacturers publish this information, so if you tend to use long exposures on a regular basis you can correct it quite easily (see below for the reciprocity characteristics of popular colour transparency films).

Another side effect of reciprocity failure is that some films suffer from colour casts. These casts can be corrected with CC filters, as detailed below. More often than not, however, it isn't really necessary, as the strange colour casts that you get, especially when photographing urban scenes at night, can actually make the results more interesting.

Where 'NR' is entered below, this means the manufacturer does not recommend exposing that particular film for so long. If you do, a problem known as crossed-characteristic curves may arise, where the highlight and shadows take on strange colour casts. But there's no guarantee that this will happen, or that it will spoil your picture, so don't be afraid to ignore this recommendation.

Below are the recommended exposure increases in stops and filtration (in brackets) for a variety of popular colour transparency films. Reciprocity information is available for all films, so if your favourite isn't on the list, contact the manufacturer.

	Metered exposure (seconds)		
	1	10	100
Film type			
Kodachrome 64+	1 (CC10R)	NR	NR
Kodak Elite Chrome 100/200/400	None	None	+⅓ (CC75Y)
Kodak Ektachrome E100S/E100SW	None	None	+⅓ (75Y)
Fujichrome Velvia	None	+⅔ (CC10M)	NR
Fujichrome Sensia II 100	None	None	+1 (CC25R)
Fujichrome Provia 100F	None	None	+1 (CC25R)
Fujichrome Astia	None	None	+½
Agfachrome RSXII 100	None	+½ (CC5B)	+1 (CC10B)

R = red; Y = yellow; M = magenta, B = blue

through but will block out green and red, while a red filter allows red through but blocks out green and blue, and a green filter admits green but blocks red and blue.

The subtractive primaries (magenta, cyan and yellow) are made up of two different colours so their effect is rather different in that they admit more than one colour but block only one. Magenta is a mixture of red and blue, for example, cyan a mixture of blue and green, and yellow a mixture of red and green. If you place a magenta filter on your lens it will admit red, blue and magenta, but block out green. A cyan filter will admit blue, green and cyan, but block out red. A yellow filter will admit red, green and yellow, but block out blue. So, if you are taking pictures in fluorescent lighting, which gives a green colour cast on daylight-balanced film, you need a magenta filter to block that green out.

In practice, the use of CC filters among enthusiast photographers is limited as the precision they give is generally unnecessary – with the notable exception of fluorescent lighting (see panel). Instead, they tend to be favoured by professional commercial and industrial photographers who need precise colour balance when shooting subjects such as interiors, industrial scenes, products in available lighting and so on.

Using a colour temperature meter

To get the best from CC filters, which can be used either individually or in combination, you really need a colour temperature meter. This provides the most precise means of analysing temperature variations so you know exactly which filter, or combination of filters, is required to produce perfectly balanced results.

Colour meters are used mainly indoors for interior photography, food shots and so on that are taken mainly or completely in available light. One of the problems of working indoors is that the lighting tends to be mixed, with daylight coming in through windows and one or more artificial sources providing much of the overall illumination. Because your eyes will adapt to this mixture very easily, being able to assess it visually is difficult and a colour temperature meter is able to measure what you can't see.

It does this by measuring levels of blue, green and red light separately using three filtered photocells. The cells are covered by a diffuser, which integrates the light reaching them, and the measurements are analysed by the meter to calculate both the colour temperature and the filters required so as to balance any deficiencies in order to give natural results on the type of film that is being used.

To take a reading, the meter is used in much the same way as a handheld meter when taking an incident reading of light falling onto a subject or scene. Once a reading has been taken, two scales of correction are offered. One relates to standard colour-balancing filters (81-, 82-, 85- and 80-series warm/cool). The other relates to magenta-green for colour-compensation filters to balance other colour deficiencies in the light caused by certain light sources, light reflecting from coloured surfaces and so on.

Obviously, if you invest in a colour temperature meter, you will also need a full set of colour-correction, colour-conversion and colour-compensating filters so you can respond to whatever the meter says.

EXPOSURE INCREASES FOR COLOUR-COMPENSATING FILTERS

You can use these filters either individually or in combination to achieve higher densities of one colour (CC50M+CC5M = CC55M) or to benefit from the effects of more than one colour.

Filter density	CC25	CC5	CC10	CC15	CC20	CC30	CC40	CC50
				Exposure increase (in stops)				
Filter colour								
Yellow	nil	nil	⅓	⅓	⅓	⅓	⅓	⅔
Magenta	nil	⅓	⅓	⅓	⅓	⅔	⅔	⅔
Cyan	nil	⅓	⅓	⅓	⅓	⅔	⅔	1⅓
Red	nil	⅓	⅓	⅓	⅓	⅔	⅔	1
Green	nil	⅓	⅓	⅓	⅓	⅔	⅔	1
Blue	nil	⅓	⅓	⅓	⅔	⅔	1	1⅓

Mixed lighting

In situations where you have to deal with two or more light sources, each requiring different filtration, a decision needs to be made between ignoring them all and accepting whatever colour casts you get, or filtering the predominant source and hoping that by doing so you won't do more harm than good.

Urban scenes at night give you plenty of leeway because colour casts of any kind won't necessarily look odd, and often improve on reality by allowing film to record some rather bizarre colours. You can also experiment with filters to create different effects. For example, if you photograph a building that has been spotlit by tungsten, or has tungsten lights illuminating the rooms inside, by using a

▲ **LA MAMOUNIA HOTEL, MARRAKECH**
Many interiors are lit by daylight and one or more artificial sources, so correcting colour casts can be tricky. For this shot of a reception hall, daylight was the dominant source so I decided against using any filters and accepted that some areas would come out warm due to tungsten lighting overhead.

NIKON F90x, 18–35MM ZOOM AT 20MM, TRIPOD; FUJICHROME SENSIA II 100; 2 SEC. AT F/11

HOW DIFFERENT FILTERS AFFECT COLOUR CASTS

To give you an idea of what colour cast you get on daylight film from other light sources when you filter to correct one light source, refer to this chart.

Light source	Daylight	Tungsten	Fluorescent	Sodium vapour	Mercury vapour
Filter					
No filters	Normal	Orange	Green	Yellow	Blue/green
Blue 80A	Blue	Normal	Blue/green	Yellow	Blue
CC30 Magenta	Magenta	Orange/red	Normal	Yellow	Pale amber
CC80 Red	Red	Orange/red	Yellow/green	Yellow	Normal

blue 80A filter to cool down the orange cast of the tungsten you will add a strong blue cast to any areas lit by daylight. Similarly, where fluorescent lighting is used to illuminate a bridge or monument, you could use a CC30 magenta gel or FL-D filter (purpose-made filter for correcting flourescent lighting on daylight-balanced film) to balance the green cast, knowing that everything else will be affected by the magenta of the filter. The results can be striking.

Indoors things aren't quite so easy, especially if you want to get as close to natural as you can, because the counter-effects of different filters won't necessarily help (see panel on p. 73). As you can see, whatever you do it's going to be a compromise because, by filtering out one cast you change others, and sometimes make them worse, although if you filter for the main source and other sources aren't visible, you should be okay.

As mentioned earlier in this chapter, one option is always to shoot on colour negative film so you can at least ask the processing lab to play around with the filtration and see what they can come up with during printing. Failing that, digital technology can come to the rescue – in skilled hands, colour casts affecting only small areas could be balanced out.

▲ **Museum des Amis du Marrakech**
The colour cast in this picture was created not by artificial light sources, but by daylight being filtered by a canvas canopy stretched over the courtyard. Such abnormal casts can be corrected with the aid of a colour temperature meter, but I didn't have one so I had no way of knowing how to balance it.

Nikon F90x, 28mm lens, tripod; Fujichrome Velvia; 1 sec. at f/11

BALANCING DISCHARGE LIGHTING

If you are unlucky enough to need natural colour balance under discharge lighting, then you're going to have problems because this type of lighting is very difficult to filter. One option is to try and overwhelm the artificial source with your own – ideally electronic flash. This can work successfully if you are shooting a small area in close-up that can be lit, but for industrial plant, large interiors or urban views, it's an impossible task and you might as well accept defeat – plus any colour you happen to get. Alternatively, you could try the following CC filters – but don't expect miracles. If all else fails, shoot on colour negative film, then get the printer to filter out as much of the colour cast as possible during printing, or have your colour slides scanned and digitally balanced.

Type of lamp	Daylight-balanced film Filter/s	Tungsten-balanced film Filter/s
Clear mercury	CC80R (+1⅔)	CC90R+CC40Y (+1⅔)
De luxe white mercury	CC40M+CC20Y (+1)	CC70R+CC10Y (+1⅔)
High pressure sodium	CC80B+CC20C (+2½)	Not recommended
GE Luca	CC70B+CC50C (+3)	CC50M+CC20C (+1)
GE multi-vapour	CC30M+CC10Y (+1)	CC60R+CC20Y (+1⅔)

R = red; Y = yellow; M = magenta; B = blue
The figures in brackets represent the exposure increase in stops.

THE CASE FOR COLOUR CASTS

Whether you decide to use filters to correct a colour cast or not is very much a matter of personal preference. Cool casts tend to be less desirable than warm as they have negative connotations, as well as looking downright unnatural in many cases. If you took someone's portrait under shade beneath a blue sky, for example, the picture would take on a cool cast and your subject would look terrible, with unflattering skin tones. However, that same cool blue cast could work well on a landscape shot in stormy weather, enhancing the mystery and desolation of the scene.

Warm colour casts are more acceptable as their symbolic value is more positive – health, warmth, happiness and so on. Who in their right mind would want to try and cool down the colours of a sunrise or sunset, for example? The low colour temperature of the light may mean that pictures taken at this time of day are much warmer than the

scene really was, but that's likely to result in better photographs.

The same applies with tungsten lighting, or the warmer light from a candle flame. More often than not the orange colour cast is best avoided, but for certain still-life shots, portraits or nude studies the warm light can work wonders, adding atmosphere and enhancing skin tones to give them a healthy warm glow.

Even the sickly green colour cast you get from fluorescent lighting can help rather than hinder. Admittedly, a whole interior glowing green won't look particularly attractive, and if you're taking pictures for an architect to show off his or her latest creation, he or she would almost certainly want you to deal with it and produce a natural-looking image. But if fluorescent is one of two or more sources used to illuminate a building or urban scene, its contribution to the range of colours created by the artificial illumination may work well.

The key is not to get too wrapped up in

▲ NOAH

The strong orange cast in this picture of my son was created by the light of a single candle. Technically, it should be filtered with blue 80-series filters to reduce the intense warmth, but aesthetically I feel it works fine as it is and decided to do nothing.

NIKON F90X, 50MM LENS; FUJICHROME SENSIA 400 RATED AT ISO1600 AND PUSHED 2 STOPS; 1/15 SEC. AT F/1.8

◀ CASARES, SPAIN
When I photographed this night scene, my eyes had adapted and everything looked fairly normal, so I had no idea what type of lighting had been used to illuminate the narrow streets. When I examined the processed film on a lightbox I was therefore surprised to find a strong green colour cast caused by fluorescent lighting. Had I known this was the light source used at the time, I would probably have tried to balance it with an FL-D filter or CC30 magenta gel, but in retrospect I'm glad that I didn't because the clash of colours in the scene is what makes it work for me. For once, ignorance was bliss!

PENTAX 67, 105MM LENS, TRIPOD; FUJICHROME VELVIA; 45 SEC. AT F/16

making everything colour perfect. You may not always be able to correct a colour cast completely, but provided that you get within 100–200K, it's unlikely that the end result will look odd – and if you do try to correct fully, your effort may be counterproductive.

Any type of warm lighting will usually benefit if some of the warmth is retained. For example, if the warmth of tungsten light is relevant to the situation – such as an old market stall lit by bare bulbs – you should avoid filtering it out completely as by doing so you will take away much of the mood it has created. Sometimes, colour casts serve an important role in making a photograph as aesthetically pleasing as possible, and if you open your mind to the creative use of them your photography can only benefit.

CC FILTER CONVERSION

As well as using CC filters to correct colour imbalance, they can also be combined to give the same effect as colour correction and conversion filters. The table below lists some of the more useful conversions. CC filters cannot exactly duplicate the effects of other colour-balancing filters due to their spectral quality, but the conversions listed below are approximate equals.

Colour-correction filter	CC filter equivalent	Colour-conversion filter	CC filter equivalent
81A	CC7Y	80A	CC90C+CC30M
81B	CC10Y+2M	80B	CC90C+CC25M
81C	CC15Y+CC5M	80C	CC55C+CC17M
81D	CC25Y+CC7M	80D	CC35C+CC12M
81EF	CC30Y+CC10M	85C	CC35Y+CC10M
82A	CC15C+CC5M	85	CC50Y+CC17M
82B	CC20C+CC7M	85B	CC65Y+CC22M
82C	CC25C+CC7M		

NEUTRAL-DENSITY
FILTERS

CHANGING OF THE GUARD, BUCKINGHAM PALACE
For this panned photograph of the Changing of the Guard at Buckingham Palace in London I needed a slow shutter speed to produce plenty of blur and introduce a sense of motion. With my lens set to its smallest aperture – f/22 – the slowest speed I could manage in the bright sunlight was $\frac{1}{30}$ sec.: not slow enough for the effect I had in mind. By using a 0.6 ND filter, however, the light entering the lens was reduced by 2 stops and I was able to shoot at $\frac{1}{8}$ sec. to increase the amount of blur.

NIKON F5, 80–200MM ZOOM AT 200MM, 0.6 ND FILTER; FUJICHROME SENSIA II 100; $\frac{1}{8}$ SEC. AT F/22

Neutral-density (ND) filters are designed to reduce the amount of light passing through the lens so that a longer exposure is required to record an image on film. In order to achieve this without causing a colour cast they are designed to absorb all the colours in the visible spectrum in equal amounts, which is why they are grey in appearance. If you combine all the colours in the visible spectrum you get black – or grey, which is a shade of black.

The basic ND filter is coated evenly with the grey neutral density. There are two variations on this: the vignette filter, which has only its edges coated, and the centre-spot ND filter, which has the central area of the filter coated. These are both covered in this chapter. Also included here are ultra-violet and skylight filters, both of which produce clearer images.

USING ND FILTERS

Why would you want to reduce the amount of light hitting the film, when there's rarely enough in the first place? The answer to that question is that you wouldn't very often, but ND filters have two main uses that you may occasionally need to take advantage of.

The most common is so you can use a longer exposure to emphasize movement. For example, the most effective way to photograph waterfalls is by using an exposure of a second or more, so the moving water records as a graceful blur on film. If light levels are high, however, you may find that even with slow film (ISO50–100) and your lens set to its smallest aperture (f/16 or f/22 usually), the longest exposure you can use may be only ⅛ or ¼ sec. Although this is slow enough to record a reasonable effect, it isn't ideal. By using an ND filter, you can force an exposure increase and in doing so emphasize the effect of the moving water.

The same applies when trying to emphasize movement with other subjects. Using a slow shutter speed to capture crowds of commuters rushing to work in the morning, or shoppers walking down a busy high street, can produce striking images, but if light levels are high you won't be able to do that. Capturing the motion of waves pounding the coastline is another example, or using techniques such as panning at sporting events.

The second use for ND filters is to allow use of wider apertures to reduce depth of field. If you are using fast film (ISO400 or higher) outdoors, high light levels may limit you to an aperture of f/8 or f/11, even with your camera set to its fastest shutter speed. By using an ND filter you will be

forced to set a wider aperture in order to get enough light to the film.

A similar application applies when using mirror lenses, which have a fixed aperture – usually f/8. Imagine you are shooting sports or wildlife with a mirror lens in dull weather, so you load the camera with ISO400 film. Halfway through that roll the sky clears, the sun shines, and suddenly, even with your camera set to its fastest shutter speed, you're still getting over-exposure because you cannot set the lens to a smaller aperture. One option would be to switch to a slower film, but if that's not possible, the only solution is to use an ND filter to lose light so you need to use a slower shutter speed. Most mirror lenses come with a neutral-density filter for this very reason.

▲ Neutral-density filters are grey in appearance. The denser the filter, the darker the colour. This picture shows 0.6 and 1.2 ND filters, which reduce the light by 2 and 4 stops.

▲ WINDERMERE, LAKE DISTRICT, ENGLAND
If you are using a mirror lens to shoot into the light, you may find that the fixed aperture requires a shutter speed faster than your camera is capable of setting. By using a neutral-density filter you can reduce the brightness and bring the shutter speed down to within the available range.

NIKON F90X, 600MM F/8 MIRROR LENS, 0.6 ND FILTER; FUJICHROME SENSIA 400; 1/100 SEC. AT F/8

Which ND filters to buy?

As you are unlikely to use ND filters on a day-to-day basis, it seems pointless buying a full set, but one or two of the more moderate densities could make a valuable addition to your filter collection. Perhaps the most useful all-rounder is the 0.6 ND filter, which causes a 2-stop light loss. It would enable you to set a shutter speed 2 stops slower – 1 sec. instead of ¼ sec., say, or an aperture 2 stops wider. The 1.2 ND is also worth investing in for more extreme situations. Cutting the light by 4 stops, it would enable you to use a shutter speed of 1 sec. instead of ¹⁄₁₅ sec., which is a significant difference – especially when trying to emphasize movement in bright light. Equally, you could also use an aperture 4 stops wider.

ND filters that lose less than 2 stops of light, or more than four, are less useful. The darker NDs would only be necessary when photographing something like a solar eclipse, to prevent eye damage when you look directly at the sun through a long telephoto lens.

If you buy two ND filters, remember that you can also use them together to achieve even greater light loss. Combining a 1.2ND with a 0.6ND would give you a total density of 1.8, and a whopping 6-stop light loss.

Another option is to use your polarizing filter as an ND filter since it loses 2 stops. This isn't ideal as not all polarizers are neutral (some are a little cool) but, if you don't have a genuine ND filter, at least it could help you overcome a problem.

Achieving correct exposure with ND filters is very straightforward. One option is to take a meter reading with a handheld meter, then apply the exposure increase required by the density of ND filter you are using. The other is to fit the ND filter to your lens, then meter through it using your

▲ **East Gill Force, Northumberland, England**
The most popular use for ND filters is probably when photographing waterfalls, so a longer exposure can be set to enhance the blurred effect of the moving water.

Nikon F90x, 80–200mm zoom at 200mm, 0.6 ND filter; Fujichrome Velvia; 8 sec. at f/16

FILTER FACTORS AND EXPOSURE INCREASES

As with ND graduate filters, traditional ND filters are available in different densities, stated logarithmically, which reduce the light by a specific and accurate amount, as shown below.

ND filter density	Filter factor	Exposure increase (light loss) in stops
0.1	x1.25	⅓
0.2	x1.5	⅔
0.3	x2	1
0.6	x4	2
0.9	x8	3
1.2	x16	4
3.0	x1,000	10
4.0	x10,000	13⅓

camera's TTL metering system. The exposure increase will be compensated for automatically as the filter reduces the light before it reaches the metering sensors inside the camera.

Vignette filters

A variation on the basic neutral-density filter is the vignetter. This is essentially a clear filter with the edges coated in neutral density, leaving a clear oval, circular or square shape in the middle. The idea of vignetters is to darken the edges of an image so that attention is drawn towards the main subject, positioned in the clear central area. They're mainly used for portraiture and wedding photography, and the effect produced can look highly effective – especially when combined with soft-focus filters to add a romantic feel to the image.

For the best results, set your lens to a wide aperture, such as f/5.6 or f/4, and use a short telephoto lens. This will ensure that the neutral density part of the filter merges gently with the

clear area, rather like a soft ND grad, so you don't see the 'join' in the final picture. Smaller apertures, such as f/11 and f/16, increase the risk of this because they significantly increase depth of field. To check the effect, use your camera's depth-of-field preview to view the image at the aperture you intend using.

Centre-spot ND filters

These are effectively the opposite of vignetters – instead of having the edges coated in neutral density, a circular area in the centre of the filter is coated instead, and the neutral density gradually fades out to nothing.

Centre-spot ND filters are required mainly for panoramic cameras and when using certain ultra wide-angle lenses on large-format cameras. The reason in both cases is that the field of view of the lens is almost as wide as its image circle, so you get a fall-off in illumination towards the frame edges, and the corners of the picture come out darker than the centre.

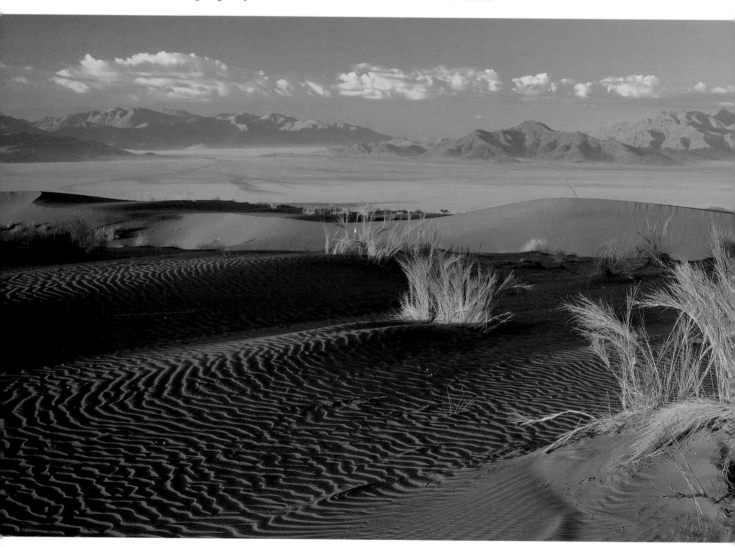

Once that difference exceeds 1 stop, it's noticeable enough to need resolving so a centre-spot ND filter is used to reduce the amount of light reaching the central area of the image. In doing so it balances out the difference so illumination is even across the whole image area. Most of these filters cause a light loss of between 1 and 2 stops.

The type of centre-spot ND filter you need will be governed by the camera and lens in use. Usually the manufacturer produces a specific filter for each lens, so, with the Fuji GX617 panoramic camera, for example, a specific centre-spot ND filter is required for the 90mm lens, and a slightly different one for the 105mm lens. The same applies with other specialist cameras, such as the Horseman 612, the Linhof 612 and 617 models and the Hasselblad XPan.

Centre-spot NDs are required only with wide and ultra-wide lenses because longer focal lengths use only the central part of the lens's image circle so there's no fall-off. The 180mm and 300mm lenses for the Fuji GX617 don't require an ND filter, for example. Neither does the 90mm lens for the Hasselblad XPan, although the 45mm and 30mm lenses do.

If you use a camera system that requires centre-spot ND filters for some lenses but not others, this can get a little confusing and it's easy to make exposure errors. If you're taking pictures with a 90mm lens on a Fuji GX617, for example, it will have a centre-spot ND filter fitted and you must increase the exposure by 1 stop to compensate for it. If you then switch to the 180mm or 300mm lens, which doesn't need a centre-spot ND filter, you must remember not to increase the exposure, otherwise the pictures will be over-exposed.

The best policy when using a lens that requires a centre-spot ND is to leave it screwed into place permanently. Other filters or filter holders can then be attached to the front of it as normal.

▼ **NAMIB RAND, NAMIBIA**
If you use a panoramic camera with a wide-angle lens, a centre-spot ND filter will be required. The type and density depends on the lens. For the 90mm lens I used here on my Fuji GX617, a purpose-made Fuji filter is required. This reduces the light reaching the centre of the image by 1 stop so the whole image requires the same exposure.

FUJI GX617 WITH 90MM LENS AND 0.3 ND CENTRE-SPOT FILTER; FUJICHROME VELVIA; 1 SEC. AT F/22

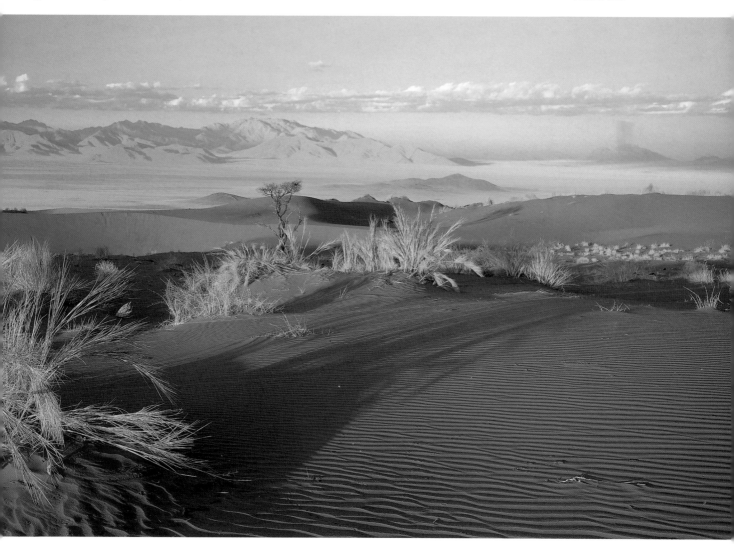

SKYLIGHT AND UV FILTERS

Dust, heat, water droplets and pollution create particles in the atmosphere that scatter light wavelengths passing through them, especially at the blue end of the spectrum. The result is haze, which reduces visibility, clarity, colour saturation and detail, and adds a bluish cast to photographs.

Sometimes haze can work to your advantage, producing aerial perspective where colour and tone diminishes with distance to give a sense of depth. More often than not, however, it's an undesirable element that you should try to eliminate from your pictures, especially when shooting with a telephoto lens, which accentuates the effects of haze.

The easiest way to do this is by using an ultra-violet (UV) or skylight filter. Both do a similar job in that they filter out ultra-violet light, which causes the cool cast in hazy conditions, and penetrate haze to produce crisper, clearer images. A skylight filter has a pale pink colouring so it will also add a slight warmth to the image.

Either a skylight or a UV filter should also be used if you are taking pictures at high altitude – especially in mountainous regions. This is not so much because of haze – visibility may be crystal clear – but because there's a greater concentration of ultra-violet light wavelengths at high altitude, so your pictures are likely to come out with an unattractive blue cast.

More commonly, however, both skylight and UV filters are used as lens protection. Being clear (or almost, in the case of the skylight) and inexpensive, they're ideal for leaving permanently screwed to your lenses so the front element is protected from dust, dirt, moisture, fingermarks and scratches – all of which could reduce its optical quality. The thinking is that it's much safer to clean a filter on a regular basis than the delicate multi-coated front element of a lens, and also much cheaper to replace a damaged filter than a whole lens.

If you do use either of these filters to protect your lenses, remember that the depth of the mount will project any additional filters, or filter holders, further out in front of the lens than if you fitted them direct to the lens itself. With wide-angle lenses this increases the risk of vignetting. Consider, also, that with one filter already in place, you're not helping image quality by then fitting a further one or two to the front of it.

The simple solution is to remove any protective filter if you intend using other filters, to minimize the total number of filters used, and to reduce the risk of vignetting with wide-angle lenses. If you are not willing to do this, make sure you buy the highest quality skylight or UV filters, with the slimmest mount possible. Hoya SHMC Pro-1 Slimline Sky and UV filters are some of the best around in that respect, with a mount just 3mm deep.

◀ **ZAHARA DE LA SIERRA, ANDALUCIA, SPAIN**
A UV filter is ideal for cutting through haze to improve image clarity – especially when using a telephoto lens to photograph distant subjects.

NIKON F90X, 80–200MM ZOOM, UV FILTER; FUJICHROME VELVIA; 1/60 SEC. AT F/22

FILTERS
FOR BLACK-
AND-WHITE
PHOTOGRAPHY

6

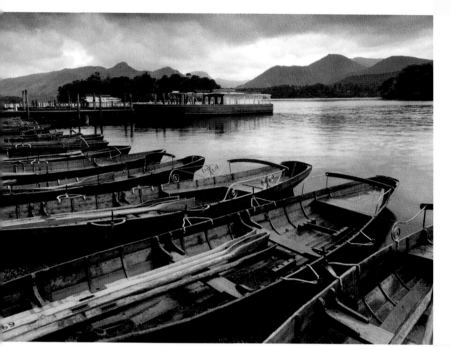

DERWENTWATER, LAKE DISTRICT, ENGLAND
Once you understand how coloured filters affect the tonal balance and contrast of a black and white photograph, you can use them to your advantage. For this dramatic view I used an orange filter to boost contrast and emphasize detail in the sky.

PENTAX 67, 55MM LENS, ORANGE FILTER, TRIPOD; ILFORD FP4+; 1 SEC. AT F/16

Coloured filters of any type work by allowing certain wavelengths of light through while blocking out others. This is what gives the filter its colour. In black-and-white photography, coloured filters affect the way different colours translate to grey tones, either lightening or darkening them. This allows you to manipulate the tonal balance of a photograph as you take it. As a consequence, contrast is also affected due to the way some colours are darkened and others lightened, and this can make a profound difference to the mood and impact of a photograph.

There are six main coloured filters used for black-and-white photography – yellow, yellow/green, green, orange, red and blue. Each filter's principal role is to lighten its own colour and darken its complementary colour. Depending on the filter you use, the effect this has on a photograph can be subtle or significant. However, you don't have to limit your filter choice to this small selection of coloured filters; others, such as polarizers, neutral-density graduates and soft-focus filters can be used with equal success.

COLOUR COMPARISONS

You can see from the sets of comparison pictures included here how coloured filters change the tonal relationship in a black-and-white photograph by lightening and darkening certain colours. In the still-life photographs of fruits and vegetables, the way colours are affected by each filter can be seen very clearly, although changes in contrast aren't so obvious. Conversely, with the scenic photograph, the changes to individual colours are less clear, but the way contrast is affected, especially in the sky, cannot be disputed.

On a day-to-day basis the scenic comparisons provide better evidence of what you can expect, since coloured filters are mainly used in black-and-white-photography when shooting landscapes or architecture. In fact, they are often referred to as 'sky' filters, because photographers tend to use them for the effects they have on the sky more than for other parts of the scene (with the possible exception of the blue filter, which has a negative effect on the sky, and, to a lesser extent, the green filter).

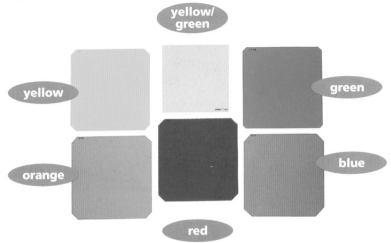

▲ The different filter colours used in black and white photography are shown here – yellow, yellow/green, green, orange, red and blue.

COLOUR AND BLACK-AND-WHITE COMPARISON

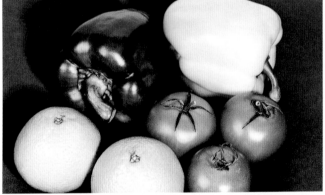

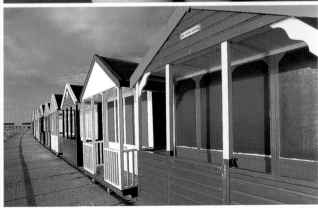

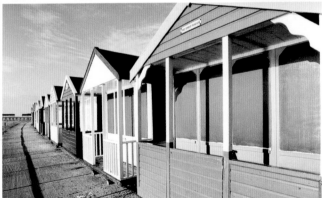

▲ IN COLOUR
This is how both the landscape scene and the still life appear to the naked eye when viewed in full colour. Including a colour version allows you to cross-reference it with the different black-and-white versions (opposite) to establish exactly what effect the different filters have.

▲ NO FILTERS
A straight black-and-white photograph of the original landscape and still life shows how the colours in them translate to grey tones. If you look carefully you can see how some colours – such as red and green – come out as similar grey tones. This is one of the reasons why filters are used – to change that relationship.

COLUUR FILTER COMPARISON ON BLACK-AND-WHITE FILM

▲ YELLOW FILTER

This produces the least dramatic effect, so it's handy as a general-use filter on scenes where contrast is already quite high. It will darken blue sky a little to emphasize white clouds and reduce the effects of haze, and can be handy for outdoor portraits against the sky. In the still life you can see how the yellow pepper is a lighter tone than on the unfiltered photograph, while the blue background is a little darker.

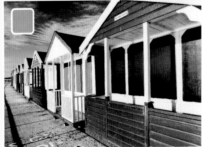

▲ YELLOW/GREEN FILTER

This filter has a similar effect on the sky to a yellow filter, but it also lightens the green tones in a scene, so the contrast between the sky and ground is increased a little. You can see in the still life that the yellow and green peppers are lighter, while the red tomatoes are a little darker. This is a useful alternative to yellow for general use.

▲ GREEN FILTER

The principal effect of a green filter is to darken reds and lighten greens. Outdoors this effect works well if there are important elements in the scene in these two colours, such as a red sports car photographed in a green landscape – without the filter there would be little contrast between the two. A green filter is also handy as a general-use landscape filter, although it doesn't affect the sky.

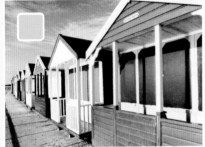

▲ RED FILTER

This is the most dramatic filter of all for black-and-white photography. In the still life the red tomatoes have been lightened while the green pepper and blue background are darker. But on the landscape the blue of the sky is almost black, white clouds stand out starkly, greens and shadow areas have been darkened and the overall effect is very dark and brooding. Water also comes out black.

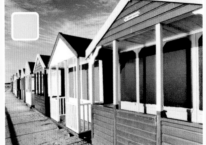

▲ ORANGE FILTER

If you want a bolder effect, particularly in the sky, this is the filter to choose. Blue sky is deepened, so white clouds stand out – along with other light-toned features that are against the sky. Greens are also darkened a little, along with shadows, so there's a general increase in contrast, which produces bold images.

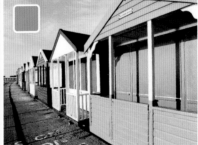

▲ BLUE FILTER

A less common choice for black-and white-photography, this filter is used to lighten greens and darken reds. In the still life this has a noticeable effect on the background and the tonal relationship of the fruits and vegetables. For landscapes it's less useful as it emphasizes haze and lightens blue sky. It can be used for portraits, however, as it strengthens skin tones and brings out detail in the face.

WORKING WITH COLOUR FILTERS

Once you are familiar with the way different coloured filters work in black and white photography, you can use them to help you produce photographs that express your own creative vision – this is a bigger part of black-and-white photography than it is colour, simply because you are taking a step back from reality by removing colour from a scene.

Most keen black-and-white photographers equip themselves with a set of three or four filters so they can pick and choose as necessary. Yellow, orange and red are the most common for general use as they have more or less the same effect, but on a rising scale, with yellow being the most subtle, red the strongest, and orange falling somewhere between the two.

When you use these filters, and which filter you choose in any given situation, is down to personal preference. Landscape photographers often use an orange filter to make the sky more dramatic when shooting in dull or stormy weather, but because it darkens greens and blues as well, it also gives an

increase in contrast, which helps to overcome the flatness of the light in such weather conditions.

In sunny conditions, when contrast is naturally higher anyway, a yellow filter may be enough to give your picture that extra little push. If you want a more extreme effect, an orange or red filter could be just what the doctor ordered, but with a red filter especially, you need to take care. As well as making skies more dramatic, a red filter also darkens greens significantly, makes water almost black if it's reflecting blue sky, and deepens shadows since they tend to be lit mainly by blue sky light. This can result in a very dark landscape – fine if you want it, but frustrating to try and print up if you don't.

One way around this is to include something bold in the foreground that won't be darkened by the red filter, but will instead be enhanced if the green areas around it are darkened. A bank of red flowers, such as poppies, or anything else that's red in colour, would be ideal as it would be lightened by the red filter.

Initially you may find this decision-making

LEARNING TO SEE IN BLACK AND WHITE

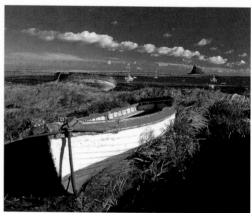

The biggest hurdle you have to overcome when shooting in black and white is understanding how a colour scene will translate to black, white and the numerous grey tones in between. A good way to learn initially is by photographing the same scenes or subjects in both black and white and colour so you can compare the two images and note how certain colours record as grey tones.

Ideally, set up a shot or look for a scene that contains a wide range of different colours – reds, yellows, oranges, greens and blues. What you find when you do this will prove invaluable in the future. It will help you to visualize whether a scene will work well in black and white, and what you may need to do at both the taking stage and the printing stage to ensure that a successful image is produced. For example, if you photograph red and green objects in close proximity, in colour their relative colour difference creates a contrast that makes each item stand out clearly. In black and white, however, red and green record as similar grey tones, so that contrast is reduced and the impact of the photograph with it.

When shooting landscapes, you need to consider the way the sky will record when you expose for the ground, and how the many different shades of green in the scene will translate. With still-life shots, you need to pre-visualize how the different objects will relate to each other when they are converted to grey tones.

▲ **LINDISFARNE**
These pictures compare how a typical scene would look to the naked eye, and how it translates into black and white. Note how the relationship between different colours changes when those colours are recorded as grey tones. Filters can help you alter and control that relationship.

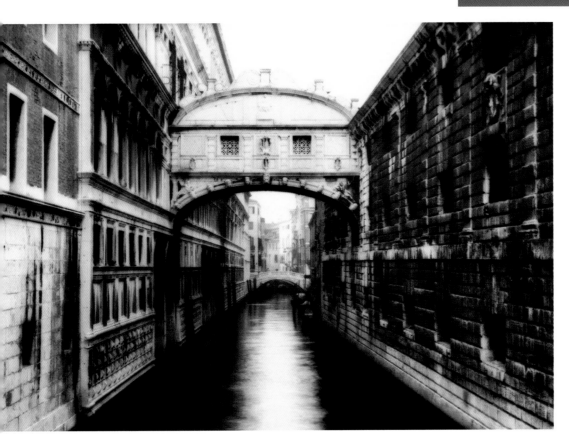

◀ **BRIDGE OF SIGHS, VENICE**
I used a yellow filter here.
Doing so lightened the pale
colour of the bridge and the
lighter parts of the walls either
side so they contrasted more
with the water and the darker
areas of the scene. The image
was also printed through a
soft-focus filter (see pp.
99–100) to enhance the mood.

NIKON F90X, 50MM LENS, YELLOW
FILTER; ILFORD HP5 PLUS;
1/60 SEC. AT F/11

process confusing; if in doubt, take a picture with
the filter you think will give the best result, then
another with a weaker one as a safer bet. It's also
worth taking a shot with no filters, so that when you
print up the negatives you can compare the
unfiltered and filtered versions.

Equally, you shouldn't feel under pressure to
use any filters when taking pictures in black and
white. At least 75 per cent of the black-and-white
pictures I take are unfiltered, and if I want to
change the feel and balance of the image I tend
to do so at the printing stage by using different
contrast grades or by dodging or burning in parts
of the image.

HIGH ALTITUDES

If you are shooting at high altitudes where
the atmosphere is much cleaner and the light
crisper, you need to take care when using
contrast-controlling filters. Even a yellow
filter, which gives a subtle effect normally, will
darken blue sky considerably, while orange
and certainly red will reduce it to black.

In some situations this effect may work
well, but a black sky generally looks
unnatural, so choose wisely. A plain UV filter
may be all you need to darken the sky a little.

▼ **RANNOCH MOOR,
HIGHLANDS, SCOTLAND**
To emphasize the bad
weather I used an orange
filter. As well as making the
sky more dramatic, it also
darkened the moorland
grasses and heathers, giving
prominence to the rock in the
foreground. I emphasized this
by dodging the rock for a few
seconds during printing, and
burning in the sky. The
colouring on the print was
created by partial sepia
toning, followed by several
minutes in gold toner.

HASSELBLAD XPAN, 45MM LENS,
HOYA ORANGE FILTER, TRIPOD;
ILFORD DELTA 400; 1/15 SEC. AT F/22

◄ **TORQUAY, DEVON, ENGLAND**

A red filter must be used with care as its effect is so strong, but marry it with the right type of subject or scene and the results can be stunning. In this case it emphasized the stormy sky to add a strong sense of foreboding, a feeling emphasized by the figures on the beach, who are completely dwarfed by the enormity of the scene.

OLYMPUS OM2N, 28MM LENS; ILFORD HP5; 1/250 SEC. AT F/8

USING OTHER FILTERS

As well as the coloured filters outlined earlier in this chapter, there are others worth considering for black-and-white photography. The most useful is a polarizer. Although intended primarily for colour photography, most of its effects work just as well in black and white.

Blue sky will be deepened so it records as a darker grey tone, while white clouds will be emphasized – in the same way as they would if you used an orange or red filter. A polarizer will also reduce or eliminate reflections, which may be desirable when shooting landscapes or architecture, as well as removing glare. This latter effect is more significant when working in colour, because it results in deeper colour saturation, but in black and white it produces crisper images with improved clarity, so it's well worth considering.

If you want to create a very bold effect you could also consider combining a polarizer with a deep red filter. This will produce very dark, dramatic images with black sky and water, stark white clouds and dark landscapes. On cloudless days you can produce almost a night-time effect. This approach wouldn't work on every scene, but it's definitely worth trying from time to time.

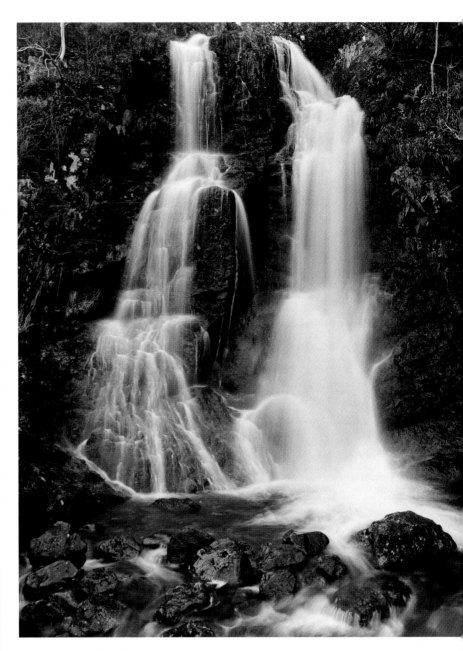

FILTER FACTORS

If your camera has TTL metering, as all 35mm SLRs do, you can meter with the filter of your choice in place and any light loss will be taken into account automatically. If you meter without the filter in place, or use a handheld meter to determine correct exposure, the following factors should be applied:

Filter colour	Filter factor	Exposure increase
Yellow	x2	1 stop
Yellow/green	x4	2 stops
Green	x6	2½ stops
Orange	x4	2 stops
Red	x8	3 stops
Blue	x4	2 stops

Graduated filters

In situations where the difference in brightness between the sky and landscape is great, the consequences will be the same in black and white as they are in colour – expose for the landscape, and the sky burns out.

The traditional way to deal with this when working in black and white is to burn in the sky at the printing stage by giving it more exposure. However, you can reduce the amount of burning in required, or perhaps even eliminate it altogether, by using graduated filters to tone down the sky at the taking stage.

There are numerous options available here. In

▲ **LAKELAND WATERFALL**
This waterfall didn't require a coloured filter to alter the tonal balance or to increase contrast, but I did use a filter when I was photographing it – a polarizer, which forced a 2-stop exposure increase and so allowed me to increase the level of blur in the moving water.

PENTAX 67, 55MM LENS, POLARIZING FILTER; ILFORD FP4+; 6 SEC. AT F/16

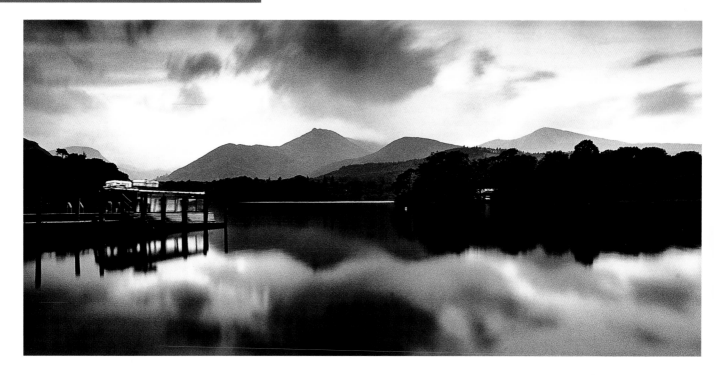

colour you would use neutral-density graduates to reduce sky brightness without changing its colour. In black and white, of course, you don't have to worry about that so you can be a little more ambitious. Instead of using straight ND grads, for example, you could use a yellow, orange or red graduate filter, which will not only tone down the brightness, but also have the same effect on the sky as a solid yellow, orange or red filter would.

The benefit of using coloured grads instead of solid coloured filters is that they affect only the sky, leaving the landscape itself unchanged. So,

for example, you can emphasize the sky using an orange grad filter without affecting the tonal balance of the foreground.

Some photographers take this a step further and have filters specially made with the top half in one colour and the bottom half in another. For example, a red/green combination would give you a dramatic sky, while the green part would lighten green tones in a landscape scene. If you used a solid red filter it would do the opposite and darken the landscape, while a solid green wouldn't make much of the sky. Combining the two effects gives you the best of both worlds.

▲ **Derwentwater, Lake District, England**
Don't feel you have got to use filters when shooting in black and white. More often than not I don't bother, and if I need to alter the contrast and tonal balance of a scene I do so at the printing stage – as here, when I increased the contrast grade to IV to produce a more dramatic image.

Hasselblan Xpan, 45mm lens, tripod; Agfapan APX 25; 2 sec. at f/16

◄ **Loch Linnhe, Scotland**
For the ultimate in drama, combine red and polarizing filters. For this loch scene the two filters together transformed the sky and increased contrast to a level where the hills recorded in silhouette and the range of tones between black and white have been dramatically reduced to produce a very stark, graphic image.

Hasselblad XPan, 45mm lens, Cokin red and polarizing filters, tripod; Ilford HP5+; ½₅₀ sec. at f/16

SOFT-FOCUS
FILTERS

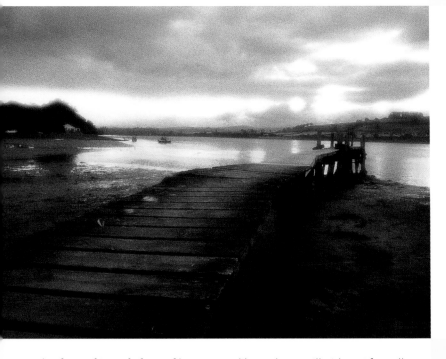

TEIGN ESTUARY, DEVON, ENGLAND
The gentle glow introduced by a soft focus is ideal for adding atmosphere to a photograph, though you need to use the effect with care as it won't work on every picture you take. For this shot taken at dusk I also used fast, grainy film to impart an impressionistic feel to the image.

OLYMPUS OM4-Ti, 28MM LENS, SOFT FOCUS FILTER; AGFACHROME RS100; 1/60 SEC. AT F/16

On the face of it, soft-focus filters seem like rather a silly idea. After all, what's the point in spending a small fortune on the sharpest lenses you can find if you then proceed to degrade this hard-won quality with a piece of misty plastic? The answer is simple – mood. Soft-focus filters add mood, atmosphere and a sense of romance to your pictures. A plain portrait, glamour or nude shot can be miraculously transformed with the addition of a little diffusion. Hard edges disappear, fine detail is obscured, the light takes on a dreamy quality, and the overall effect can be incredibly evocative. Soft-focus filters are also ideal for hiding spots and blemishes in imperfect complexions, and making even the roughest skin look silky smooth.

You needn't limit your use of soft-focus filters to people, though – they can work equally well on landscapes, architecture, still-life shots, close-ups, and so on. Throughout this chapter we will be looking at the type of effects you can create by using both shop-bought soft-focus filters and home-made ones.

SOFTENING THE IMAGE

When light rays pass through a camera lens, the layout of the elements helps to ensure that all those rays come into sharp focus on the film plane – the focusing mechanism on the lens helps you achieve this by changing the distance between the lens and the film. If you don't focus the lens correctly, those light rays will meet in front of or beyond the film plane so the picture you take will be unsharp.

Soft-focus filters work in a similar way. You bring the subject or scene you are photographing into sharp focus with the lens, but then, when you place a soft-focus filter over that lens, it causes some of the light rays passing through to refract or bend so they don't focus on the film plane.

Instead of making the picture look out of focus, however, soft-focus filters merely obscure fine details, while bolder details and the overall form of the subject remain intact, so the image appears to be sharply focused in general, but with a gentle diffusion across it.

Light fantastic

Soft-focus filters work by bleeding the highlights into the shadow areas to create an ethereal glow. To show this at its best, position your subject against a dark background so that it's surrounded by an attractive glow. If you are shooting a portrait outdoors, for example, pose them against a shady area, but make sure their face is well lit. Keeping the sun behind them, then bouncing light onto their face with a reflector, works well, as the background will naturally be in shade and will come out very dark or even totally black on the final picture.

Shooting into the light can also produce beautiful results. If you photograph sunlight bleeding through woodland and expose for the shadow areas, the highlights will burn out and merge with the shadows to create incredibly atmospheric images. This technique can also be used on any subject that's against a bright background, such as buildings against an overcast sky. By exposing for the shadow areas or increasing the exposure set by your camera by 1 or 2 stops, you will lighten the tones of the image to produce high-key soft-focus effects.

Apertures and soft focus

Although there are many different types of soft-focus filter available, you can obtain various levels of diffusion from just one filter simply by setting your lens aperture to different f/stops. Basically, the wider the aperture, the stronger the effect, and

▼ **GONDOLAS, VENICE**
Soft-focus filters produce beautiful atmospheric effects when used on backlit scenes. Noticing these gondolas bobbing on the lagoon in Venice I knew there was the potential for a great shot, but it was only when I placed soft focus and warm-up filters on my lens that the image really came to life. Increasing the exposure to burn out the bright background added to the high-key effect. Had I used the metered exposure, the gondolas would have recorded as silhouettes, and the photograph would have looked completely different.

NIKON F90x, 80–200MM ZOOM AT 200MM, COKIN DIFFUSER 1 AND 81D WARM-UP FILTERS; FUJICHROME SENSIA II 100; $\frac{1}{250}$ SEC. AT F/2.8

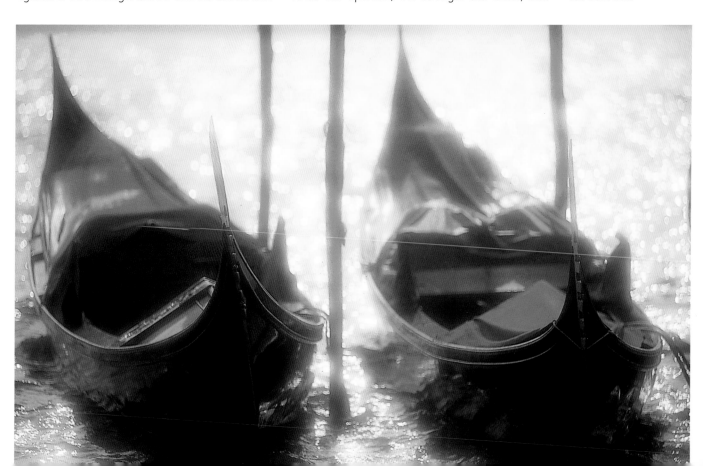

SOFT-FOCUS FILTER COMPARISON

No filter

Cokin Diffuser 1

Cromatek Moderate Diffuser 1

Hitech Movie Mist Black 1

Hoya Softener A

Lee Soft Focus 3

vice-versa. So if you shoot at f/2.8 or f/4 you'll get the full effect of the filter; the diffusion gradually tails off as you stop the lens down, until by f/11 or f/16 it almost disappears.

This is worth knowing because it can make a big difference to the success of your pictures. Portraits tend to be shot at wide apertures, to throw the background out of focus, so you get the best of both worlds. But subjects such as landscapes and architecture usually need small apertures, such as f/11, f/16 or f/22, for maximum depth of field, so if you are using a fairly tame soft-focus filter the effect may be so subtle at small apertures that it's hardly noticeable.

Brand differences

Soft-focus filters vary considerably from one manufacturer to the next, and no two give an identical effect. It's therefore a good idea to experiment with different makes.

Different manufacturers use different names for their soft-focus filter, from 'softar' and 'diffuser' to 'haze', 'sunsoft' and 'dream'. Some have smooth surfaces; other have bubbles, dents or even holes punched in them to distort the light rays passing through. There are also numerous 'net' filters that have a fine black mesh built into the filter to break up the finest details without affecting the overall sharpness of the image.

SOFT-FOCUS VARIATIONS

As well as traditional soft-focus filters, there are numerous variations on the basic theme that are well worth trying out.

Soft spots

These are soft-focus filters with a clear central area. The idea is that you place your main subject in the centre of the image so it's left unaffected, while the surrounding area is softened. The most popular types of soft spots are based on colourless diffusers, but some manufacturers make them with a coloured soft-focus area and clear centre, so the edges of the picture take on a gentle colour cast. You can even buy soft-spot filters with different colours all merging together in the diffusion zone.

The size of the clear area is also varied in some brands so you can use them with lenses of different focal length – a larger clear zone works better with lenses from 28–50mm, while a smaller clear zone is better suited to longer lenses up to 135mm. This is because wider lenses give greater depth of field, so you need a larger clear zone to avoid it being too small and clearly defined in the final image. Longer lenses give less depth of field, so a smaller clear zone is necessary to avoid it disappearing altogether.

Whichever type of soft-spot filter or lens you use, the transition from clear to soft areas will be more noticeable when you are shooting at small apertures, such as f/11 or f/16, while the wider the aperture is, the more subtle the effect will be. Although they are designed mainly for portrait and wedding photography, soft spots can also be used for atmospheric still-life and landscape images.

Pastels

Pastel filters work in the same way as conventional soft-focus filters, but they degrade the image more to give it the same kind of feel as an old painting where the colours have started to fade. This may not sound particularly attractive, but wonderful painterly effects are possible, and they work well on landscapes, portraits and still-life shots.

Try combining a pastel filter with fast, grainy colour film to produce images that look more like impressionistic watercolours than photographs. The diffuse light of an overcast day is ideal for shooting landscapes or details this way, while window light will produce perfect illumination for portraits or still-life shots.

Mist and fog filters

These filters, as their names imply, are designed to mimic the atmospheric effects you get in misty and foggy weather. So instead of adding a glowing form of diffusion, they scatter light rays, mute colours and reduce contrast – the only difference between the filter and the real thing is that the filter doesn't change the colour temperature of the light.

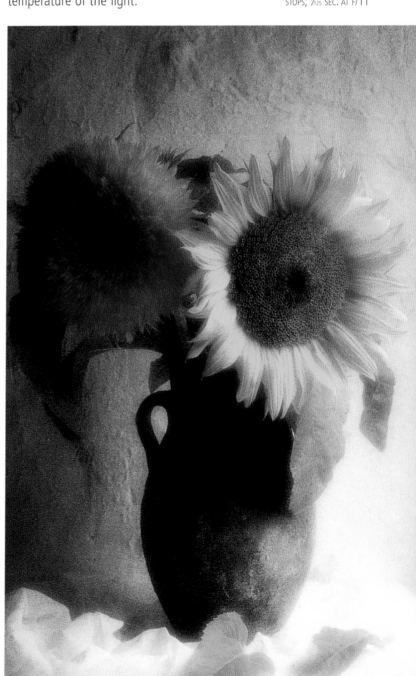

▼ **SUNFLOWER**
Pastel filters work differently to traditional diffusers in that they add an overall misty effect to the image that obscures fine detail and makes colours appear muted – effects that suit this still life perfectly.

NIKON F90x, 105MM MACRO LENS, COKIN PASTEL 086 AND 81B WARM-UP FILTERS; FUJICHROME SENSIA 400 RATED AT ISO1600 AND PUSHED 2 STOPS; 1/125 SEC. AT F/11

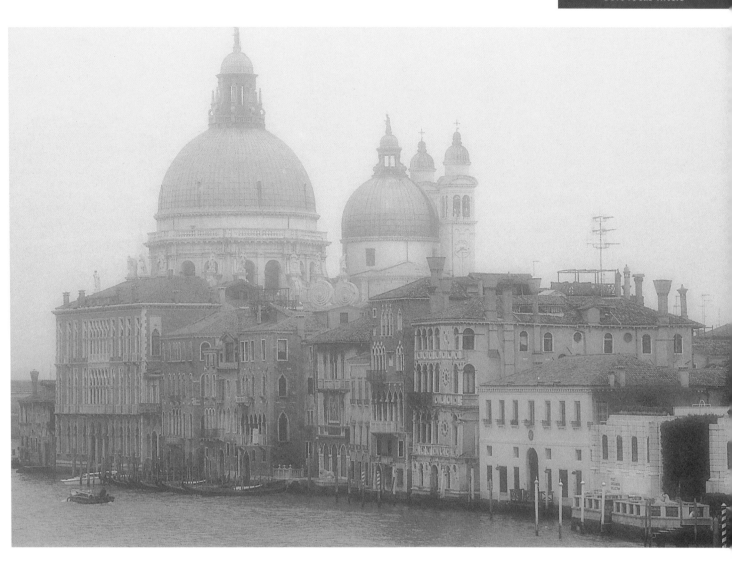

Use them on woodland scenes, landscapes, or views across lakes to add atmosphere. Most fog filters have the same effect across the whole filter area, but some are graduated so the fog effect is stronger towards the top of the frame – as it would be in reality. One or two manufacturers even produce mist filters that create the effect only across the top third of the image area, to mimic the effect of mist or fog lifting – they're ideal for shots of rivers, lakes and valleys where you would expect to see mist rising in the morning.

To enhance the effect of these filters, combine them with other coloured filters – a blue 80-series filter will add a mysterious cold cast, while an orange 85-series filter or strong warm-up will add a more welcoming warm feel.

▲ Santa Maria della Salute, Venice

This dull winter's morning along the Grand Canal in Venice was captured using a fog filter to flatten the scene and soften the colours. The combined effect of this has produced a simple but highly evocative image.

Nikon F90x, 80–200mm zoom at 200mm, Cokin fog and 81B warm-up filters; Fujichrome Sensia II 100; ½₅₀ sec. at f/8

SOFT-FOCUS LENSES

If you like using soft-focus effects on your pictures, you could invest in a purpose-made soft-focus lens, rather than using filters. Soft-focus lenses produce their effect using controlled spherical aberrations – so not all light rays come into sharp focus on the film plane – and flare-reduction masks to reduce contrast. Also the strength of diffusion can be controlled with a fair degree of accuracy mainly by adjusting the lens aperture.

Some models offer soft focus only at certain apertures, some simply throw the image slightly out of focus, and some only affect the background – so the effect you get will depend very much on which lens you buy. Several of the main 35mm SLR manufacturers produce soft-focus lenses, as do Mamiya and Pentax for their 6 x 7cm cameras. The focal length tends to be 85–100mm, or the equivalent for medium-format cameras. This is because short telephoto lenses are the most common choice for portraiture, and soft focus is mainly used for people pictures, too.

DIY SOFT FOCUS

Because of the way soft-focus filters work, it's actually very easy to make your own, or to find materials around the home that will create a diffusion effect, so if you don't fancy spending money on the real thing, here are some ideas that you can experiment with.

Breathing on the lens

The easiest and quickest way to create soft focus is simply by breathing on the front element of your lens – or a clear filter placed in front of it. The condensation that forms on the lens or filter adds a misty effect, which is very heavy initially, but becomes more subtle as the condensation clears. To make the most of this, watch the mist begin to clear by looking through your camera's viewfinder, and when the effect looks pleasing, take the picture.

Hair spray

Take an old skylight, UV or warm-up filter, and spray a very gentle coating of hair spray on it from 25–30cm away, so a fine mist settles on the filter.

Because hair spray is tacky, it will stick to the filter and stay there. Allow it to dry for a few minutes, then place the filter on your lens to check the effect. If it's too subtle, apply another layer of hair spray – after taking the filter off the lens! If the effect is too strong, wash the filter in warm water to remove the hair spray, dry it and try again. This DIY technique can produce attractive soft-focus effects, so if you have a selection of old filters, why not use them to produce soft-focus filters with different levels of diffusion from very subtle to very obvious.

Petroleum jelly

Another popular technique is to place a tiny blob of petroleum jelly – literally just 1–2mm in diameter – on a clear or warm-up filter, then smear it across the filter surface. Doing this covers the whole filter in a greasy film that degrades the light passing through to produce a very effective form of soft focus. What makes this technique interesting is that you can vary the effect from one shot to the next simply by smearing the jelly in different ways with your finger

▼ **ARAGON, SPAIN**

A tiny amount of petroleum jelly smeared on a clear filter produces quite a subtle effect, which you can control by smearing it around with your finger in different patterns. To get vertical streaking like this, smear the Vaseline horizontally. Don't ask me why!

CANON 605 5LR, 28MM LENS, HOME-MADE FILTER WITH VASELINE; FUJICHROME VELVIA; 1/30 SEC. AT F/8

or a cotton wool bud – try streaks, squiggles or circles. Another option is to leave a central area of the filter – 15 to 20mm in diameter – clear, but cover the rest with petroleum jelly to create a soft-spot filter. For a delicate soft-focus effect you need only a tiny amount of jelly, but if you want to produce more abstract, distorted images, apply more and smear it around with your finger.

Women's stocking

Hollywood film cameramen devised this simple technique back in the 1940s, to make their heroines look as beautiful as possible in close-up shots, but it can also be used for still pictures, too. All you do is stretch a piece of stocking material over the lens. For a one-off you can secure it in place with an elastic band, but if you like the effect obtained you could make a more permanent filter by stapling the material to a frame made from stiff card that has been cut to size so it fits your filter holder. The level of diffusion can be varied by using different grades of stocking material. This is measured in deniers; the smaller the number, the finer the material and the weaker the soft-focus effect. Use black stockings for a neutral effect, or you could try flesh-coloured stockings to warm up the image a little as well as softening it.

SOFT-FOCUS TIPS

- Soft focus subdues fine detail, so take care when using it on subjects that rely on this for their appeal.
- Colour saturation will be slightly reduced, too, so if you photograph a scene containing strong colours, don't expect them to look as strong on the final image.
- With home-made soft-focus filters, cut a small hole in the centre so part of the image will be rendered sharp, while the area around it shows the soft-focus effect.
- When shooting backlit subjects and scenes, over-expose your pictures slightly – by ½ to 1 stop – to make the bright background burn out a littleand enhance the moody feel of the image.

◄ **CAMBRIDGE**
If you want to distort the image and produce abstract results, apply more petroleum jelly to the filter and experiment.

OLYMPUS OM4-TI, 28MM LENS, HOME-MADE FILTER; AGFACHROME 1000RS; ¹⁄₂₅₀ SEC. AT F/8

▼ **GONDALAS**
A piece of women's black stocking was stretched over the camera lens for this shot.

NIKON F90X, 80–200MM ZOOM WITH BLACK STOCKING STRETCHED OVER IT; KODAK ELITECHROME EXTRA COLOR 100 RATED AT ISO400 AND PUSHED 2 STOPS; ¹⁄₂₅₀ SEC. AT F/5.6

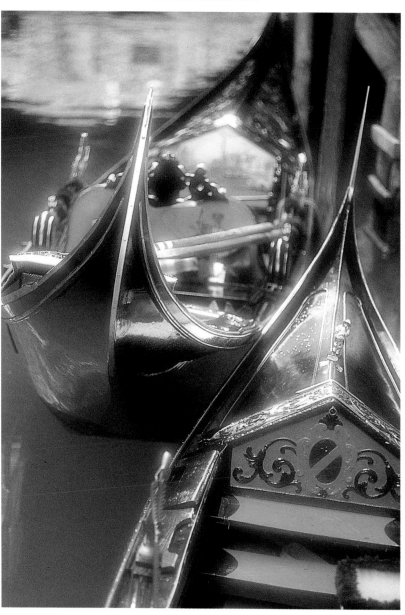

Anti-Newton glass

Anti-Newton glass has a frosted finish that creates a wonderful soft-focus effect – I actually prefer it to most purpose-made soft-focus filters because it adds an attractive dreamy feel to the image that works particularly well with fast, grainy film or on backlit scenes, such as sunlight bleeding through woodland. GePe anti-Newton glass slide mounts are ideal. If you buy a pack of 6 x 6cm medium-format mounts and use the frosted half, the glass is already mounted in a plastic frame, which you can secure to the lens with blobs of low-tack gum. Alternatively, cut a frame from card to fit your filter holder and tape the glass in its plastic mount to it so you can combine it with other filters, such as warm-ups. An alternative to glass slide mounts is the small pieces of anti-Newton glass found in some enlarger negative carriers – I have some from my Durst enlarger that work well, although the effect you get from a glass slide mount is hard to beat.

Food wrap

If you're struggling to find any of the materials outlined so far, you will find that a sheet of food wrap stretched across your lens will actually produce a delicate form of soft focus. Try screwing the wrap into a ball first so that it creases, then unravel it and stretch it over your camera lens – the creases will enhance the effect it produces. You can also smear petroleum jelly on it, or rub a finger down the side of your nose so it picks up a little grease, and smear your finger across the film.

▼ **BACKLIT TREE**

This is the dreamy kind of soft-focus effect you can get from a piece of anti-Newton glass. I used the frosted half of a 6 x 6cm GePe anti-Newton glass slide mount, which I mounted in card to slot into my filter holder to combine with other filters.

OLYMPUS OM2N, 28MM LENS, GEPE ANTI-NEWTON GLASS SLIDE MOUNT; FUJICHROME RFP50; $\frac{1}{125}$ SEC. AT F/11

SOFT FOCUS FOR BLACK-AND-WHITE PHOTOGRAPHY

Soft-focus filters can be just as useful for black-and-white photography as they are for colour. The most important factor to consider is that if you want to add soft-focus effects to black-and-white prints, you can do so either at the taking stage, or at the printing stage.

Most photographers prefer the latter approach because it means that not only can they make prints from the same negative with no soft focus if they choose, but they can also experiment with different types and levels of soft focus during the printing process. Clearly, if you take the original picture with a soft-focus filter on your lens, that effect will be recorded on the negative and you will be stuck with it.

Another reason for adding soft focus at the printing stage is that it actually gives a different effect. Take a picture with a soft-focus filter on the lens and the effect is formed because the highlights bleed into the shadow areas. But add soft focus

when printing, and the shadows bleed into the highlights. The end result is a diffused image, but the quality of diffusion is different and can look incredibly atmospheric.

All manner of subjects suit the soft-focus

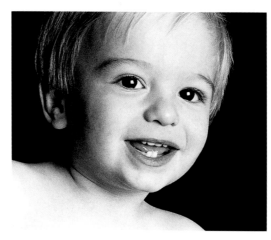

▲ Straight print
▼ Printed through soft-focus filter

◄ ▼ Noah
This pair of pictures shows the kind of effect you can achieve by printing a black and white image through a soft-focus filter. The filter used in this case was a Cokin Diffuser 1 and I held it beneath the enlarger lens for the duration of the print exposure.

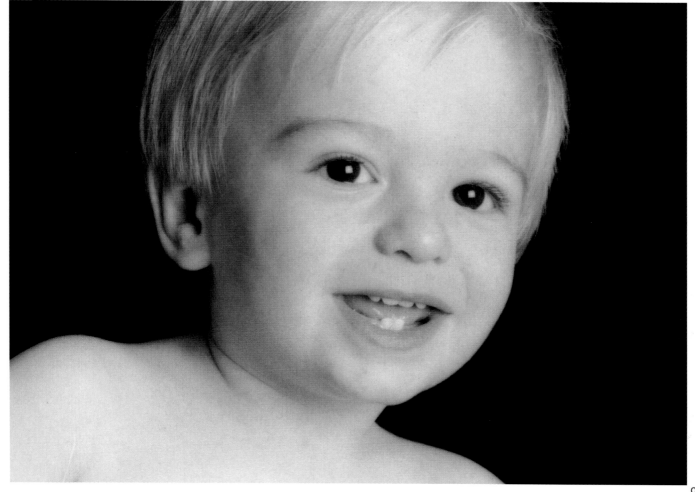

treatment – portraits, nude studies, still life, landscapes, seascapes, architecture – so experiment. Even if you took pictures originally with no plans to add a soft-focus effect, they may still work, so it's worth going back through your negative collection and maybe printing a few old favourites.

Any soft-focus filter can be used during printing, and the usual approach is to hold it beneath the lens during exposure so the image from the negative is projected through the filter. Attach the filter to the lens with small balls of low-tack gum, hold it in the light path between your fingers, or remove the red safety filter from its frame and lay the soft-focus filter on top. By varying the amount of time the soft-focus filter is kept in place, you can control the level of diffusion added. You may, for example, decide to expose the print for half the required time with the filter in place, then remove it from the light path for the second half of the exposure, so the final image has sharper edges but still shows a gentle diffused effect.

Another option is to print the image through tissue paper. Take a large sheet of white tissue paper, screw it into a tight ball, then unfurl the ball and

flatten it out. This gives you a flat sheet full of fine lines and creases. Lay the tissue paper on top of the printing paper, keep the two in contact with a sheet of glass, and expose as normal so the final print is diffused and shows the pattern of creases from the tissue paper.

▲ **FENLAND DRAIN**
This is the type of effect you can get by printing an image through tissue paper. Note the way the texture and pattern in the paper has printed through to give the image a dreamy quality. I enhanced this by partially bleaching the print in diluted sepia bleach so the image has faded back a little. It was then re-fixed to make the image permanent.

OLYMPUS OM4-TI, 28MM LENS; ILFORD XP2; ⅟₆₀ SEC. AT F/16

◄ **KING'S COLLEGE, CAMBRIDGE**
You don't have to go over the top when adding soft focus to a black and white image – just a subtle degree of diffusion is all it takes to transform the mood of the picture.

OLYMPUS OM4-TI, 85MM LENS, HOYA SOFTENER 1 AT PRINTING STAGE; FUJI NEOPAN 1600; ⅟₆₀ SEC. AT F/11

USING COLOUR
FILTERS

FROM HADRIAN'S WALL, NORTHUMBERLAND, ENGLAND
I photographed this scene in midwinter after a day of
heavy snow. Nightfall was fast approaching and the light
had a distinct coolness about it that I decided to play on
by shooting through a blue filter. When I had the film
processed, I felt that the image still wasn't blue enough,
so I copied the original 6 x 7cm colour slide onto 35mm
film with a blue filter on the lens to deepen the colour
cast. I also decided to add the moon at this stage, to
provide an extra point of interest, so I did this using a
double exposure, copying the moon from another colour
slide, but with no filter on the lens so it came out white.

PENTAX 67 AND 55MM LENS FOR ORIGINAL, NIKON F90X AND
105MM MACRO LENS FOR DUPLICATE, BLUE FILTER FOR BOTH;
FUJICHROME VELVIA FOR BOTH; 20 SEC. AT F/11 FOR ORIGINAL

Although coloured filters are primarily designed either to correct
colour casts caused by different types of lighting, or control contrast
when shooting in black and white, there's nothing to stop you using
them to create a strong colour cast for visual effect when taking
pictures on colour film. The orange 85 series and blue 80 series of
colour-conversion filters are ideal for adding a strong warm or cold
cast to your pictures (see pp. 64–67), while the red, orange, yellow
and green filters normally used for black and white can be used to
give even stronger chromatic effects. Colour-compensating filters can
also be used to provide other colours, such as magenta, as can an
FL-D (fluorescent-to-daylight) filter, which has a magenta colouring
to balance the green cast of fluorescent light on daylight-balanced
film (see p. 70).

COLOUR SYMBOLISM

Every colour in the visible spectrum has the power to convey different moods and emotions, so by adding a specific colour to an image you can encourage a certain response in the viewer.

Red

This is a very dominant, advancing colour that symbolizes blood, danger and urgency. It's the colour used to warn us, so pictures with a red colour cast have tension about them. Think 'red with rage', or 'like a red rag to a bull'. Using a deep red filter to colour a photograph must be done carefully and on the right subject, as the effect can be stark and other-worldly. Bold silhouettes or shapes work well because their strength helps to keep the red cast in check by adding contrast. Without a bold feature in the shot the colour cast will completely swamp it, as detail is suppressed.

Blue

This can be an ambiguous colour, depending on the context in which it's used. On the positive side,

it's a tranquil, serene, reassuring, stable colour, symbolizing authority, royalty, truth, hope, freshness, the sky, the sea, wide open spaces, the world around us. But it can also represent loneliness, depression, loss, sadness and coldness. It can be a moody, mysterious, secretive colour. Think 'blue with cold' or 'feeling blue'.

A deserted country road photographed on a bleak, misty or rainy day suggests a sense of isolation, loneliness and coldness. But a shot of the vivid blue sea basking beneath a vast expanse

▲ **Brighton Pier, Sussex, England**
An orange filter, normally used for black-and-white photography, added the rich glow to this sunset.

Nikon F90X, 50mm lens, orange filter, tripod; Fujichrome Velvia; ½ sec. at f/16

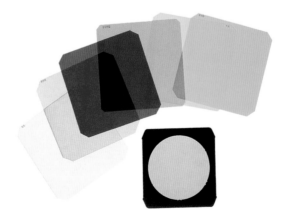

◄ The coloured filters intended for black-and-white photography, along with colour-conversion and colour-compensating filters, can all be used to add strong colour casts to your photographs.

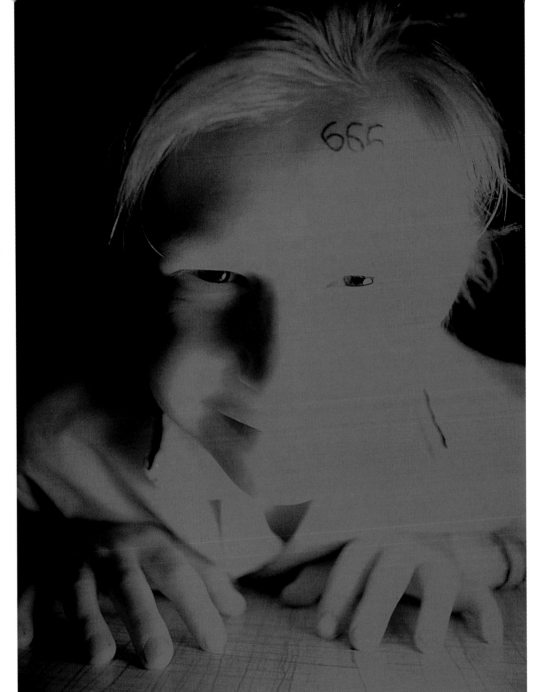

◄ **LITTLE DEVIL**

I took this shot many years ago as a bit of fun. My younger brother was going through a mischievous phase, so I decided to depict him as the proverbial little devil. This was achieved by placing a deep red filter over a portable flash gun, rather than the camera lens, so he was bathed in rich red light.

OLYMPUS OM1N, 50MM LENS, VIVITAR 283 FLASH GUN, COKIN RED FILTER; FUJICHROME RF50; ⅛₀ SEC. AT F/4

▼ **DERWENTWATER, LAKE DISTRICT, ENGLAND**

This photograph was taken on the dullest of days I've ever seen, so to make the most of what I had I used a deep blue 80A filter to add the cool colour cast.

ART 617 PANORAMIC, 90MM LENS, 80A FILTER, TRIPOD; FUJICHROME VELVIA; 4 SEC. AT F/22

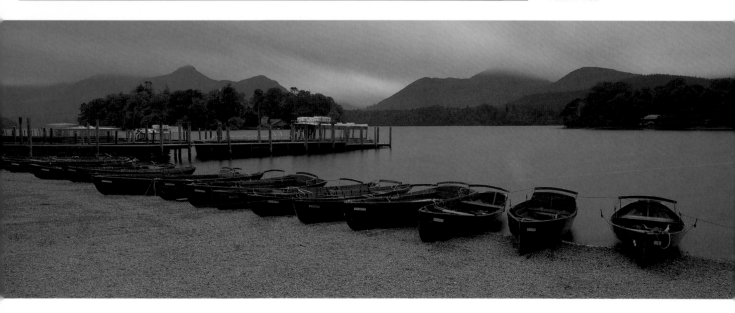

of deep blue sky suggests freedom, wide open spaces, harmony and happiness.

Use a blue filter to add drama to pictures taken in any kind of bad weather – mist, fog, rain – or on snow scenes to emphasize the sense of cold. The effect can also work well on pictures taken outdoors at dusk. In urban settings a strong blue filter will cool down artificial light sources, such as tungsten, that are used to spotlight buildings or illuminate interiors, while adding its own colour to the part of the shot illuminated by daylight. This contrast between the cold blue of the daylight and the warmer artificial lighting can look very striking.

Green

Symbolizing life, health, freshness, nature and purity, green reminds us of the landscape – green fields and rolling hills – so it's a refreshing colour to look at. At the same time it can also look rather sickly when used to add a strong colour cast – unless the natural colours in the scene are predominantly green anyway. If you shot a close-up of a leaf, for example, you could use a green filter to emphasize that lush green colour and, because there's nothing else included in the shot with a different colour, the effect will look perfectly natural.

Yellow

Yellow is the colour of the sun, buttercups, corn, gold and lemons. It's a powerful colour, symbolic of joy, happiness and richness and it advances like red to produce images that leap from the page. You can use a standard yellow filter to emphasize the warm glow at sunrise or sunset. The effect will be very loud, but it won't appear unnatural. If you fill the frame with yellow subjects – such as a field of oil-seed rape flowers, a crate of lemons or a detail of a painted door – you can also use a yellow filter to add impact.

Contrast

Unless you are using a strongly coloured filter on pictures where the dominant colour in the shot is the same as the filter itself, it's important to include at least one strong element in the composition so as to provide contrast. By overpowering all other colours, strongly coloured filters suppress details, texture and contrast, so pictures can easily appear flat and featureless

unless you include something to rise above the dominant colour cast.

It's for this very reason that coloured filters work well on silhouettes – because the silhouette itself is black it doesn't take on the colour of the filter, so the end result is a black shape or shapes against a coloured background. It's also worth noting here that cooler colours – blue and green – make better backgrounds because they are said to recede, whereas warmer colours, such as red, yellow and orange, advance.

Combine two filters with the same colour for an even bolder effect. A blue 80A combined with any other blue filter from the same series – or from the 82 series of cool filters – will produce a deeper blue cast, as will orange filters from the 85 series combined with each other, or warm-up filters from the 81 series. But nothing beats the orange filter normally used for black and white photography if you want a truly glowing orange.

What you should avoid doing is combining similar colours. If you use a deep red and any orange filter together, the red will dominate the orange so its contribution will go unnoticed. There's also the danger of ending up with a muddy, unattractive colour if you carelessly combine filters.

▲ **LEAF DETAIL**
Sometimes a coloured filter can be used, not necessarily to add a strong colour cast, but to enhance the colour of the subject you are photographing. For this close-up I used a green filter to make the natural green of the leaf even stronger, though looking at it you wouldn't know that a filter has been used at all.

NIKON F90X, 105MM MACRO LENS, GREEN FILTER; FUJICHROME VELVIA; ⅛ SEC. AT F/11

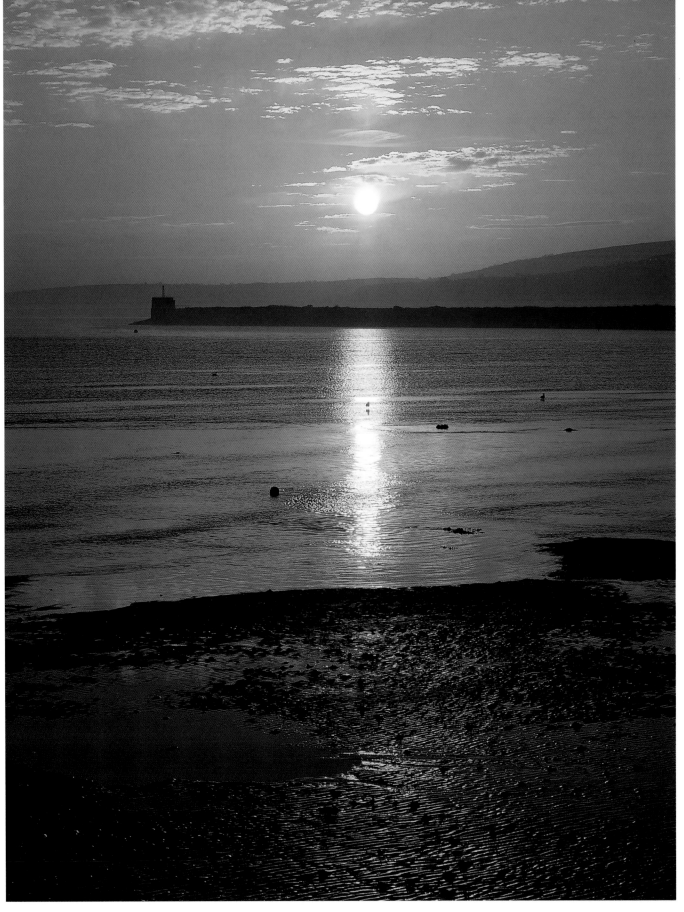

▲ **FISHGUARD BAY, PEMBROKESHIRE, WALES**
The warm light at sunrise and sunset often needs no enhancement, but if you wish to capture a truly golden glow, filters will help you out. In this case I used an orange 85.

PENTAX 67, 105MM LENS, ORANGE 85 FILTER, TRIPOD; FUJICHROME VELVIA; $^1/_{30}$ SEC. AT F/11

SPECIAL COLOUR

In addition to using colour-balancing or black and white contrast filters to add strong colour casts, there are also numerous specialized coloured filters available to extend your palette. Cokin produces a set of 21 coloured gels in one kit, for example, so you can add pretty much any colour you like – or combine two or more gels for something more unusual.

Then there are varicolor filters from Cokin, which are rather like bi-coloured polarizers. You can buy them with combinations of red/green, red/blue, purple/orange and yellow/blue. The effect they have is varied by rotating the filter in its holder like you would a polarizer until the best effect is obtained. Each filter adds its dominant tone to a photograph, but then you can introduce other colours by rotating it to affect reflections. Turn the filter through 90 degrees, for example, and the colour of reflections will be inverted – with the

yellow/blue varicolor filters, yellow reflections become blue. Used alone, the effect can sometimes look a little over the top. If you combine it with a polarizing filter, however, and rotate both independently of each other, the shot will take on the dominant colours of the polarizer – red or blue, red or green, yellow or blue and so on.

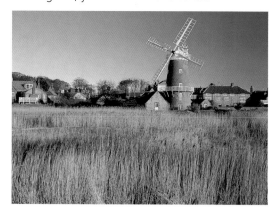

No filter

◄ **WINDMILL**
This pair of pictures shows the same scene, first taken unfiltered, then with a Cokin yellow/blue varicolor filter. Such filters don't suit all types of scene, but in this case you can see how it has enriched the naturally warm colour of the reeds in the foreground, as well as deepening the blue sky to produce a much more saturated and altogether punchy image.

PENTAX 67, 200MM LENS, COKIN YELLOW/BLUE VARICOLOR FILTER, TRIPOD; FUJICHROME VELVIA; 1/8 AND 1/2 SEC. AT F/16 RESPECTIVELY

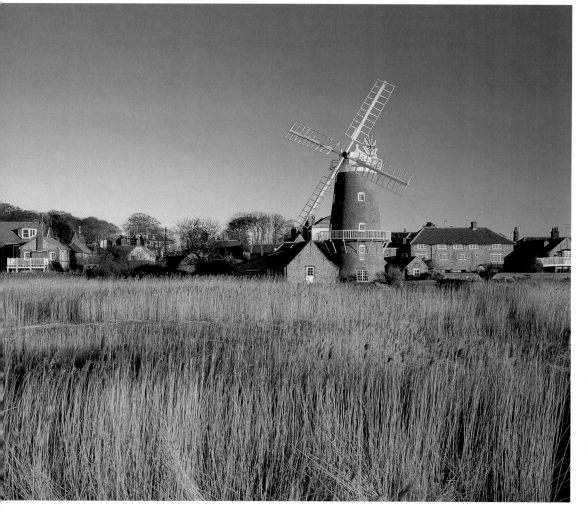

Cokin yellow/blue varicolor filter

► **SUNBATHER**
Roger Howard transformed this straightforward poolside shot into an eye-catching abstract using a Cokin varicolor red/blue filter in combination with a normal polarizer. The effect is clearly unnatural compared to the other varicolor shot shown here, but visually it works very well. Experimentation is the key when using such filters.

MINOLTA DYNAX WITH 28–85MM ZOOM, COKIN A-SERIES VARICOLOR 171 AND POLARIZING FILTERS; FUJICHROME RD100; 1/125 SEC. AT F/5.6

Another way to use these filters is on scenes that are dominated by the same two colours as the filter, so the effect you get is more realistic. A yellow/blue varicolor filter works really well on scenes where the foreground is warm and the sky is blue, for example – such as reeds and grasses on a river bank, a field of ripe cereal crops or sand dunes beneath deep blue sky. By rotating it carefully you can intensify both the foreground colour and make the sky a richer blue. Similarly, the red/blue would work best on scenes where the foreground is dominated by red, and the sky is blue. The transformation canbe amazing.

Polacolor filters work in a similar way, although the effect isn't quite as striking. They have only a single colour – either red, blue or yellow – and work by adding their own colour to reflections, plus a warm or cool cast to the rest of the scene.

For the best results, use a polacolor filter in conjunction with a normal polarizer so you can eliminate reflections and vary the intensity of the polacolor filter's own colour. Yellow and blue are the most useful on a day-to-day basis – red has a tendency to be too overpowering.

Adding strong colours to your photographs isn't something you would want to do too often, but when the subject and the lighting suits this treatment, it can work wonders and turn the ordinary into the extraordinary. Any of the coloured filters mentioned in this chapter can also be combined with other non-chromatic filters, such as soft-focus and starburst.

No filter

Cokin varicolor red/blue filter and normal polarizer

Sunset filter

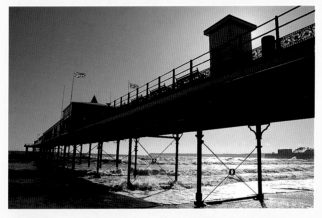

No filter

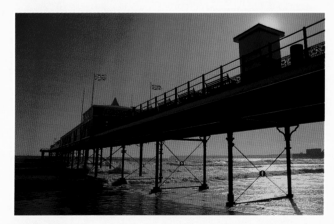

Orange filter

◄ ▲ **PAIGNTON PIER, DEVON, ENGLAND**
Bold, graphic structures such as piers, trees, buildings and monuments work well with strongly coloured filters, especially if you set out to produce a silhouette so only the background is affected by the filter. This set of pictures shows the same scene with different filters. All work well in their own way, but I prefer the orange filtered version.

OLYMPUS OM2N, 28MM LENS, COKIN ORANGE, RED, BLUE AND SUNSET 1 FILTERS; FUJICHROME VELVIA; VARIOUS SPEEDS AT F/11

Red filter

FILTERS
FOR SPECIAL
EFFECTS

◄ **TRAFALGAR SQUARE**
There are many special effects filters available that can be used to add an extra element to your pictures. In this case, photographer Roger Howard used a diffractor to turn the bright lights in the scene into colourful stars.

PENTAX 645 WITH 40–80MM ZOOM, COKIN 41 DIFFRACTOR, TRIPOD; FUJICHROME RDP100; 10 SEC. AT F/8

Special-effects filters have been around for decades, but it wasn't until the early 80s, with the launch of the legendary Cokin filter system, that they took off in a big way. We've now got filters that will turn bright points of light into stars or colourful explosions; filters that will take your subject and multiply it; and filters that can make stationary subjects appear to be moving at the speed of light, or create a zoomburst effect without you having to move a muscle.

The effects produced by some special-effects filters are pretty ridiculous, and should be taken with a very generous pinch of salt. But there are some that are worth adding to your filter collection, if only to use occasionally when a subject or scene is encountered that would benefit from the effects they can offer. The purpose of this chapter is to take a look at those filters, see just what they are capable of, and offer advice on how to use them. So, if you're a traditionalist, I advise you to look away now. But if you're an open-minded photographer, turn the page and prepare to be inspired!

STARBURST FILTERS

A starburst filter is the most popular special-effects filter, and one of the most useful, as the effect can look pleasing without being too over the top. All it is in reality is a clear filter with hundreds of very fine parallel lines etched into the surface. These lines create a sort of controllable flare, turning bright points of light and highlights into stars.

Where there's just one set of lines, a two-point star is created. If a second set of lines is added, at right angles to the first, four-point stars are created, and so on. Cokin offers the biggest range – two-, four-, eight- or sixteen-point – while others manufacture four-, six- and eight-point starburst filters.

The effect of a starburst filter is seen most clearly on urban night scenes containing lots of bright lights, such as street lamps, seafront illuminations, decorative lights in avenues of trees or Christmas decorations. The stars stand out clearly against the darker background of the sky or unlit areas, and this can produce very effective images – although if the scene contains too many bright lights, your photographs can easily end up dominated by twinkling stars, and the effects begin to take over.

MAKE YOUR OWN STARBURST FILTER

If you fancy experimenting with starburst effects but don't want to spend money on a purpose-made filter, why not make your own? If you have an old clear filter, such as a skylight or UV, or a tatty warm-up filter, you can turn it into a starburst simply by scratching fine lines into the surface with a pin and a straight edge. A clear piece of plastic could also be used if you don't have a filter to hand. Make very fine scratches, keeping the lines parallel and close together – no more than 0.5mm apart. When you have scored lines across the whole surface, repeat this process again with the lines running at right angles to the first set, and you will end up with a four-point starburst filter. To add more points to the star, etch further lines diagonally across the surface – in one direction to make a six-point star, then diagonally in the other direction to make an eight-point star.

▶ **ULLSWATER, LAKE DISTRICT, ENGLAND**
I photographed this lake scene using a home-made starburst filter – I simply scratched fine lines over the surface of an old soft-focus filter at 90 degrees to each other to produce a dual-purpose 'soft-star' filter. By shooting into the sun I was able to record every highlight on the water as a star – along with the sun's orb that was hidden behind a tree to reduce its intensity.

OLYMPUS OM1N, 28MM LENS, HOME-MADE SOFT-STAR FILTER; FUJICHROME RFP50; ½₅₀ SEC. AT F/11

Starburst filters can also be used during the daytime to create stars from bright highlights. The sun is the most obvious highlight you are likely to encounter – try partially hiding it behind a monument, building or tree, then use a starburst filter to give the effect of a bright star emerging from behind this obstacle.

Highlights on water react well to starburst filters, creating a shimmering sea of fine stars that can work well as the background to silhouettes of boats or people. You can also use a starburst filter to make stars from highlights in reflective objects, such as chrome bumpers on cars, sunglasses and so on.

Starburst filters can be used with pretty much any lens, from wide-angle to telephoto, and at any aperture setting, although a smaller f/stop, such as f/11 or f/16, is advised. As they are clear filters there's no light loss, and no exposure adjustment to be made if you take exposure readings with a handheld meter, or with your camera, before the filter is attached to the lens.

If the starburst effect isn't enough for you, try combining it with other filters. Cokin have already done this by creating a Softstar filter, which, as the name implies, is a starburst combined with a soft-focus filter. The effect it gives can work well for still-life shots, or atmospheric scenes such as boats on water, but you can create many more by combining a starburst with a strongly coloured filter, such as an orange or blue.

Something else worth trying when shooting night scenes is to rotate the starburst filter in its holder while the image is being exposed. This will turn the stars into white halos of light around each point source that created them.

As with all special-effects filters, the key is to use starbursts sparingly and on the right subjects. If you abuse the effect, your work will quickly become predictable and boring, and you should never use any filter to try and turn a boring subject or scene into a successful picture – technique over content rarely works.

▲ **PARIS**
When used on the right subject, starburst filters can improve a picture no end. For this Parisian night scene, Roger Howard used a six-point starburst to make a feature of the bright lights. Because there were few point sources of light in the scene, the effect is obvious without looking over the top.

PENTAX 645,40MM LENS, SRB STARBURST FILTER, TRIPOD; FUJICHROME RDP100; 1 SEC. AT F/8

DIFFRACTION FILTERS

These filters work in the same way as starbursts, but instead of turning highlights and point sources of light into stars, they break up the light into the colours of the spectrum to create colourful streaks and halos of light. Various different types of diffractor are available, mainly from Cokin, but other filter manufacturers also produce them, so it's worth checking the effect before making a purchase.

The effect is best shown on night scenes where each bright point of light is given the rainbow treatment. However, diffractors also

◀ **WINDMILL**
For this striking image, Roger Howard used a sunset filter to add the golden glow, plus a diffractor to turn the sun's orb into a halo of colour. The combined effect of the two filters is striking.

PENTAX 645 WITH 40MM LENS,
COKIN 198 SUNSET GRAD PLUS
COKIN DIFFRACTOR 42;
FUJICHROME RDP100;
$\frac{1}{60}$ SEC. AT F/8

◄ **BIG BEN**
Diffraction filters come in
various forms so you can
produce different effects.
Here Roger Howard chose
one with a more random
pattern to add interest to his
night shot. The diffraction
effect was created mainly
from the headlights of
passing traffic and street
lighting on Westminster
Bridge.

MINOLTA DYNAX WITH 28–80MM
ZOOM, COKIN 41 DIFFRACTOR
WITH FOG HALO FILTER (A FREE GIFT
WITH A PHOTOGRAPHIC MAGAZINE),
TRIPOD; FUJICHROME RD100; 6
SEC. AT F/5.6

work well on highlights and reflections in
polished surfaces, such as metal, and on the sun
itself. If you are including the sun in a
photograph, partially hide it behind something
in the scene so the effect isn't too over the top.

Wide-angle lenses give the best effect, as the
broad angle of view means that highlights and
light sources will be small in the frame. If
you use a telephoto lens to enlarge the sun,
for example, then you will get a much bolder
diffraction.

When using diffractors at night, try rotating
the filter in its holder while the exposure is
being made, because this will create streaks of
light or continuous halos of colour.

◄ **TRAFALGAR SQUARE**
I took this picture in Trafalgar
Square, too, but during the
daytime instead of at night. I
saw the potential for a
silhouette of the statue, but
felt it needed something
extra. Fortunately, I had a
diffraction filter tucked inside
my gadget bag, so I decided
to use that and adjusted the
camera angle until the sun
was just peeping around the
side of the statue.

OLYMPUS OM4-TI, 28MM LENS,
JESSOP DIFFRACTION FILTER;
FUJICHROME VELVIA; ½₅₀ SEC. AT F/8

MULTIPLE-IMAGE FILTERS

◄ **DAFFODILS**
Multiple-image filters create one of the more bizarre special effects, allowing you to record a number of repeated images of your main subject.

OLYMPUS OM4-TI, 50MM LENS, COKIN MULTI-IMAGE 5 FILTER; FUJICHROME VELVIA; 1/125 SEC. AT F/5.6

How would you like to take a subject and multiply it by five, seven, thirteen or twenty-five times on the same photograph? That's basically what multi-image filters do, and on the right subject the effect can look striking. These filters are quite big and heavy as they use angled facets to record reflections of the main subject, while in the centre there's a hole through which your subject is recorded by the lens.

What could you use them for? Well, any single, bold subject that would create an interesting effect when multiplied. People are an obvious subject, but statues and monuments, flowers, a stationary car or motorbike, a candle flame, and

▲ ALI

I used a Cokin Multi-Image 5 filter for this portrait to record four additional images of my subject on the same frame. The success of this effect is determined by the lens you use, and the aperture that lens is set to, although you can gauge it using your camera's depth-of-field preview.

OLYMPUS OM2N, 85MM LENS, COKIN MULTI-IMAGE 5 FILTER; FUJICHROME RDP100; ⅟₆₀ SEC. AT F/8

PARALLEL WORLDS

As a development of this idea, Cokin has also produced a multi-image parallel filter, which has an empty area on one side and a half-prism on the other. The idea is that you compose an interesting scene in the clear area, then let the prism create several parallel repeated images of that scene. This effect can work well on night scenes, such as a busy street containing neon signs, and you can control the effect a little by sliding the filter in its holder. Lenses and apertures are as for standard multi-image filters.

many other things suit the multi-image treatment if you're willing to experiment.

For the best results, use a lens between 50–100mm and a mid-range aperture, such as f/5.6 or f/8. This will ensure that the images all merge together at the edges quite gently to give a good effect – if you use a smaller aperture there will be a much sharper division between each image. To check the effect before committing it to film, use your camera's depth-of-field preview.

▲ ST PAUL'S CATHEDRAL

Multiple-image filters work best on bold, simple subjects such as buildings – in this case St Paul's Cathedral in London. Rotating the filter in front of your lens will change the position of the individual images and allow you to produce the best effect.

PENTAX 645, 75MM LENS, COKIN MULTI-IMAGE 201 FILTER; FUJICHROME RDP100; ⅟₂₅ SEC. AT F/8

DOUBLE-EXPOSURE MASKS

If your camera has a multiple-exposure facility, you can produce some bizarre double images using Cokin's double exposure mask. All you do is mount your camera on a tripod, compose the shot and focus the lens. Next, slide the mask into the filter holder so it covers half the lens, and trip the shutter so half of the film frame is exposed. After re-cocking the shutter without advancing the film, and refitting the mask so that it covers the other half of the lens, you can then expose the other half of the picture.

The obvious effect to create with this mask is recording the same person twice on one frame of film, because they can move from one side of the shot to the other between exposures. For the best results, include a bold feature in the centre of the picture, such as a tree, so that there's a neat join between the two exposures, and take your pictures when the light is constant to get an evenly balanced final image. You will need to set your camera to manual exposure mode so the exposure reading doesn't change when you slide the mask into position, and make sure the mask is correctly positioned so there isn't a gap between the two exposures, or an overlap. If you are using a lens between 21–35mm, then set an aperture of f/5.6 or f/8, while with lenses from 50–100mm you should set f/11 or f/16.

DOUBLE TROUBLE

This set of pictures shows how a double-exposure mask works. First, photographer Billy Stock took a picture of his son standing against one side of the wall, exposing only half of the frame. He then switched the mask over and exposed the other half of the same frame of film, with his son standing against the opposite side of the wall.

CANON EOS 3, 50MM LENS, COKIN DOUBLE EXPOSURE MASK; FUJICHROME VELVIA; ⅟₆₀ SEC. AT F/11

SPEED FILTERS

If action photography isn't your forte, but you like the idea of adding a sense of motion to your pictures, give a speed filter a try. These natty pieces of plastic stretch out part of your subject in a series of horizontal streaks so it appears to be moving at breakneck speed, while part of it remains sharply defined.

It's all a bit of a visual joke really, because you couldn't create this effect in reality. But, if nothing else, a speed filter will add humour to the occasional shot, and you can take the idea to extremes by using it for shots of babies, tortoises, battered old cars and other subjects that naturally move at a snail's pace. The streaking effect can also be used in an abstract way for pictures of architecture, still-life studies and so on – the key is to experiment and see what you can come up with.

Lenses with a focal length between 50–100mm give the best effect, and you should shoot at apertures of f/5.6–f/11. To check the effect before taking a picture, use your camera's depth-of-field preview. If there's too much definition between the sharp and streaky parts of the shot, set a wider lens aperture.

A development of this idea is the Cokin Super Speed filter, which comprises a concave prism on one side and an empty area on the other. All you do is position your subject – a person, a statue, or whatever in may be – in the empty portion, then let the prism perform its unique magic, which it does by adding a series of streaks to one half of the image, which will give the impression of motion.

The effect is more graceful than that from the basic speed filter, so it has more creative use. For the best results use it on bright subjects against dark backgrounds so the streaking is emphasized, and experiment with different aperture settings to vary the effect.

▼ **SPEED KING**
This is the kind of effect you can achieve using a speed filter. It's not exactly convincing, so don't expect anyone to take it seriously, but as a means of creating fun pictures it's definitely worth a try.

CANON EOS 3, 28MM LENS, COKIN SPEED FILTER; FUJICHROME VELVIA; ⅟₆₀ SEC. AT F/11

RADIAL ZOOM

The zoomburst effect, created by zooming a lens through its focal-length range during exposure, can produce striking results. However, it's a little hit and miss, no two frames are ever the same, and trying to repeat the effect is very difficult. Unless you use a Cokin Radial Zoom filter, that is. The effect it gives isn't quite the same as a genuine zoomburst, but it's close, and requires absolutely no skill to achieve.

All you do is compose a shot with your main subject – a person, statue, neon sign, car, flower, and so on – in the centre of the frame. The filter itself has a clear centre so your subject will be clearly recorded, but it's surrounded by etched lines that turn the area around your subject into an explosion of streaks radiating out towards the edges of the shot. To get the most from this filter, photograph bold subjects and make sure there's plenty of detail in the background to show the zoom effect. Lenses from 28–50mm should also be used, and an aperture of f/11 or f/16.

▼ NOAH

Make pictures of your kids look like stills from a spine-chilling horror movie by using a radial zoom filter… OK, so perhaps the effect isn't that scary, but it was fun to play around with.

NIKON F90X, 28MM LENS, COKIN RADIAL ZOOM FILTER; FUJICHROME VELVIA; 1/60 SEC. AT F/11

CLOSE-UP
FILTERS

SUNFLOWER

A set of inexpensive close-up filters will open up a whole new world of creative photography, allowing you to fill the frame with subjects that are just too small for your lenses to cope with alone – macro lenses excluded, of course. For this picture of the centre of a sunflower, I used a +2 dioptre attachment on a 50mm standard lens. Image quality does fall off a little towards the edges of the image, but in this case the most important part of the flower is in the centre of the shot where sharpness is very good.

NIKON F90X, 50MM LENS WITH +2 DIOPTRE CLOSE-UP LENS; FUJICHROME VELVIA; 1/60 SEC. AT F/11

Close-up filters, or supplementary close-up lenses as they are more commonly known, aren't filters in the normal sense, but optical attachments that fit to the front of your lens and reduce its minimum focusing distance. Compared to other close-up accessories, such as extension tubes, bellows units or genuine macro lenses, their macro capability is relatively poor. That said, if you like to shoot the occasional close-up and can't justify the cost of more specialized pieces of equipment, they provide an inexpensive means of capturing small subjects on film by adapting existing lenses in your system. They don't incur any light loss either, unlike bellows and tubes, so you can meter normally through them. Nor do they darken the viewfinder, so composing and focusing isn't impaired. If you already own a macro lens, you can also increase its power by using close-up lenses. Most filter manufacturers include close-up lenses in their range, and you can buy them in both screw-fit, or to slot into a system holder.

HOW CLOSE-UP FILTERS WORK

The unit of measurement used to denote the magnification capability of close-up lenses is dioptres – the higher the number, the closer you can focus and the greater the magnification. The range available is usually +1, +2, +3 and +4 dioptres, although a few manufacturers make more powerful lenses – up to +10 dioptres. Kits containing three lenses – typically +1, +2 and +3 dioptres – are also available, and you can use them individually or in combination to achieve different levels of magnification. Using +1 and +2 lenses together is the same as using a +3 dioptre lens alone, for example, while using a +2 and +3 will give +5 dioptres.

Close-up lenses work by shifting the plane of focus of the camera lens from infinity to the distance corresponding to the focal length of the close-up lens. A +1 dioptre lens has a focal length of 1m, for example, so if you attach it to a lens and focus that lens on infinity, sharp focus will be achieved when you are exactly 1m away from your subject. A +2 dioptre lens has a focal length of 0.5m, so it shifts focus to 0.5m when the camera lens is focused on infinity. This system works regardless of the focal length of the camera lens, so, whether you use a +2 dioptre

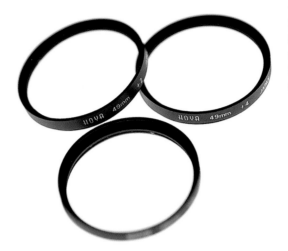

◀ Close-up lenses can be purchased individually or as a set of three – the set shown here is produced by Hoya and includes +1, +2 and +4 dioptre lenses.

close-up lens on a 50mm standard lens or a 500mm telephoto (not recommended; see below), the plane of focus will be shifted to 0.5m when that lens is focused on infinity.

You don't have to work with the camera lens focused on infinity, of course. If you focus it on its minimum focusing distance, the addition of the close-up lens will take you much closer, so you can shoot more powerful close-ups. You can also adjust focus with the lens as normal to bring your subject into sharp focus.

◀ **BACKLIT LEAF**
This close-up was taken by placing the leaf on a lightbox in a darkened room, so it was backlit to reveal the intricate pattern of veins and cells. To move in sufficiently close, a +10 dioptre close-up lens was used on a 50mm standard lens, which gave almost life-size reproduction.

NIKON F90X, 50MM LENS WITH +10 DIOPTRE CLOSE-UP LENS; FUJICHROME SENSIA II 100; ⅛ SEC. AT F/11

REPRODUCTION RATIOS

This set of pictures shows the type of results you can achieve using close-up lenses. The first shot was taken with a 50mm standard lens at its minimum focusing distance as a comparison. With a Hoya +10 dioptre lens used, the reproduction ratio is close to life-size.

50mm lens, no filters

With +1 dioptre close-up lens

With +2 dioptre close-up lens

With +3 dioptre close-up lens

With +4 dioptre close-up lens

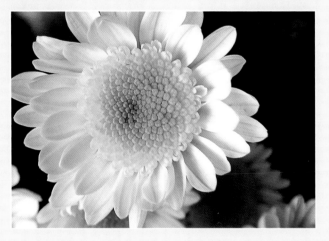

With +10 dioptre close-up lens

◄ **LUPIN**
With a close-up lens or two at your disposal, even your own back garden becomes a treasure trove of interesting subjects – all you have to do is look.

NIKON F90X, 50MM LENS WITH +4 DIOPTRE CLOSE-UP LENS, TRIPOD; FUJICHROME SENSIA 100; ¹⁄₁₅ SEC. AT F/2.8

► **IRIS**
Shooting at a wider aperture when using close-up lenses dramatically reduces depth of field to produce attractive results like this, where only a small area of the flower is in sharp focus.

NIKON F90X, 85MM LENS WITH +2 DIOPTRE CLOSE-UP LENS, TRIPOD; FUJICHROME SENSIA 100; ¹⁄₃₀ SEC. AT F/2.8

Image quality

For optimum image quality, use close-up lenses on fixed focal length (prime) lenses rather than zooms. Standard (50mm) and short telephoto focal lengths up to 135mm are the best, and you should set the lens to an aperture of f/8 or f/11, which is where most lenses give their best optical performance.

If you use more than one close-up lens at once, place the most powerful one on your lens first and the weakest last. Technically it is possible to use three or more together, but image quality will suffer badly, so make two the maximum number used at any one time.

Most close-up lenses are fashioned from a single element, while more expensive models may have a two-element construction for improved image quality. If you intend using them a lot, it's worth spending the extra on the best available, since basic close-up lenses, although reasonably sharp, can't compare with true macro lenses, or with the quality that can be achieved by using non-optical attachments, such as extension tubes, bellows and reversing rings.

REPRODUCTION RATIOS

The table below shows the reproduction ratios you can achieve using different dioptre close-up lenses on a 50mm standard prime lens, focused on 1m, along with the size of the area recorded.

The reproduction ratio is used to denote the size of the subject on a 35mm

Close-up lens (dioptres)	Reproduction ratio achieved	Approx. area covered (mm)
+1	1:10	240 x 360
+2	1:6	145 x 220
+3	1:5	120 x 180
+4	1:4	100 x 145
+5	1:3	75 x 110
+6	1:2.5	60 x 90

frame of film in relation to its size in real life. So, if you shoot at a reproduction ratio of 1:4, the subject will be one-quarter life-size on a frame of film, and at a ratio of 1:2 it will be half life-size.

Depth of field

An important factor to bear in mind when using close-up lenses is that there will be far less depth of field at close focusing distances than you will be used to in normal picture-taking situations. Even at small apertures, such as f/11 or f/16, depth of field will be down to millimetres rather than metres, especially if you use more powerful dioptres and focus as close as possible.

This makes careful and accurate focusing vital if you want your subject to be sharp. You are also advised to mount your camera on a tripod so you can focus with greater precision and avoid camera shake.

Split-field filters

This handy attachment is basically a close-up lens that has been cut in two so it occupies only half of the field, while the other half is left clear. The idea of doing this is to achieve enormous depth of field. You can move very close to something in the foreground and bring it into sharp focus using the dioptre close-up part of the filter, but also record the rest of the scene through the clear half in sharp focus too, effectively achieving impossible depth of field. For example, you could fill the foreground with a butterfly or flower that's only a few centimetres away, but also show the environment around it in sharp focus.

For the best results you need to look for scenes and subjects where there's an empty area in the middle, so you don't see the join between the clear part of the filter and the close-up part. Being able to control the position of the foreground subject you are shooting in close-up helps, but is by no means essential, and you simply have to juggle the elements in the scene by adjusting camera position until they work for you. Often you will see a blurred zone in the middle of the shot, and if the foreground subject isn't solid – such as flowers – then the area behind it will be blurred. But this needn't be a problem if you compose carefully.

To maximize depth of field, set your lens to a small aperture – ideally f/16 or smaller. You can then either set the focus on the lens to infinity and move the camera forwards or backwards until the foreground seen through the close-up part of the filter is sharp, or juggle the camera position and focusing distance on the lens until you get what you want. Using the former technique means you won't be able to get as close to the foreground as you could if the lens wasn't focused on infinity, so experimentation is the key. If you don't focus on infinity, use your camera's depth-of-field preview to check that the background is sharp before taking a picture.

◄ **SOUTHEY WOODS, CAMBRIDGESHIRE, ENGLAND**
Split-field filters allow you to achieve much greater depth of field than is normally possible, so you can include objects in the composition that are just a few inches from the camera while keeping the more distant parts of the scene in sharp focus too. For this shot I used a +1 dioptre split-field filter.

NIKON F90X, 28MM LENS, COKIN +1 DIOPTRE SPLIT-FIELD FILTER; KODAK ELITECHROME EXTRA COLOUR 100; 1/15 SEC. AT F/22

FILTERS
FOR INFRARED
PHOTOGRAPHY

11

CAUSEWAY TOLL FARMHOUSE
This photograph shows all the effects of mono infrared film – high contrast, the darkening of blue sky, and the transformation of foliage to ghostly white tones. I used Kodak High Speed mono infrared, which is the fastest, grainiest and most infrared-sensitive film available, printing to grade IV to boost contrast even further.

NIKON F90X, 28MM LENS, HOYA R25 DEEP RED FILTER; KODAK HIGH SPEED MONO INFRARED RATED AT ISO400; 1/60 SEC. AT F/11

As discussed in Chapter 4, light is made up of wavelengths of electromagnetic radiation, some of which we can see, but most of which are invisible to the naked eye. These wavelengths are measured using a unit known as nanometres (nm). One nanometre is the equivalent to one thousand millionth of a metre. Conventional photography is concerned with controlling and recording light in the visible spectrum, which extends from about 400nm at the blue end to 700nm at the red end.

Infrared occurs in the 700–1,200nm range, so it's invisible to the naked eye. Fortunately, there are specialist films available, in colour and black and white, that are sensitive to both the visible and infrared spectrums over a range of around 250–900nm, making it possible to capture a range of surreal effects. To make the most of infrared film, however, you must use filters to block out as much of the visible spectrum as possible.

MONO INFRARED

There are three types of mono infrared film available – Kodak High Speed, Konica IR 750 and Ilford SFX 200. Konica and Ilford are both available in 35mm and 120 rollfilm formats, while Kodak High Speed comes in 35mm rolls only.

Kodak High Speed is the most infrared-sensitive of the three, with a peak sensitivity of 900nm, which is well into infrared territory. It's also the fastest (ISO400 guide speed), so it's an easy film to shoot handheld, and produces dramatic, grainy images. Konica IR 750's peak sensitivity is slightly lower at 750nm, but it's still very effective and gives a strong infrared effect in bright sunlight. Being much slower (ISO50 guide speed), it's also much finer-grained, so you may prefer it for pictorial work. Ilford SFX 200 has the lowest sensitivity and is really a panchromatic film with extended red sensitivity rather than being a true infrared film. It does produce a good effect when used in the right conditions, however, and with a guide speed of ISO200 is a useful all-rounder.

Filter choice

There are two basic types of filter you can use with black and white infrared film. The most common and convenient is a deep red filter, the type used for normal black and white photography. Examples include the Cokin 003, Tiffen 25, Hitech 25, B+W 092 or Kodak Wratten 25 and 29.

Using a deep red filter will block out light at the bluer and near ultra-violet end of the spectrum, plus green wavelengths, but admit red and infrared light with wavelengths over 580nm, so you can record a strong infrared effect. Best of all, it does this while still allowing you to see through the camera lens with the filter in place, so you can compose and focus the image with ease. You can also expose through the filter using your camera's TTL metering system, making infrared photography quick and easy.

The other option is to use a true infrared transmitting filter, which admits only infrared radiation. There are numerous IR filters available, from manufacturers such as Kodak (Wratten), Heliopan, B+W and Hoya. All do the same job, but have different cut-off points in terms of which wavelengths they admit and which they block out (see illustration p.128).

COLOUR AND BLACK-AND-WHITE COMPARISON

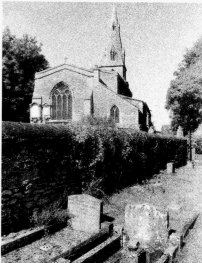

Original scene

Kodak High Speed, no filter

The further into the infrared spectrum this cut-off point is, the stronger the infrared effect, although in fact, if you photographed the same scene with two different IR filters, you would be hard pressed to tell the difference. Also, infrared film can only record infrared radiation up to around 900nm, beyond which even more specialized materials would be required.

Another important factor to consider is that some infrared filters can't be used with Konica 750 and Ilford SFX film as they block out most of the red and infrared wavelengths those films are sensitive to. In practice this means you would end up with a blank image because the film is unable

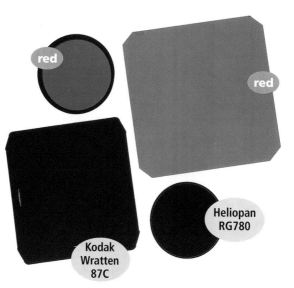

red

red

Kodak Wratten 87C

Heliopan RG780

◄ You have a choice between deep red filters, or visually opaque infrared-transmitting filters when shooting mono infrared film.

MONO INFRARED FILTER COMPARISON

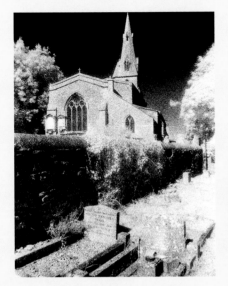

Kodak High Speed, with deep red filter

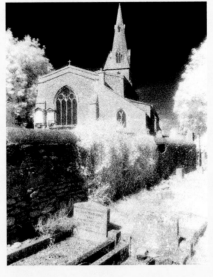

Kodak High Speed, with Heliopan RG780

Kodak High Speed, with Kodak Wratten 87C

Konica 750 Infrared, no filter

Konica 750 Infrared, with deep red filter

Konica 750 Infrared, with Heliopan RG780

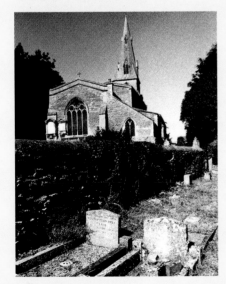

Ilford SFX, no filter

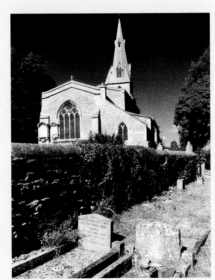

Ilford SFX, with deep red filter

◄ ▲ Paston Church

This set of pictures shows the various effects you can get using different mono infrared films and exposing them through different filters. The colour shot shows what the scene looked like to the naked eye.

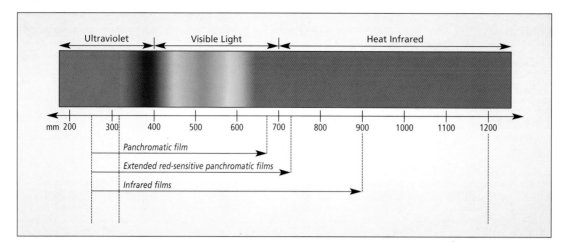

Ultraviolet *Visible Light* *Heat Infrared*

mm 200 300 400 500 600 700 800 900 1000 1100 1200

Panchromatic film

Extended red-sensitive panchromatic films

Infrared films

◄ This illustration shows the part of the electromagnetic spectrum that includes visible and infrared light, and the spectral range that normal and infrared film can record.

to record the light passing through the filter.

To prove this theory I put it to the test while shooting the comparison pictures on page 127.

As you can see, Kodak High Speed Mono Infrared performs well with all three filters due to its high sensitivity – even a Kodak Wratten 87C. Konica 850, on the other hand, is OK with filters up to a Wratten 87 or equivalent – in this case a Heliopan RG780 – but with a Kodak Wratten 87C the film was left blank because it wasn't sensitive enough to record the infrared wavelengths being transmitted by that filter.

With Ilford SFX, filter choice is even more important. Basically, anything much beyond a deep red becomes unsuitable as the film is sensitive mainly to red rather than infrared light, and true infrared transmitting filters block out most red light. For this reason, nothing was recorded when I used the film to photograph the churchyard scene through both a Heliopan RG780 or a Kodak Wratten 87C.

Black-out

The main problem with infrared transmitting filters is that, due to the fact that they block out visible light, they are visually opaque to the naked eye. If you use one you must therefore compose the shot, set the focus and determine the exposure before putting the filter in place. This rules out handheld infrared photography and makes a tripod pretty much essential.

Another drawback is that you can't meter through the filter because your camera's integral metering system isn't designed to measure levels of infrared radiation. Getting the exposure right can also be tricky because, with only infrared light being admitted by the filter, the film's effective speed (ISO) will vary with the type of subjects you

photograph and the prevailing weather conditions – there is more infrared radiation around in bright, sunny conditions, for example.

The only way around this is to use the ISO ratings given in the panel as a guide, then bracket exposures. To be sure of getting one frame well exposed, you are advised to bracket 2 stops over and 1 stop under the initial exposure. This can be done in full stop increments, so in effect you would expose four frames to each scene or subject.

Although the guide speeds have been given for Kodak Wratten filters, you can apply the same ISO ratings to other brands of infrared filter with a similar sensitivity. Looking at the chart plotting the sensitivity of different infrared filters, you can see that the cut-off point for the Hoya IR72 filter is similar to the Kodak Wratten 87, so you could apply the same ISO ratings for both filters.

Whatever ISO rating you use as a starting point, set it on your camera and/or handheld meter, take an exposure reading without the filter in place, then don't change the exposure once the filter is on the lens. This means setting your camera to

▼ This illustration shows the transmission range of popular brands of both deep red and infrared transmitting filters. If you use a deep red filter you will record wavelengths from around 580nm to 900nm, which is the maximum sensitivity of infrared film. Therefore, visible light at the red end of the spectrum is recorded, along with infrared radiation. With most of the true infrared filters, only infrared radiation is recorded. The most popular are those that fall somewhere in the middle of the range – the Kodak Wratten 87 and its equivalents from other manufacturers, such as the Hoya IR72, B+W 093 and Heliopan RG780.

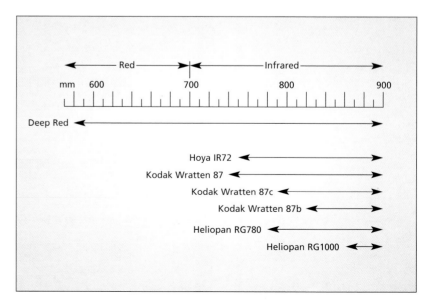

◄ Red ► ◄ Infrared ►

mm 600 700 800 900

Deep Red ◄──────────────────────►

Hoya IR72 ◄──────────►

Kodak Wratten 87 ◄──────────►

Kodak Wratten 87c ◄────────►

Kodak Wratten 87b ◄────────►

Heliopan RG780 ◄──────────►

Heliopan RG1000 ◄──►

MONO INFRARED TIPS

Although this book is primarily concerned with filters for different photographic applications, it seems sensible to include some advice on how to use infrared film when discussing the filters required for this specialist area of photography.

◄ A lightproof changing bag is essential if you want to load and unload infrared film while on location.

- Infrared film must be loaded and unloaded very carefully if you're to avoid fogging it and spoiling your pictures. Kodak High Speed must be handled in complete darkness – so invest in a black changing bag to change films on location. Konica IR750 and Ilford SFX 200 can be handled in subdued light, so on location you could simply put your camera beneath a coat while loading and unloading, or stand in the shade.
- The effective speed of infrared film varies, depending upon levels of infrared radiation around at the time. If you are using a deep red filter, a good starting point is to rate Kodak HIE at ISO400, Ilford SFX at ISO200 and Konica IR750 at ISO50, and take TTL meter readings with the filter in place. If you prefer to meter without the filter in place, or use a handheld meter, rate Kodak HIE at ISO50, Konica 750 at ISO6 and Ilford SFX 200 at ISO25. For recommended ISO ratings with infrared transmitting filters, refer to the table on page 128.
- Infrared radiation focuses on a different point to visible light. If you're using a wide-angle lens of 35mm or wider, and an aperture setting of f/8 or smaller, you can focus normally as there will be enough depth of field to cope with the difference. If you're using a telephoto lens, or any lens at a wide aperture, focus normally, then adjust the lens so the required focusing distance falls opposite the red infrared index on the lens barrel.
- You'll get the strongest results from mono infrared film outdoors in sunny weather, when there's lots of infrared radiation around. Scenes containing blue sky, white clouds and plenty of foliage or grass are ideal, and spring and summer are the best seasons.
- Process mono infrared film like any other black and white film, making sure you don't fog it during loading into the tank. When you come to print the negative, use a hard contrast grade – grade IV or V – to produce rich blacks with glowing white highlights.

manual exposure mode so that neither the aperture, nor the shutter speed – or both – changes when the filter is put into position – as they would if the camera were set to aperture priority, shutter priority or program mode.

Another consideration is the type of exposure readings you can expect with the different infrared transmitting filters. If you were using Kodak HIE infrared film with a deep red filter on a bright, sunny day, exposures would be around 1/60 sec. at f/11–f/16. Infrared transmitting filters reduce the film's effective speed considerably, however, as shown in the panel on p.128. With a Kodak Wratten 87 filter, or equivalent, that exposure

ISO RATINGS FOR INFRARED FILMS AND FILTERS

Film	Guide speed with deep red filter	Guide speed with Kodak Wratten 87	Guide speed with Kodak Wratten 87C
Kodak High Speed (HIE)	ISO50	ISO25	ISO10
Konica IR 750	ISO6	ISO3	N/a
Ilford SFX 200	ISO25	N/a	N/a

would drop to ⅓₀ sec. at f/11–16. With a more sensitive Kodak Wratten 87C or equivalent, which reduces the film's effective speed to ISO10, the exposure would be down to ⅒ sec. at f/11–f/16.

It gets even worse with Konica 750 infrared film, which is a much slower film to begin with. Using a deep red filter with this film in bright sunlight, you could expect metered exposures around ⅛ sec. at f/11–16. With a Wratten 87 it would drop to ¼ sec. at f/11–16, and to almost ½ sec. at f/11–16 with a Wratten 87C, which reduces its effective speed to around ISO2.

This needn't be a problem, but remember that it will take only the slightest breeze to record movements in trees and anything else in the scene that is moving, which may not be what you want. As the difference in infrared effect between, say, a Wratten 87 and 87C isn't huge, it may therefore make sense to stick with the less sensitive filter so you can benefit from a slightly higher ISO rating – especially with Konica 750 infrared film.

▲ **LINDISFARNE**
This unusual boat shed has been enhanced by photographing it on infrared film. I also exposed the scene through a Kodak Wratten 87C filter to optimize the infrared effect.

NIKON F90X, 28MM LENS, KODAK WRATTEN 87C INFRARED FILTER; KODAK HIGH SPEED MONO INFRARED; ⅟₆₀ SEC. AT F/16

◄ **LYNMOUTH, ENGLAND**
In this scene the effect works well because the shops were painted white, so they contrast strongly with the black infrared sky.

OLYMPUS OM2N, 21MM LENS, HOYA DEEP RED FILTER; KODAK HIGH SPEED MONO INFRARED; ⅟₆₀ SEC. AT F/11.5

COLOUR INFRARED

There's one colour infrared film available, in 35mm format only – Kodak Ektachrome EIR. This film was launched a few years ago to replace its ageing stablemate and it has made colour infrared photography easier than ever before, mainly because it's E6 compatible, rather than requiring the almost obsolete E4 process. That said, it's not a cheap film and, as infrared photography is always a little hit and miss, some degree of wastage is inevitable. To minimize this, and produce successful pictures with your very first roll, it therefore pays to understand a little of how the film works.

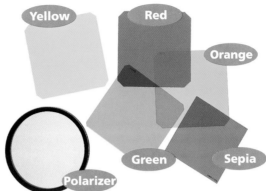

◄ Although a yellow filter tends to give the best results with colour infrared film, orange, red, green and even sepia are worth trying out, plus a polarizer in conjunction with any of these colours to give added impact.

Colour sensitivity

Colour infrared film consists of three colour-sensitive layers, all of which are sensitive to blue light – there's an infrared and blue layer, a green and blue layer, and a red and blue layer.

Kodak recommends that a Wratten no. 12 yellow filter be used at all times – or to use the equivalent yellow filter from any other range, such as Cokin, Hoya, Heliopan, or Tiffen – to block out much of this blue light so the layers record only red, green and infrared. Where there is no exposure, reversal processing will reveal cyan dye in the infrared layer, yellow in the green-sensitive layer and magenta in the red-sensitive layer.

In the final images, green records as blue due to cyan and magenta dye formation and an absence of yellow, red records as green due to cyan and yellow dye formation and an absence of magenta, while infrared light records as red, the result of yellow dye formation in one layer, magenta in another and the absence of cyan dye formation. The actual sensitivity of the film ranges from 400nm–900nm, though by using a yellow filter to block out light at the blue end of the spectrum it actually records a range of 600–900nm.

► **CAUSEWAY TOLL FARMHOUSE**
This is the same property – my former house – as that shown on page 125, only this time captured in colour rather than mono infrared. Note how the blue sky looks normal – albeit a very dark blue – while the shrubs and lawn in the foreground have gone completely mad! This effect is characteristic of exposing the film through a yellow filter.

NIKON F90x, 18–35MM ZOOM AT 20MM, COKIN YELLOW FILTER; KODAK EKTACHROME EIR; 1/125 SEC. AT F/16

Put this theory into practice in bright, sunny weather, and blue sky goes a very deep blue, foliage comes out a brilliant rich red, while surfaces like masonry, which reflects little infrared radiation, look fairly normal. Certain colours of fabric also change colour – blue comes out red.

Don't limit your use of colour infrared film to yellow filters alone, however, because you can produce some amazing effects with different coloured filters. An orange filter gives a similar effect to yellow, with rich blue sky, white clouds and vibrant orange/red foliage. Much depends on the weather conditions – bright sunlight and clear blue sky will give the best effect. It's also worth using a polarizing filter with an orange or yellow filter because this will increase contrast further to produce even stronger colours. Try it on buildings as well as landscapes – you will find that windows come out black.

A red filter admits red light but blocks out green, so while foliage still comes out as a deep red colour, the sky and buildings tend to adopt a

On Kodak Ektachrome EIR colour infrared film

Original scene

◄ ▲ BEACH HUTS

There's only one word to describe colour infrared film –
bizarre. The effects it produces are like nothing on earth,
but they always look great, so try it on all types of subjects –
these seafront beach huts have been completely transformed,
as you can see by comparing the image to one of the same
scene taken on normal colour film.

NIKON F90X, 17–35MM ZOOM LENS AT 17MM, ORANGE AND
POLARIZING FILTERS; KODAK EKTACHROME EIR COLOUR INFRARED
RATED AT ISO400; 1/60 SEC. AT F/11

TIPS FOR COLOUR INFRARED PHOTOGRAPHY

To help you make the most of your Kodak Ektachrome EIR film, here are
some important factors to consider.

- The film must be loaded and unloaded in complete darkness, so a
 changing bag is essential on location.
- Careful storage of EIR film is essential. Ideally, place it in an airtight box
 as soon as it's purchased and store it in a deep freeze until required,
 allowing it to thaw for 24 hours at room temperature before loading it
 into your camera.
- Use the smallest aperture you can – f/11 or f/16 – to maximize depth of
 field and compensate for any focusing differential. In bright sunlight,
 expect exposures in the region of 1/125 sec. at f/16.
- EIR is an E6 compatible film, so it can be processed along with ordinary
 colour slide film. Tell your lab it's infrared film though, so they know not
 to open the film tub in daylight or to use any infrared equipment when
 processing it – either of which would cause fogging and ruin your shots.

sickly yellow colour cast. Green is even wackier,
adding a vibrant magenta colour cast to the
whole of the image, with no clear separation of
colour at all.

The effect you end up with depends very much
on the weather conditions. There's more infrared
radiation around in bright sunlight, so that's
when you will get the strongest effect, and
because that radiation shows itself most clearly
in foliage, landscapes or scenes containing trees
are obvious targets for your infrared exploits.

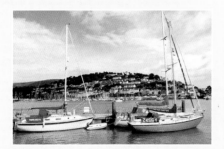

The original scene

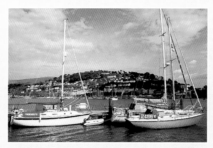

Ektachrome EIR, no filters

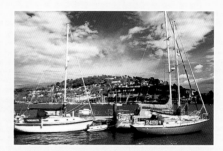

Ektachrome EIR, with yellow filter

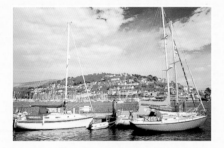

Ektachrome EIR, with orange filter

Ektachrome EIR, with red filter

Ektachrome EIR, with green filter

▲ **KINGSBRIDGE, DEVON, ENGLAND**
This set of comparison pictures shows the various effects you can achieve by photographing a scene on Kodak Ektachrome EIR colour infrared film with different filters. The first shot was taken on conventional colour film to show what the scene looked like to the naked eye.

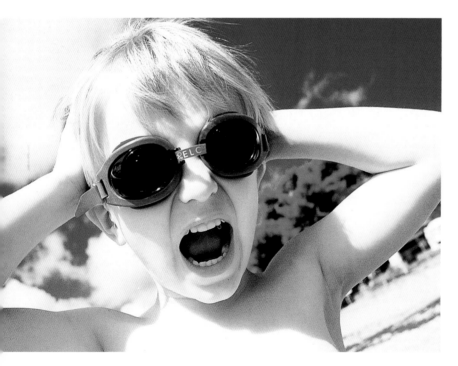

▲ **NOAH**
For this unusual portrait of my son I used Kodak Ektachrome EIR in conjunction with a yellow filter. You can see how his skin tones have taken on a ghostly pallor while his lips are bright yellow and the foliage behind is blood red – typical colour infrared effects.

NIKON F90x, 17–35MM ZOOM AT 20MM, ORANGE AND POLARIZING FILTERS; KODAK EKTACHROME EIR; ⅓₀ SEC. AT F/11

Exposure accuracy

Like mono infrared film, Kodak Ektachrome EIR can also be a little unpredictable when it comes to determining correct exposure. Kodak recommends that with a yellow filter you rate it at ISO200. This speed takes into account the 1-stop light loss of the yellow filter, so you would use this ISO if you took a meter reading either with a handheld meter, or with your camera's TTL metering system. In either case, set the exposure reading obtained on your camera in manual exposure mode and change nothing when the filter is fitted.

A quicker way to work is by metering with the filter in place, so the camera automatically takes the 1-stop light loss into account. If you use this method, rate the film at ISO400.

Either way, it still pays to bracket exposures at least 1 stop over and 1 stop under the metered exposure, in ½-stop increments, to be sure of at least one acceptable frame.

When using other coloured filters, set ISO400 on your camera and meter through the filter you're using, whether it be red, orange, green or sepia.

COMBINING
FILTERS

FENLAND SCENE
This bleak winter scene looked rather boring and dull to the naked eye, but the use of two filters has completely transformed it. First, a 0.9 ND grad was selected to hold colour and detail in the sky, while a blue 80B added the cold cast to the image.

NIKON F90X, 18–35MM ZOOM, 0.9 ND GRAD AND 80B FILTERS, TRIPOD; FUJICHROME VELVIA; 15 SEC. AT F/11

Although the vast majority of filters are designed to give a single effect, most can be used with one or more other filters to give a combination of effects on a single image. For many photographers this is standard practice. A polarizing filter is often used with a warm-up filter and/or a neutral-density graduate when shooting landscapes, for example.

With this combination, the polarizer is often selected first and used for one or more of its well-known effects – to deepen blue sky, reduce glare so colour saturation is increased, improve overall clarity and eliminate reflections. Next, a neutral-density graduate may be added to reduce the difference in brightness between the sky and the ground, or to tone down part of the sky if it's darker on one side than the other due to uneven polarization. Finally, a warm-up filter is often selected in order to balance any slight coolness in the light, or to add an intentional warmth.

Of course, this is just one practical combination – but there are thousands of others that are waiting to be discovered if you are willing to experiment.

CHOOSING COMBINATIONS

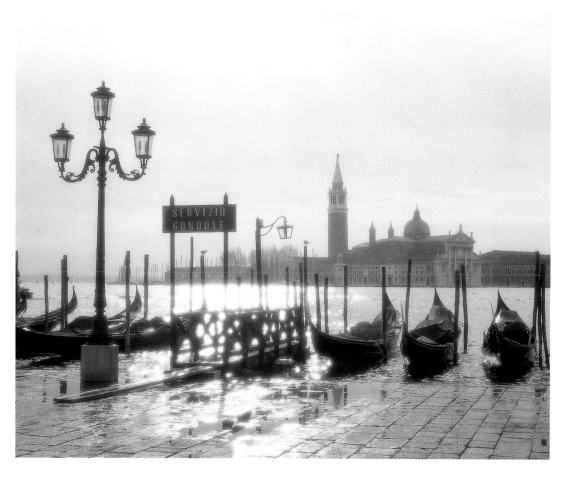

◄ **SAN GIORGIO MAGGIORE, VENICE**
Warm-up and soft-focus filters make a great combination, especially on backlit scenes like this view across the lagoon in Venice. I wanted a high-key image so instead of metering for the highlights I took an incident reading of the light falling on the shadows and exposed for that, knowing that the background would burn out.

PENTAX 67, 105MM LENS, ORANGE 85 AND SOFT-FOCUS FILTERS, TRIPOD; FUJICHROME VELVIA; ⅟₆₀ SEC. AT F/16

Combining technical filters with effects filters is a good way to begin. When shooting a portrait you could use a warm-up filter to enhance the colour of your subject's skin, then a soft-focus to add a romantic feel. This combination is very popular because the two effects – warming of the light and the addition of diffusion – are very evocative and atmospheric. Try these two filters with fast, grainy film for impressionistic images, as well as on normal speed film.

Soft-focus filters can also be used with warmer filters from the orange 85 series if you want a truly golden glow, or a sunset graduate filter. But they also work with cool filters – either subtle 82-series cool filters, or the blue 80 series of colour-conversion filters.

Depending upon the type of subject you are photographing, you might then decide to add a second effects filter. A starburst could be used with a colouring filter and soft-focus, for example, if there are highlights or point sources of light in the scene that will show its effect. The same applies to diffractors. Multiple-image, speed and other similar special-effects filters would also work as part of this combination.

If your main filter provides a strong colour cast across the whole image, then obviously a second or third filter must add an effect that will still be noticeable. So, for example, there's no point using a blue 80A filter to add a cool cast to your pictures, then combining it with a warm-up – the warming effect will be cancelled by the blue filter and you will end up with a less blue colour cast than if the 80A filter had been used alone.

Multiple colours

Two or more strongly coloured filters can be used together effectively if you place one over the lens as normal, and the second over a flash gun. Do this by using two filters of opposing colour that will cancel each other out. The colour of the filter you place on the lens will add its colour to the image, while any areas lit by the flash will look normal because the cast added by the first filter

► **DERWENTWATER, LAKE DISTRICT, ENGLAND**
These filter effects were added as an afterthought, simply by copying the original colour slide using a lightbox and a macro lens. This isn't an approach I'd recommend, but if you take a picture and feel that it could have been improved by the use of certain filters, there's nothing to stop you adding them at a later date.

NIKON F90x, 105MM MACRO LENS, LIGHTBOX, BLUE 80A AND COKIN DIFFUSER 1 FILTERS, TRIPOD; FUJICHROME VELVIA; ⅟₁₅ SEC. AT F/11

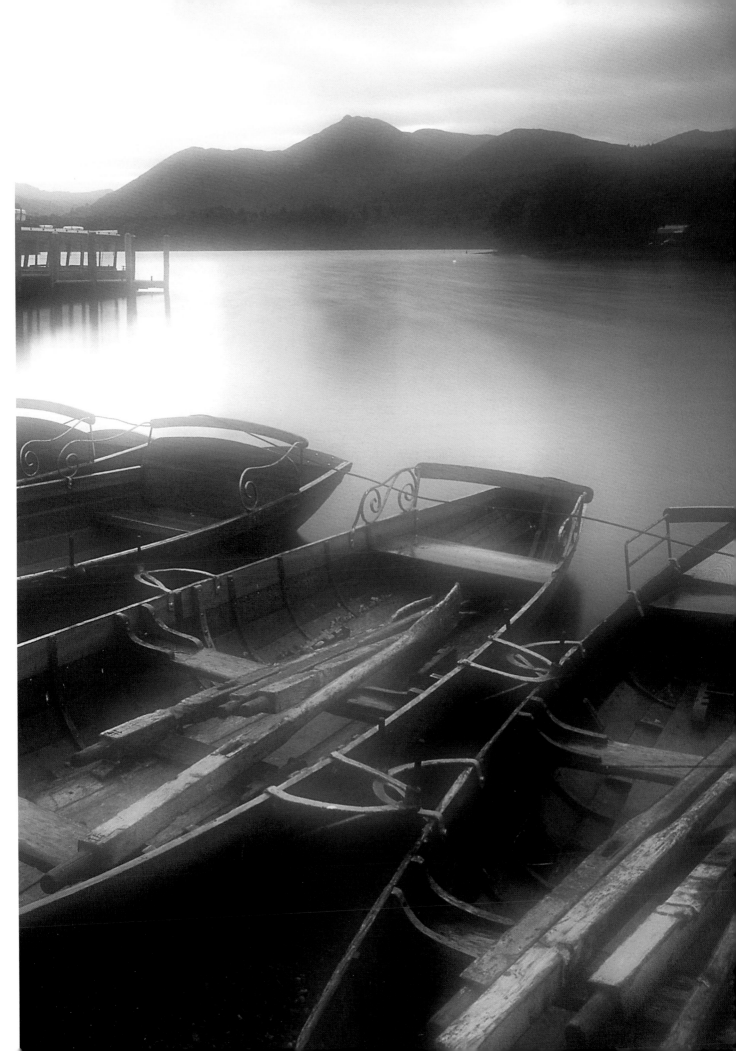

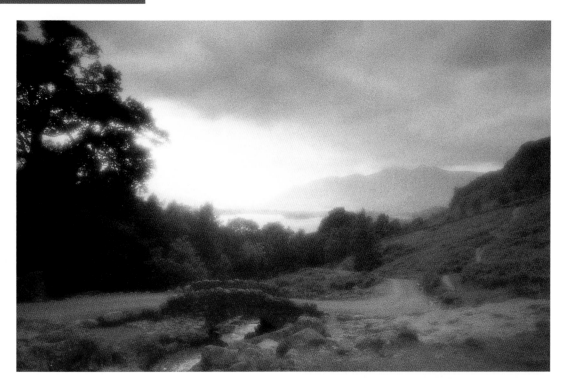

◀ Ashness Bridge,
Lake District, England
Fast, grainy film combined
with soft-focus and strong
warm-up filters provides all
the ingredients you need for
delicate impressionistic
images. Shoot in overcast
weather for the best results
– the soft light and muted
colours will add to the effect.
I took this picture in the Lake
District on a drab, rainy day
and it captures the mood of
the place perfectly.

Olympus OM2n, 28mm lens,
orange 85B and soft-focus
filter made from GePe anti-
Newton glass slide mount;
Agfachrome 1000RS;
1/125 sec. at f/11

will be cancelled by the filter on the flash.

For example, if you place a blue 80A filter on the lens, it will add a blue cast to the whole image. However, if you then place an orange 85B filter on your flash gun, it will cancel out the blue cast on any areas lit by the flash – such as a person, an animal or a statue – so they appear normal. This is because a blue 80A and orange 85B adjust the colour temperature of the light by the same amount – 2,300K – but in opposite directions. Using a blue filter on the lens and a warm filter on the flash tends to work best because it leaves the areas unlit by the flash with a blue cast, and cool colours make better background than warm colours.

Another technique worth trying is known as tricolour. This requires three pure-coloured filters – red, green and blue – and works on the basis that if all three colours are combined they cancel each other out. You will need a camera with a multiple-exposure facility, so you can re-expose the same frame of film three times, each time with a different-coloured filter on the lens. All you need to do then is find a scene that contains both stationary and moving elements, such as a stream tumbling over rocks, or a landscape on a windy day. Mount your camera on a tripod, compose the shot, then make your first exposure with one of the three filters in place. Next, re-cock the shutter and make your second exposure with another filter in place, then do the same thing again with the third filter in place.

The idea here is that any solid features in the scene will come out looking normal because they have been exposed to all three filters, so the colour casts will have cancelled each other out. Any moving features, such as clouds or water, will take on the three colours, however, because they will have been in different positions each time that you exposed the scene with a different filter on the lens.

The main point to remember is that you must reduce the metered exposure by 1½ stops for each individual exposure, otherwise the stationary features in the scene will be over-exposed. The effect works better in some situations than it does in others, but it's worth experimenting with.

▲ ▶ These two pictures
show good use of the
tricolour technique. Notice
how the moving elements in
each shot – the clouds and
traffic trails – have picked up
the colours of each filter,
while stationary elements
look natural because all
three filters have cancelled
each other out. This is
particularly noticeable in
the building.

Canon EOS5, 28mm lens for
building, 85mm for traffic
trails, red, blue and green
filters, tripod; Fujichrome
Velvia; exposures not recorded

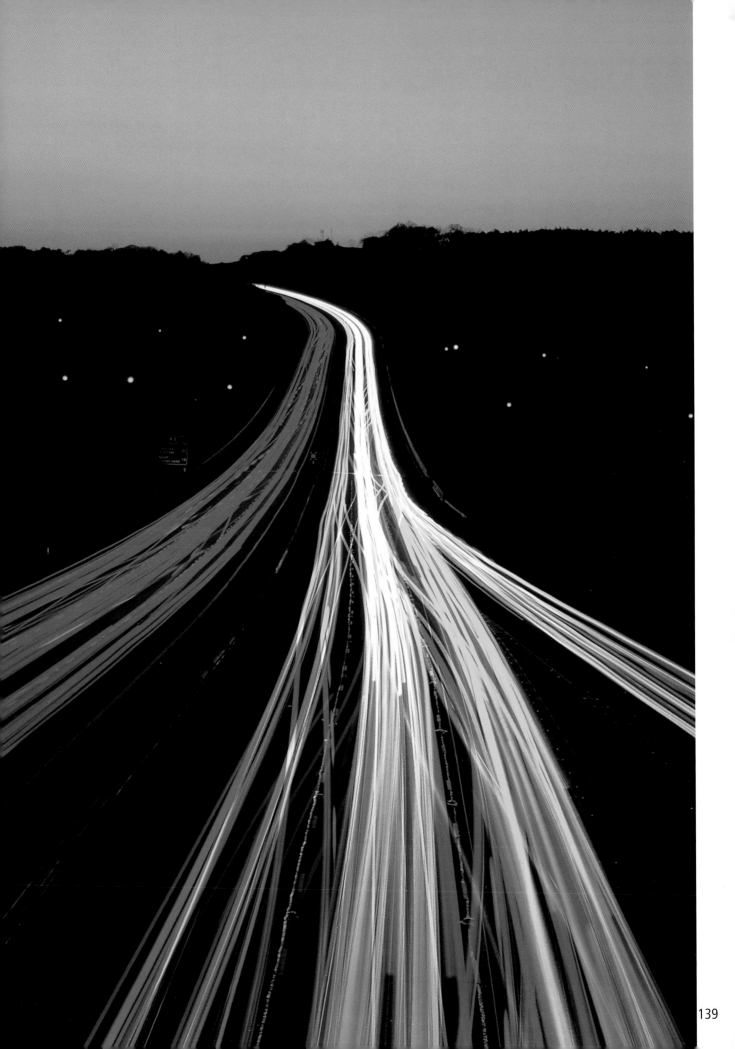

GRADUATED OPTIONS

We have already looked at using more than one neutral-density graduate filter together to give a higher level of neutral density in order to tone down bright skies, or to produce a staggered effect for more precise contrast control. And coloured graduates can also be used in combination – one to colour the sky– a second to colour the foreground.

But the two types of graduate filter can also be used together. You may choose a neutral-density grad to tone down the sky partially, then a coloured grad to complete the toning down, but also to add a subtle colour. Similarly, you could use an ND grad to balance the sky and foreground, but then an inverted coloured grad to colour the foreground as well.

Getting a balance

The great thing about filters is that, once you have a reasonable collection, there are countless combinations you can experiment with. At the same time, don't overdo it. Three is the maximum number of filters you should really consider using at any one time – if only because each time you place another piece of glass or resin in front of your lens, you are reducing its optical quality and affecting the sharpness of your pictures. Even if your filters are of the highest quality and kept spotlessly clean, they will still do this.

Also, if you find that you are using three or more filters together on a regular basis, perhaps you need to ask yourself why you feel it's necessary to do so. Is it because the subject or scene you are photographing isn't interesting enough in its own right? Or have you become so thoroughly obsessed with adding effects to your pictures that 'straight' photography no longer holds any appeal?

Either way, you are in serious danger of

▼ **BAMBURGH CASTLE, NORTHUMBERLAND, ENGLAND**
Two grad filters were used here – an ND grad to tone down the bright sky, and an inverted mauve grad to mirror the colour of the sky and enhance the foreground.

PENTAX 67, 55MM LENS, 0.9ND AND MAUVE GRAD FILTERS, TRIPOD; FUJICHROME VELVIA; 2 SEC. AT F/16

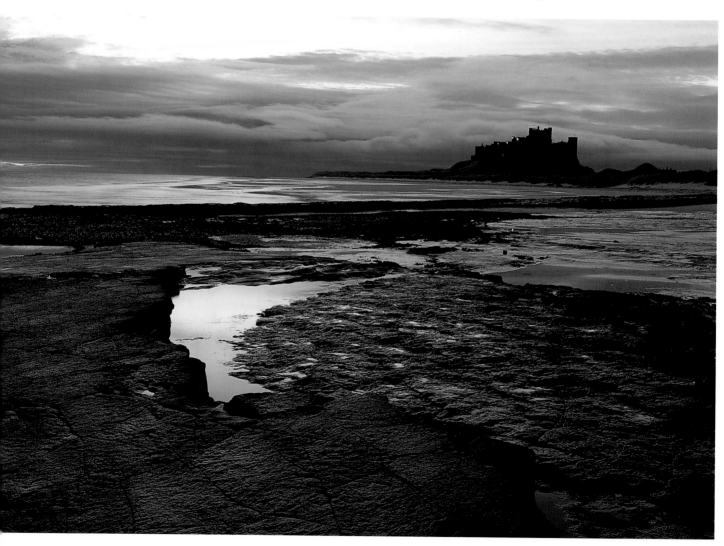

▲ TORQUAY MARINA, DEVON, ENGLAND
Tobacco grads are rather passé these days, but at the time this picture was taken they were all the rage. To enhance the harbour scene I also used a soft-focus filter.

OLYMPUS OM1N, 28MM LENS, COKIN TOBACCO GRAD AND DIFFUSER 1 FILTERS, TRIPOD; FUJICHROME RFP50; 1/125 SEC. AT F/16

placing technique over content, and although that approach may be necessary once in a while, and under the right circumstances can produce stunning images, if it becomes the main motivating factor in your work it will eventually do more harm than good.

Don't be mistaken – filters are invaluable aids to creative photography, and any photographer who claims to never use or need them is fooling no one but him- or herself. But at the same time, they must be used carefully, sparingly and only when the effects they produce will genuinely help you improve on what is already a worthwhile photograph.

You can't make boring light interesting by adding filters, and neither can you hide the fact that the subject matter is uninspiring by filtering it to death. Filters can make an already good photograph even better, but they transform a mediocre photograph. Remember that, and you won't go far wrong.

▲ CHILLINGHAM, NORTHUMBERLAND, ENGLAND
Two graduated filters were used for this shot – a 0.6 ND grad to tone down the brightness of the sky, then an apricot grad to further tone it down but also to enhance the subtle, natural colouring of the clouds.

NIKON F90X, 80–200MM ZOOM AT 200MM, ND AND APRICOT GRAD FILTERS, TRIPOD; FUJICHROME VELVIA; 1/2 SEC. AT F/16

USEFUL ADDRESSES

The main filter manufacturers around the world are listed below, along with contact details. Websites are a good source of product information, technical data, testimonials from satisfied customers, articles on using filters and links to other related websites.

B+W

UK: Prisma Europe Ltd,
Priory House, Pitsford St, Hockley,
Birmingham B18 6LX
Tel: 0121 554 5540

France: Rollei Diffusion,
BP41, ZA de Mauly, F-91412
Dourdan Cedex
Tel: 01 64 59 78 78

Spain: Disefoto,
Bilbaog, E-08339 Vilassar de Dalt,
Barcelona
Tel: 93 750 7205

Italy: Mamiya Tradings,
Via Cesare Pavese 31, 1-20090
Opera, Milano
Tel: 02 5760 4435

Germany: *See website for full list of dealers.*

USA: CSchneider Optics Inc,
285 Oser Avenue, Hauppauge, New
York 11788 - 3886
Tel: 631 761 5000

Australia: Mainline Photographics Lty
Ltd,
64 Alexander St, Crows Nest, NSW
2065
Tel: 02 9437 5800

New Zealand: C R Kennedy (NZ) Ltd,
Unit 2, 3 Hotuniu Drive, Mt
Wellington, PO Box 14508, Panmure,
Auckland
Tel: 09 276 3271

Website:
www.schneiderkreuznach.com

COKIN

UK: Introphoto Ltd, Priors Way,
Maidenhead, Berkshire SL6 2HR
Tel: 01628 674411

France: Piktus, 50/52 Rue des Solets,
Silic 458, 94593 Runguis Cedex
Tel: 01 41 73 45 50

Spain: Optitecnica, Avda de la
Hispanidad 9-11, 28042 Madrid
Tel: 91 320 3443

Italy: Fowa, Via Tabbachi 29,
10132 Torino
Tel: 011 81441

Germany: Hapateam, Giethestrasse
11, 85386 Eching
Tel: 089 37 99 57 30

USA: Minolta Corporation, 101
Williams Drive, Ramsey, NJ 07446
Tel: 201 934 5213

Australia: R Gunz (Photographic) Pty,
Locked Bag 690, Beaconsfield, NSW
2014
Tel: 02 9935 6600

New Zealand: HE Perry Ltd, 97
Nazareth Avenue, Middleton, PO Box
111, Christchurch
Tel: 03 366 5569

Website: www.cokin.fr

CROMATEK

UK and manufacturer: Lastolite Ltd,
8 Vulcan Court, Hermitage Industrial
Estate, Coalville, Leicestershire LE67
3FW
Tel: 01530 813381

France: McDonna Multiblitz France,
24 Rue da Davoust, 93698 Pantin
Cedex
Tel: 01 48 91 20 66

Spain: Cromalite S.L, Vimnalf, 29
Bajof, 08041 Barcelona
Tel: 93 436 0561

Italy: Lino Manfrotto & Co Spa, Via
Livinallongo 3, I-20139 Milano
Tel: 02 566 0991

Germany: Brenner Foto Versand
Gmbh, Mooslohstrasse 60, B92637
Weiden
Tel: 96 167 0600

USA: Bogen Photo Corp, 565 East
Crescent Avenue, Ramsey, NJ 07446
Tel: 201 818 9500

Australia: Eyesight Australia Lty Ltd,
Unit 1/9 Hotham Parade, Artarmon,
Sydney, NSW 2064
Tel: 02 9439 9377

New Zealand: Euroco Distribution
(NZ) Ltd, 640 New North Road,
Morningside, PO Box 77088,
Auckland
Tel: 09 849 5872

Website: lastolite.com

HELIOPAN

UK: Teamwork Photographic,
41–42 Foley St, London W1W 7JN
Tel: 020 7323 6455

Germany: Heliopan Lichtfilter-Technik
Summer GmbH & Co KG
Postfach 1228,
D-82154 Gräfelfing/München
Telefon: 089/8 54 30 06
Telefax: 089/89 80 29-33
e-mail: info@heliopan.de

Website: www.heliopan.de

HITECH

UK and manufacturer: Formatt
Filters, Unit 23–27, Aberaman
Industrial Estate, Aberaman,
Aberdare, Mid Glamorgan CF44 6DA
Tel: 01685 870979

Spain: Casanova, C/Pelai 9, Entresol,
08001 Barcelona
Tel: 93 301 6112

Italy: Itallux, Via Soperga 45, 20127
Milan
Tel: 022 613 358

USA: Visual Departures, 13 Chapel
Lane, Riverside, CT 06978
Tel: 203 698 0880

Australia: L&P Photographic, 96
Reserve Road, Artarmon, Sydney,
NSW 2064
Tel: 02 9906 2733

Website: www.formatt.co.uk

HOYA

UK: Introphoto Ltd, Priors Way,
Maidenhead, Berkshire SL6 2HR
Tel: 01628 674411

France: Kotow, 60 Rue Francais,
De Pressense, 93200 Saint Denis,
Tel: - 1 4811 2929

Spain: Arkofoto S A, Villar, 27–29,
08026 Barcelona

Italy: Apshot SRL, Via Zuretti 61,
20125 Milano
Tel: 02 669 3941

Germany: Hapa Team Handelsges
GmbH, Arnoldstrasse 23,
40479 Dusseldorf
Tel: 211 4920 002

USA: THK Photo Products Inc,
2360 Mira Mar Avenue, Long Beach,
CA90815
Tel: 562 494 9575

Australia: R Gunz (Photographic) Pty
Ltd, Unit 1/4 City South Business
Park, 26–34 Dunning Avenue,
Rosebery, 2018 Sydney, NSW
Tel:˙02 9935 6600

New Zealand: Ian R Little Ltd,
124–126 Peterborough St,
PO Box 1287, Christchurch
Tel: 03 366 7622

JESSOPS

UK: Jessop House, Scudamore Road,
Leicester, Leicestershire LE3 1TZ
Tel: 0116 232 6000
e-mail: sales@jessops.co.uk

Website: www.jessops.com

LEE FILTERS

UK: Central Way, Walworth Industrial
Estate, Andover, Hampshire SP10
5AN
Tel: 01264 366245

France: Manfrotto France, 8/10 Rue
Sejourne, Creteil Parc, 94044 Creteil
Cedex
Tel: 01 45 13 18 70

Italy: Lino Manfrotto & Co Spa, Via
Livinallongo 3, I-20139 Milano
Tel: 02 556 0991

Germany: Calumet Photographic
Gmbh, Eppendorfer Weg 213, 20253
Hamburg
Tel: 40 423 1600

USA: Lee Filters USA, 2237 North
Hollywood Way, Burbank, CA 91505
Tel: 818 238 1220

Australia: Van Bar Photo Supplies,
159 Cardigan Street, Carlton,
Victoria 3053
Tel: 03 9347 7788

INDEX

New Zealand: Panavision NZ, PO Box
47091, Ponsonby, Auckland
Tel: 09 378 9493

Website: www.leefilters.com

SINGH-RAY

USA: Singh-Ray Filters, 2721 SE
Highway 31, Arcadia, FL 34266 -
7974

Tel: 1 800 486 5501

Website: www.singhray.com

SRB FILTERS

UK: 286 Leagrave Road, Luton,
Bedfordshire LU3 1RB
Tel: 01582 572471

Website: www.srbfilm.co.uk

TIFFEN

USA: The Tiffen Company LLC, 90
Oser Avenue, Hauppauge, New York
11788 - 3886
Tel: 631 273 2500

Website: www.tiffen.com